RELIEF PRINTMAKING

Relief Printmaking

A Manual of Techniques

Colin Walklin

The Crowood Press

First published in 1991 by
The Crowood Press Ltd,
Ramsbury, Marlborough
Wiltshire SN8 2HR

Paperback edition 1997

British Library Cataloguing in Publication Data
A catalogue record for this book is available from the British Library.

ISBN 1 86126 071 7

Typeset by Chippendale Type Ltd., Otley, West Yorkshire
Printed in Great Britain at The Bath Press

Contents

Acknowledgements

Grateful thanks to the printmakers who were willing to share their expertise or give their time in the preparation of this book: Simon Brett, Claire Dalby, Peter Forster and Mollie Russell-Smith. Also to printmaking students at the Elmers End Arts Centre, Beckenham, and at West Dean College, Chichester, Sussex.

Special thanks to Peggy Strausfeld, Judy Russell and Penny Hughes-Stanton who kindly lent work to be reproduced in this book, and to Richard Bawden and Bevil Roberts for permission to use work by Edward Bawden and Luther Roberts.

Assistance with photography was given by Janey Walklin and additional research by Carol Walklin.

The following institutions and publishers have given their permission for prints to be reproduced:

Beeches Press: *The Adventures of Covent Garden* (page 155); Flowers East: *Peacock Bird* (page 131); The Folio Society: *Sonnet CLV* (page 157); Glenbow Museum, Canada: *The Mowers* (page 131); Glenmorangie Distillery Company: *Duncan Macpherson, Stillman* (page 161); Headline Book Publishing PLC: *Food and Wine Adventures* (page 155); Libanus Press: *Theodore and Honoria* (page 157); The London Transport Museum: *Kew Gardens* (page 161) and the illustration for the Greenline Countryside Routes (page 163); Mullet Press: *William Shakespeare* (page 159), *The Humble Monument* (page 162) and the linocut logo for The Mullet Press (page 162); Paulinus Press: *Hobbes' Whale* (page 156); The Victoria and Albert Museum: *Aries, The Ram* (page 10); *The Kiss* (page 17); *A Rhinoceros* (page 18); *Mahuna Atua* (page 18), *Two Courtesans* (page 48) and *Two Signs of The Zodiac* (page 145).

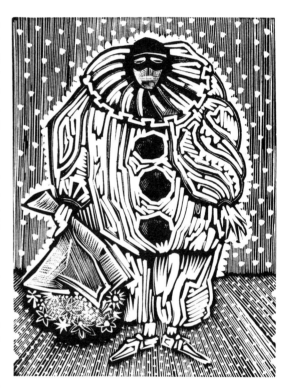

A wood engraving by Luther Roberts.

Permission was kindly granted by the following artist-printmakers to reproduce their work in this book:

Sybil Andrews (pages 21 and 131), Edward Bawden (pages 74, 80, 130, 161, and 20), Thomas Bewick (page 19), Simon Brett (page 156), Sheila Cox (page 136), Glenys Crane (page 134), Claire Dalby (pages 61, 65, 66 and 151), Edwina Ellis (page 72), Peter Forster (pages 73 and 157), Val Franco (page 39), Paul Gauguin (page 18), Jane Gray (page 153), Gertrude Hermes (pages 19, 76 and 131), Edith Hill (page 154), Arthur Howard (page 162), Blair Hughes-Stanton (page 130), Patricia Jaffé (page 56), Isabel Jeffries (page 107), Pat Kettle (pages 57, 95, 81 and 105), Ianthe King (page 142), John Lawrence (pages 69 and 155), Edvard Munch (page 17), Sarah Van Niekerk (page 70), Virginia Nokes (page 14), Colin Paynton (page 144), Pablo Picasso (page 129) © DACS 1991, Eric Ravilious (page 163), Luther Roberts (pages 6 and 71), Michael Rothenstein (page 131), Mollie Russell-Smith (page 105), Avril Sleeman (pages 37, 41 and 46), Kay Spink (page 142), Peter Strausfeld (page 160), George Tute (page 161), Kitagawa Utamaro (page 48), Carol Walklin (pages 55, 60, 75, 78, 89, 90, 98, 99, 129, 130, 143, 152, 157, 159, 161 and 162), Colin Walklin (pages 59, 86–7, 132, 154 and 163), Janey Walklin (page 15), Angela Watkins (page 134), Anne Weald (pages 41, 44 and 83), Geoffrey Weald (page 145) and Keeley Weald (page 77), Margaret Wilson (pages 57 and 150).

Foreword

An extract from *Frontiers of Printmaking: New Aspects of Relief Printmaking* by Michael Rothenstein (Studio Vista 1966):

Like painting or sculpture, printmaking should mean an exposure to new experience, a chance of expansion into a world without frontiers. Printmaking should never signify a contraction, a closing down, an involvement with narrow technical problems. Though it may well be necessary for the graphic workshop to devote itself to one aspect of printing, we should always attempt to consider its activities as a broad study, broadly related to the basic problems of visual communication.

Until recently the materials used for relief-printing were severely limited. Wood, linoleum and sometimes metal were those in general use. Normally prints were taken from rectangular blocks of smooth surfaces; their straight-cut edges were always the respected boundary of the image. But at the present time, apart from blocks he himself carves, the artist is likely to assume a much wider, more varied range of materials. He can get images from almost any flat object or surface that can be covered with ink and that is tough enough to withstand the necessary pressure for printing: a face of eroded stone, a section cut through a tree, a fragment of tortured metal found on the beach. We have made blocks from pieces of old lead gutter torn from a roof, from weathered plywood casing taken from a derelict glider, from the stamped metal lids of old fruit cans and from machine parts found on the garage floor. Even soft materials can be used: a piece of embroidery, crumpled paper, the rippling surface of a nylon stocking – you have only to dip them in a liquid hardener, and to spread them out on some sort of backing.

Hence the printmaker need not assume the use of any single material, wood or linoleum for example, any more than the painter assumes a limit to his ideas in terms of oil paint alone. Indeed from the moment when Braque and Picasso first employed collage, around the year 1915, combining paint with sand, wallpaper or pieces of string, artists everywhere have constantly attempted to widen their means of expression to include all possible materials and all practical techniques. This has not been wilful adventure on their part, but has served a philosophic intention affecting the whole basis of present aesthetic judgement.

The printmaker, too, has lately grown more suspicious of fixed assumptions both with regard to method and materials. He has become open to experience. Like the painter or sculptor, he values freedom of choice. New and different tools, different ways of work, different materials, are constantly being tried. He has grown more flexible, more resourceful, in answering the question, 'Which of these will give my image its clearest, most potent expression?'

Introduction

Printmaking, as a form of reproduction, can be referred to as a mechanical process; a production of many impressions from a single design. However, you must acquire the techniques through which you can realize your creativity and self-expression. Students who wish to have the freedom to explore their ideas must, of necessity, also have the tools and technical efficiency to achieve this end.

It is essential to the production of a satisfying print that the student's ideas are first stimulated, and then disciplined, employing the craftsmanship needed to obtain the end product, the print. When you first pull a print from the block you experience an excitement which does not diminish with time. But this kind of 'magic' can only come about with the grasping of principles and technical

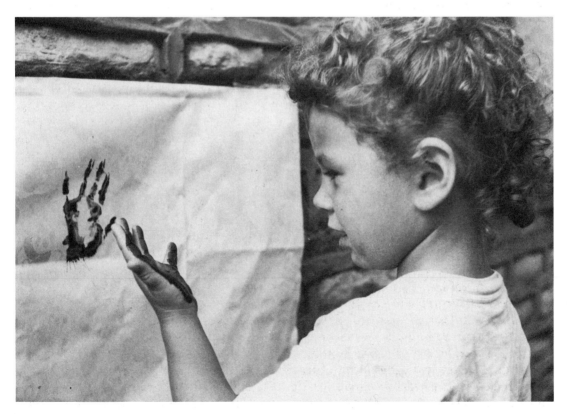

A child enjoys the experience of making a unique printed mark.

knowledge. The writer hopes that reading this book will help the printmaking student to be both creative and proficient.

Access to print workshops is not always available and classes can be either too far away or too costly for some people. Although it is often best to work in company, at least for some of the time and to benefit by others' experience or the guidance of a qualified tutor, some techniques can be learned and used, quite adequately, in the home. Materials do not have to be costly, or equipment expensive, particularly not for the simpler, more basic techniques. A humble vegetable used with powder colour and a roll of lining paper can achieve as satisfying results as a print obtained by using fine tools and a piece of boxwood.

This book is written for those who wish to experience the delights of printmaking. It is for those who have little or no training in the practical aspects of the craft. Students soon find that they become fascinated by the possibilities of printmaking and want to explore, experiment and develop their capacity for observation, selection and judgement, giving their own unique characteristics to their work.

Printmaking can be enjoyed by those who shrink from pure drawing. Such inhibitions, perhaps instilled in early education, can be broken down with sound instruction on relief printmaking. Confidence can be gained with techniques such as collage, stencils and simple linocuts. However, just the grasping of basic skills is not enough and this book lays considerable emphasis on design and an appreciation of the individual quality of each distinctive medium in order to help you choose which will be best suited to interpreting your original idea. Any printing performs a kind of 'magic' and, once you have learned to handle the relevant tools with efficiency and to understand the printing process, there are no limits to the achievements you can gain.

The book is illustrated with work from artist-printmakers ranging from the renowned to the beginner. The age range is wide as is the level of experience. Each of the techniques described can be treated at the simplest level or taken on to great depth and sophistication. Printmaking, and relief printmaking in particular, is the most flexible of art forms.

It is now accepted that prints can be works of art deliberately created through the medium of printing. It ranges from simple concise techniques using readily available materials, to the more complicated variations with a mixture of media, personal interpretation and experimentation.

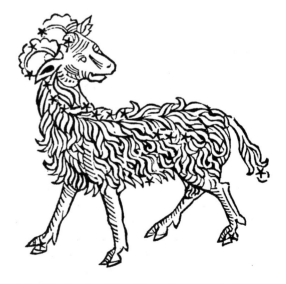

Aries (The Ram), a fifteenth-century woodcut. Open cutting allows for hand colouring.

To appreciate any printmaker's achievement intelligently the general public has to be made aware of what a 'print' is. How does a mere reproduction differ from an 'original' print? The print-makers using this book will be those who have seen examples of printmaking and who have responded to it, wishing to share in the excitement of producing, not reproducing, their own ideas translated into print. Once a student begins to work in any of the relief methods, he will become much more aware of the value of other artists' work, looking at them with a new and discerning eye.

So what is a print by definition? It is a pictorial image which is multiplied by a chosen process. It is not an imitation or replica but a truly specific image done in a specific way. The requirements are an initial idea, a theme possibly, a design, and a means of manufacturing the repetition. The transference of ink to paper is the main requisite and the resulting print should be held in as high regard as any three-dimensional replica obtained by a mould made by the sculptor. The interaction of printing ink and paper can result in the finest of impress-ions and these are never mere reprodu-ced drawings but actual unique works of art created deliberately by a printing process.

The status of the original print changed after the invention of photography in the 1820s. Photo-mechanical technology created some confusion in the mind of the general public and served to devalue the art of the genuine artist-printmaker. Sophisticated photographic methods meant that a picture created in one medium could be accurately repro-duced in another. The confusion is greater now with many contemporary print-makers utilizing photo-mechanical methods as part of their printing process. Therefore, the definition of an 'original' print must be one where the printmaker has actually prepared the printing surface. The plates or blocks may be processed or printed by another but the printmaker always remains in control. The mass-produced print is quite another matter, enabling us all to own a Van Gogh sun-flower picture or a Green Girl.

The print as an art form is as old as Man himself. An ancient handprint shows us the unique mark made by an early human being and still has the power to move us. A child's delight in printing a leaf, a student's delight in a successful outcome to hours of hard work of planning and printing, a print-maker's delight in expressing an idea reflecting affection for the image of mother and child; each printmaker at every level will never cease to feel the magic of printing. It is hoped that this book will enable more would-be printers to achieve the goals they seek but there is no final, ultimate goal for printmaking is an on-going creative process.

A way of classifying prints is by the method by which they have been pro-duced. This book deals with the relief printing processes, with a reference to monotypes, but these should be seen in the context of the other main printing methods: planographic, intaglio and stencil.

A more common name for these methods is lithography, etching and engraving, and screen-printing.

THE PLANOGRAPHIC PROCESS: LITHOGRAPHY

Lithography relates closely to drawing and painting as the image is drawn directly

onto the stone or plate. It provides opportunities for freedom of expression with the use of brushes and crayons, spatter and line-work. The process is essentially a chemical one as it is based on the antipathy of grease to water. A greasy pencil or greasy ink is used in a direct manner, or in the reverse way, that is in the *manière noire*. This involves the scraping away of 'white' lines or areas from the covering of previously applied ink on the plate or stone. The original

A lithograph in two colours.

stones came from Bavaria and were composed of limestone but, since the nineteenth century, zinc plates have been a common and more available replacement (aluminium is used in North America). Both media need the same treatment and the use of drawing materials that contain fatty acids (grease). They also require the use of gum arabic, and chemicals to increase the sensitivity of the plate or stone.

The plate is processed and dampened ready for printing. An ink-charged roller is passed over the dampened plate and the ink adheres to the drawn, dry image. The damp, undrawn parts of the plate repel the ink. The print is obtained by placing a sheet of previously dampened paper on the image. The plate or stone is fixed to the bed of a specialized lithographic press. Backing sheets are placed on the back of the printing paper and the whole is passed through the press under a leather blade which provides a scraping pressure.

Initially, the use of lithographic methods were almost wholly commercial. Goya (1746–1828) was the first important artist to use the process of lithography to produce prints that exploited the qualities unique to stone. Daumier (1808–1879) used lithography with great skill, to make satirical social comments in the form of cartoons. Artists interested in graphic design such as Manet (1832–1883), Toulouse-Lautrec (1864–1901), Bonnard (1867–1947) and Vuillard (1868–1940) were innovative with their bold approach to the medium, using it for posters, book illustration and as a means of producing pictures.

The development of the lithographic process through photo-lithography and offset lithography and the use of high precision presses have made new demands on the skills needed by the commercial printer. Although the basic principles remain the same, lithography has travelled a long way from the time when its inventor, Alois Senefelder (1772–1834) described the process as a 'chemical form of printing'.

THE INTAGLIO PROCESS: ETCHING AND ENGRAVING

Intaglione is the Italian word for engraving or cutting. The term covers a wide variety of techniques that have the common characteristics of either incising into metal with an appropriate tool, or lowering the surface with acid, creating grooves to hold the printing ink. Ink is rubbed into the marks so that the image may be transferred on to the paper. The engraving of a design is very ancient with prehistoric man scratching images on stone and bone. In 400 BC, bronze articles were decorated with hammered designs. It was the metalsmiths who developed the tools and techniques for the engravers of the fifteenth century. The roots of the process of intaglio printing can be traced to the *niello* engraving by European metalworkers. This method involved a mixture of black sulphur which was melted into the grooves of the decoration, making the design stand out well. From this process the idea developed that an actual image might be taken in the form of a print.

In the same family of intaglio printing, dry-point, aquatint, mezzotint, soft ground and sugar-lift are some of the variations used by the printmaker. They each have their own individual characteristics but

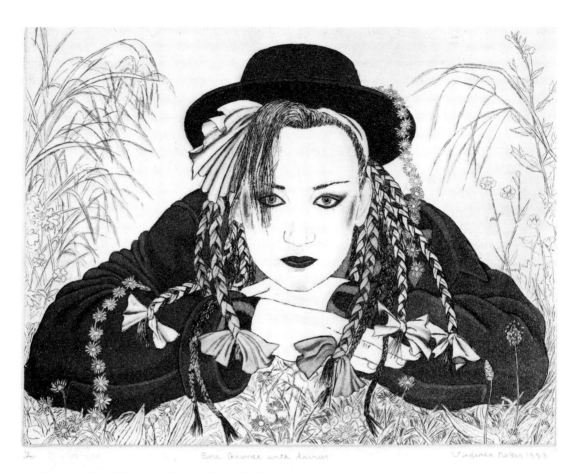

Boy George with Daisies, an etching by Virginia Nokes.

share the same method of printing. The impression or print is made when the dampened paper has been placed over the plate. Firstly, the plate has been inked-up by rubbing or pushing the specially mixed ink down into the grooves or lowered areas. Excess ink is wiped off with a piece or tarlatan or scrim, sometimes completely, at other times leaving a film of ink on the surface. The paper has to be forced down into the grooves in the plate so a powerful press is needed. Also the dampening of the paper makes it softer so that it can pluck up the ink. Blankets are used between the cylinder of the press and the back of the printing paper and the whole taken through on the principle of a clothes-wringer. If there is no ink, this process would achieve a paper 'mould' of the metal plate, that is the lines or lowered areas standing out in relief on the print. This is also called 'blind' or embossed printing.

Over the centuries many artists have found intaglio methods to be a richly rewarding process. Mantegna (1431–1506) produced many engravings by scratching lines into the metal itself. The next intaglio technique to be developed was etching. This involved covering the

14

plate with a coating of ground (a wax-resist or asphaltum or shellac), which protected the surface. The design was scratched through the ground exposing the metal underneath. The plate was then submerged in a bath of acid and water mixture which ate into the metal so that when the resist was removed the design appeared as lowered lines or areas. Rembrandt (1606–1669) used both the tonality and the linear qualities of this technique, producing many proofs of the image as he redrew and bit again repeatedly until achieving the final print. A twentieth century development of the intaglio process is photogravure. This technique enables the commercial printer to produce many impressions at great speed using a cylinder rather than a flat-bed press. The quality of the printed image is fair and the process is widely used for long runs of publications such as magazines and catalogues.

THE STENCIL PROCESS: SERIGRAPHY OR SCREEN-PRINTING

This is the youngest of the print processes but it is based on an ancient method. Prints can be seen in Pyrenean caves where colour has been blown around a spread hand using the hand as a negative area. Open stencils were used widely in the East, using impervious materials.

In the Studio, a screen-print in five colours by a student.

15

These were employed to decorate cere-monial robes, fabrics for house use, pot-tery, walls and ceilings. The 'ink' was in the form of dyes which were brushed across the open cut areas to produce repeatable images.

In the Middle Ages in Europe crude stencils were used for uniforms and heraldry. The 'screen' was fine cloth and the stencil made from painted pitch. The paint was stamped through the mesh onto the cloth with a coarse brush.

The first patented method was not until 1907 when a stopping-out solution was developed. A negative image was painted onto a stretched piece of silk which had been secured to a wooden frame. Instead of a brush, a squeegee with a fixed rubber blade enabled the printer to spread the paint or dye evenly. William Morris (1834–1896) used this method to great effect on his wallpapers and textiles.

With the development of photographic stop-out methods, and painted stencil papers, the commercial use of the screen printing process prevailed. But it was not entirely industrial, for in the USA in the 1930s artists were producing editioned prints at accessible prices. In the 1950s the Pop Art scene was dominated by Warhol and Lichtenstein who, among others, contributed towards the popular-ity of the screen-printing process for artist-printmakers.

A screen-print is achieved in a similar way as it was initially, although vacuum beds have made registration more accu-rate. Each colour requires its own screen with its taut covering, and each screen has ink or paint introduced at one end. The ink is pulled across the width of the screen with a squeegee, which forces the colour through the mesh onto the printing paper. The open, unprotected areas are printed and the stopped-out or masked areas prevent the colour from passing through the mesh.

MONOTYPES OR MONOPRINTS

Monoprints can be based on either a 'blot' method or a drawn method. In both cases the impression is taken from a hard, non-absorbent surface. The pro-cess involves transferring the ink or paint from one surface to another so it can be classified as a 'print'. Usually it is an unrepeatable image but sometimes you can obtain a second, fainter image. The technique of the 'blot' method is very simple and is described in pages 102–3, with details of monoprint drawing also. These two methods provide a rich and flexible means of simple printmaking that can be both controlled, or expres-sive. Monoprinting gives the artist-printmaker a challenging and rewarding experience.

RELIEF PRINTING

In all relief processes the printing sur-face, which receives the ink or paint, is raised above the areas which are to remain blank. The process derives its name from the Italian *rilievare* – to raise. The positive design to be printed can be built up on a flat surface such as in a collaged block, or it can be created by cutting away around the image, as in linocutting. There are 'natural' printing blocks like leaves, bark, and contrived blocks such as a woodcut. Materials can be manipulated at will and the artist-

printmaker can continually explore the many variations and permutations of all the methods which relief printing has to offer.

The handprint must be the oldest block of all time in the history of printmaking. An early use of a relief block appears in impressions taken of cylinder seals, also stamp decorations used on metal and bricks in the East, BC. In Egypt in the sixth century AD, textiles were printed with relief blocks and there is evidence of their use in China about the same time. Prints from wood-blocks were cut and printed in the form of Buddhist charms in the latter period of the eight century AD.

Relief printing was to develop more slowly in Europe perhaps because paper was not manufactured there until the twelfth century. Paper had been used by the Chinese in the second century AD but it was not until the fifteenth century that the use of parchment in Europe was superseded. The earliest woodcuts printed on paper date from the end of the fourteenth century. These came in the form of religious pictures and as playing cards. Primitive woodcuts were followed later in the fifteenth century with more sophisticated work by artists in Germany, the Netherlands and Italy, including Holbein (1497–1543), Van Leyden (1494–1533) and Titian (1487–1576). The artist drew the image directly onto the block and then handed it over to a skilled craftsman to cut. Woodcuts offered the first means of producing prints easily and cheaply. At the end of the sixteenth century woodcuts were being replaced by the more sophisticated technique of engraving and etching. In the nineteenth century artists, rather than pure illustrators, began to look again at relief printmaking as a

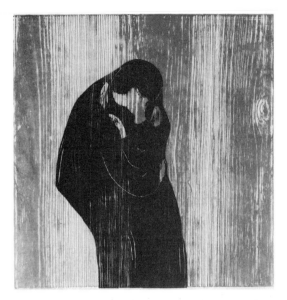

The Kiss, a woodcut by Edvard Munch.

means of creative expression and not just as mere reproduction. Many deemed it to be as valid an art form as their work in painting or drawing. Before the turn of the century, Gauguin (1808–1903) was experimenting with the woodcut, exploiting the qualities of the wood-block with lowering and textural effects, creating tones. Munch (1862–1944) developed the medium still further using separate pieces of wood as a jigsaw. Unlike their predecessors, these artist-printmakers did not hand their blocks over to craftsmen but controlled the whole process from start to finish. This creative outlook was continued in the twentieth century with the work of the German Expressionists. Many painters found the medium of the woodcut ideal for their often stark subject matter.

The early days of wood engraving are obscure but the two techniques, engraving and cut, have sometimes been combined. At the end of the eighteenth century the

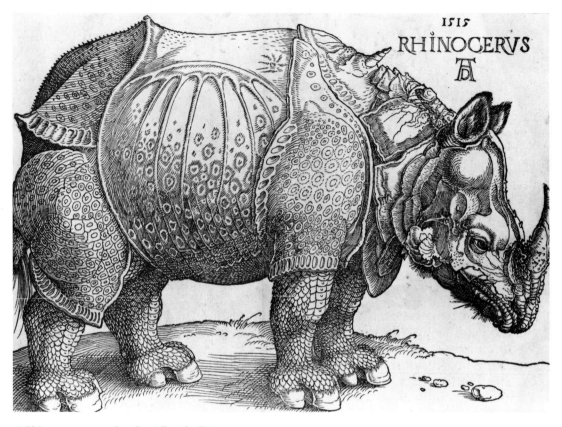

A Rhinoceros, a woodcut by Albrecht Dürer.

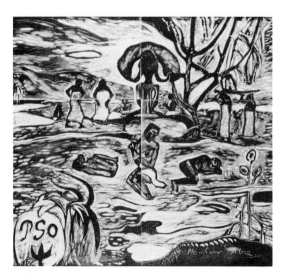

Mahana Atua, a woodcut by Paul Gauguin.

technique of wood engraving became sophisticated. Very fine lines and articulation of detail were made possible by using the finer, end-grain of the wood as opposed to the much coarser plank-side. Thomas Bewick (1753–1828), a trained metal engraver, established a school of wood engraving, in Newcastle-upon-Tyne, England. They engraved their blocks from their own drawings. The rise of the level of literacy led to an increasing demand for illustrated books and magazines and many nineteenth-century artists had their work faithfully reproduced as facsimiles. Although Calvert (1799–1883) and Blake (1757–1827) both contributed to the use of wood engraving

18

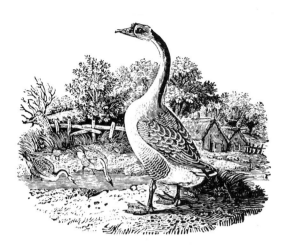

The Swan Goose, a wood engraving by
Thomas Bewick.

Undercurrents, a wood engraving by
Gertrude Hermes.

as a medium for artists, the process soon became a strictly reproductive medium and not a creative one. Some artists, such as Tenniel (1820–1914) and Doré (1833–1883), did produce work but this would be done as drawings made onto a prepared block which in turn was sent to an engraver for the actual cutting.

By the 1880s, even the Victorian weeklies such as *Punch* and the *Illustrated London News* were going over to photomechanical means. Previously, the drawing of a newsworthy event would be divided up into sections and then these would be rushed to several craftsmen in the City who would engrave their part. These would be collected and put together as a whole picture to be published in the newspaper alongside the article.

In the late nineteenth century, photography began to supersede the process of wood engraving for commercial uses but, in the 1920s, a renewed interest was shown by artists such as Robert Gibbings (1889–1968), Lucien Pissarro (1863–1944)

and others. In the 1940s and 1950s, artists of some stature like Gertrude Hermes (1901–1983), Blair Hughes-Stanton (1902–1981) and Joan Hassall (1906–1988), made their contribution to the increasing interest in the process of wood engraving, some using linocutting as a vehicle for their ideas. Also in the 1950s, Picasso (1881–1973) was cutting a series of coloured linocuts. The themes of these were largely related to his paintings of that period: bullfights, Bacchanalian scenes, interiors with still life and female busts.

The production of fine books as limited editions gave scope to illustrators such as John Farleigh (1900–1965), Eric Gill (1882–1940) and David Jones (1895–1974).

19

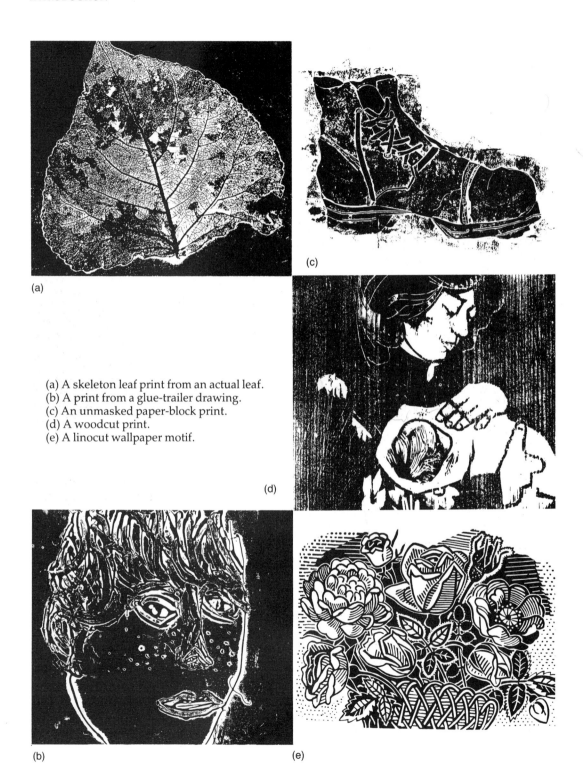

(a) A skeleton leaf print from an actual leaf.
(b) A print from a glue-trailer drawing.
(c) An unmasked paper-block print.
(d) A woodcut print.
(e) A linocut wallpaper motif.

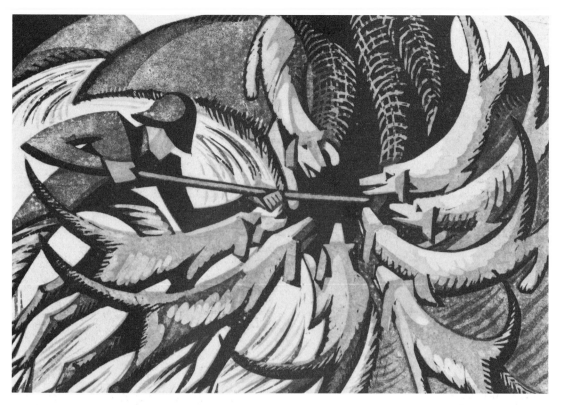

Otter Hunt, a linocut by Sybil Andrews.

They not only illustrated text-matter but produced prints in their own right. Eric Ravilious (1903–1942) had his designs used to decorate pottery as well as working on many commissions for the Golden Cockerel Press. His contemporary, Edward Bawden (1903–1989), might be said to have elevated the art of the linocut from the kindergarten to the artists' studio. His fine graphic work was used not only for bookwork, but for wallpapers, murals and the well-known London Transport Poster series for the Underground.

Michael Rothenstein (b. 1908) has made a considerable contribution to relief printmaking. He advocates the use of mixed media and has shown through his own experimentation how the artist-printmaker is able to make exciting prints using a great variety of different materials, including hand-cut blocks, collage and found materials.

The history of relief printed images is still in the making. It is an ongoing process while each artist-printmaker continues to explore the limits of the medium in seemingly endless combinations. Both the novice and the more experienced can indulge in the challenge of printmaking and contribute with their own personal discoveries.

1 Printing without Blocks

PRINTING FROM FOUND OBJECTS

Almost any material charged with ink and pressed firmly against an absorbent surface will produce a print either in line or in mass. Your own hand, a piece of card, a spool, a feather, fruit and vegetables and many more objects will enable you to make patterns, free designs, imaginative picture-making. Although so simple, accessible and not costly, found objects will give you a rich variety of printed images. These can often be used as starting points for more ambitious projects, or be just pleasing in themselves. These textures, forms and colours will also be invaluable for using with other methods as you acquire the many techniques relief printmaking has to offer.

The simplest form of relief printmaking is from 'found' objects, many of which can be discovered around the house. You will have to consider if the found object is suitable for printing. Will it accept the ink or paint? Objects that have a greasy surface will obviously not accept water-based inks. Sections of natural objects, such as a cabbage, that have a moist surface will reject any greasy ink or paint. Some found objects are too fragile for printing with heavy pressure and these may have to be either mounted onto a firm backing or printed with a gentler method such as hand-burnishing. A delicate skeleton leaf can be printed if mounted down onto board with spray glue. A rounded soft surface such as the side of a fish can be inked and printed by burnishing.

Paint may be applied with a brush, inks with a roller. Some objects are easier

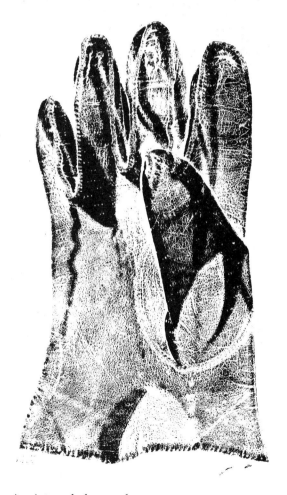

A print made from a glove.

22

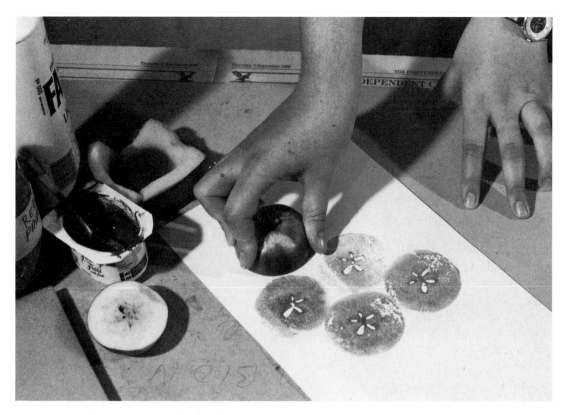

Making prints from a section of apple using ready-mix poster colour with a little wallpaper paste added.

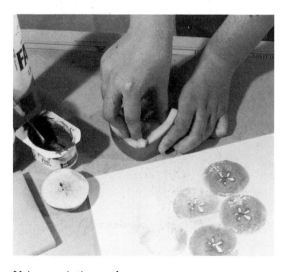

Using a printing pad.

to print successfully if pressed down onto an inking pad. You can print the found object quite freely or you can make regular patterns, or just enjoy seeing what marks the chosen object can make. Objects that are very flat and difficult to hold can be glued down onto a small block of wood or matchbox.

If you are using a printing pad you will be able to print more quickly, which is useful if pattern-making. The pad can be used by more than one person if in a class situation. The colour is spread more evenly than if using a brush and objects that have their own water content react better with a sponge pad and water-based

23

An inked up feather and onion section.

inks. An ink can be made from a mixture of powder colour or a ready-mix poster colour with a little wallpaper paste added. Use deep tin lids or saucers and put a layer of foam sponge or felt on top of the ink mixture. In a few minutes the colour will begin to be absorbed and the object, which is pressed down onto the pad, will take up the ink and be ready for printing.

Printing objects that are delicate, or hard to handle easily, can be inked up indirectly when using an inking roller. This method entails rolling up a lino or plastic flat surface with a film of printing ink. Lay your object, such as a glove, face down onto the inked surface. Cover the object with a piece of paper and take an impression either by burnishing or with a press. Remove the paper and carefully lift up the object. This is now ready for printing and can be laid down, ink surface to printing paper.

Graphic effects can be obtained equally effectively with objects that are natural products or man-made. Fragments of wood, charred wood, wood that has been exposed to the elements, feathers, fishbones, cork and many other objects will provide you with printing surfaces. Man-made products have endless possibilities from netting to a crushed drinks can.

Some of these kinds of objects are difficult to print because of the problems caused by their irregular surface. The method of printing these is to ink up the surface, place the printing paper down onto the block, and put several layers of soft packing such as newspapers, a cloth or blanket on top, in order that the packing pushes the printing paper right down into all the levels of the inked-up block.

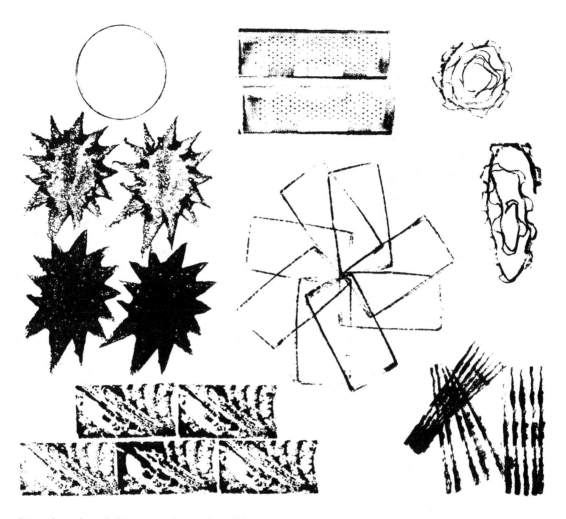

Prints from found objects. (Left to right) a lid, a matchbox side, rolled corrugated paper, potato cuts, box ends, corrugated paper, a wood-block end, toothpicks.

PRESSURE PRINTING

Pressure printing is a technique which requires very little equipment and limited printing skills. The important part of the process lies in the selection of the materials. Items such as thin card, paper, threads and certain fabrics are suitable, and the printmaker will soon learn by trial and error what materials will print best.

You will need an uncut piece of lino, that has been inked-up well with oil-based ink. This should be even and not too thick. Place a piece of printing paper over the block and then select your materials. These can be organic or inorganic but should not be too thick or textured so that the paper is cut when pressure is applied. Be careful not to press the paper with your fingers or hand as this will result in smudging but

25

Pressure prints using natural objects, seeds, leaves, and also string, paper and textiles.

lay the objects down lightly. There can be some overlapping, such as a thin piece of paper covered in part by a piece of mesh from a fruit bag net.

Place a card backing over the objects and print in your chosen way. Burnishing is not easy but you can use standing pressure or a conventional press (*see* Chapter 5). By varying the type of backing you can produce different images as the softer packing will press the printing paper further down onto the block picking up the background of inked-up lino. A firmer backing, for example, stiff card or board, will pick up the lines and textures of the laid-down objects and less of the background.

A variation of pressure printing is to combine the technique with masks. These masks will give you negative unprinted areas on your printed image. Ink up the lino but before placing the printing paper down, lay pieces of material or paper

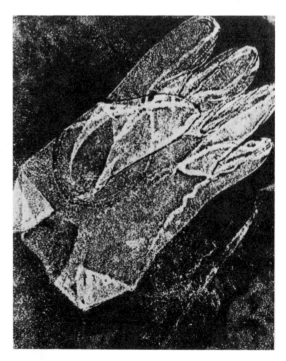

A print after the glove has been removed from the inked-up block.

down onto the lino. Then place the printing paper over the masks and proceed as before.

After you have experimented freely, you may decide to make a more planned image and wish to repeat it. To do more than one print of one image, you should make a keyline drawing or tracing as a guide to the positioning of the selection of objects. You will have to re-ink the lino so if you are using masks you will have to remove these each time. When the pressure print is made these masking objects pick up ink from the block on their underside. This transfers the ink in such a way that they are then in fact ready-made printing 'blocks'. They can be laid inked-side down on a sheet of printing paper and burnished or printed in the usual manner. This transferring of ink is an excellent method when you wish to ink up fragile or hard-to-handle materials.

Another variation is to retain the lino after you have made your print, removing any masks, and place a sheet of printing paper over the lino block. The resulting printed image will vary in strength according to the type of materials used and the density of the ink.

DIRECT INKING

The actual inking roller can be used to create colour areas and textures. Used freely it can enliven a flat area with movement and tonal effects. The colour can be lightened or darkened either by reducing the quantity of the ink or by exerting less pressure on one side of the roller. Rolling directly onto the paper can be totally spontaneous but you can control the ink area if you wish by placing a mask over the printing paper first. Then roll over the mask and paper in one movement. Attach the mask on one edge by taping it to the printing paper or backing board.

A variation of this kind of free printing is to wrap string around the roller, ink it up in the usual way and pass it over the paper. This will give you linear marks to add to the flat areas.

2 Printing with made-up Blocks

PRINTING FROM A PREPARED SURFACE

There is a great variety of suitable materials which can be altered and arranged to create original designs to form a print. Popular materials are wallpaper, string, lace, netting, sacking and adhesive labels. Actual printing blocks made from a single unit, such as fabric, require very secure glueing onto a backing of strong card or wood. A PVA resin glue is ideal as it is water-resistant when dry and tough, if the block is to be used repeatedly.

Printing from a block of plasticine which has been indented with buttons, a screw-end and a key.

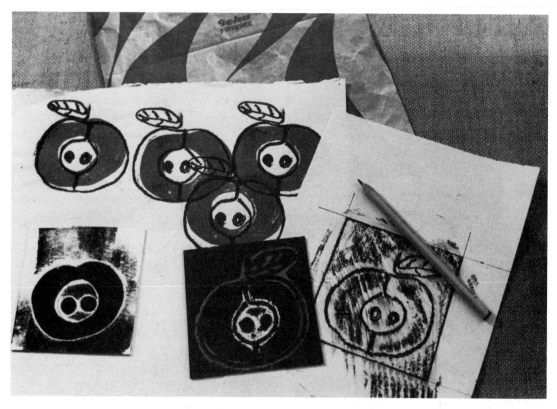

Repeated prints made from two blocks, the left-hand block, paper, the right-hand, string. Printed in red and dark blue.

This method of relief printmaking allows you to make the best use of the chosen materials, recognizing their individual characteristics as you plan your designs. You will discover delicate patterns in lace, movement in coiled string. You will be encouraged to look for yourself for new materials to exploit. There are almost endless opportunities for experimentation and your perception and appreciation will develop as you build up your own personal vocabulary of 'print'.

Plasticine, or similar modelling material, makes an excellent printing block. Roll out the material, using a glass bottle or a rolling pin covered with foil, to a height of approximately ½in (13mm). Make the block as level and as smooth as possible. Cut the block to the required shape with a knife or pastry cutter. Select objects such as screws, keys, nailheads, wire, card edges and so on, and press these firmly into the block. These depressions will not receive the ink or paint and will appear as white, unprinted shapes on your finished print. Experiment first with shapes and textures until you achieve the results you want.

The inking should be done lightly as if you press too hard you will lose some of

29

your indentations. If you are using paint, brush the mixture carefully over the block so as to avoid filling up the lowered areas. Water-based paint will be rejected by the grease in the modelling material but this can be overcome by adding a little washing up liquid to the ink or paint.

Hold the block carefully and place the inked surface down onto the printing paper or fabric. Alternatively, place the block ink-side uppermost and position the paper over it. Rub or burnish your print with a smooth, light action. This block is unsuitable for a press. Water-based ink or paint can be washed off and the material reused. If you have used oil-based ink, you can blot it off or wipe with a rag, using a little paraffin or white spirit. Then remould the material for use another time. The indented block, if treated with care, will enable you to produce several prints. At some point the block may need re-indenting with the objects.

This is an effective method for simple fabric printing and ideal for theatrical costumes. If you wish to make repeat patterns, it is advisable to make some kind of guide in the form of a grid. The three basic grids are square, brick and half-drop, and there are many variations if you use more than one colour, and even more if you use more than one unit of design. The simple string block shown has been used in a variety of ways using only one colour before adding another.

PATTERN-MAKING FROM PREPARED BLOCKS

Single units, that is stamp blocks, can be used effectively as printed repeats. There are so many variations and permutations that it is advisable to begin by experimenting with one unit only. Use only one colour and simple grid formations. These grids can be indicated by lightly drawn pencil lines. The most basic is a repeated rectangle, one block positioned closely beside another and one directly above another, called a square repeat. Other grids which are simple to use are diagonal and half-drop. Half-drop repeats are effective with more open designs, such as floral ones, and have more interest than the square variation.

For easier handling, your stamp block should be assembled on a piece of wood comfortable for your hand. You will need to grasp the block firmly when you press down on to the paper or fabric to obtain your print. Small offcuts of wood are ideal for this purpose but should not be bigger than the actual printing block.

Remember to use great care when fixing any material to your block. Stick it down really securely with a suitable glue such as PVA or any woodwork glue. Try to have your materials as near to the edges of your block as possible. This not only helps with registration should you wish to use more than one colour but it enables you to create much more effective designs by abutting each unit closely. 'White' gaps can spoil the overall unity of your repeat.

When you have experimented with a single unit and a single colour with different grids, try using a second colour in alternate spaces like a chequer-board. This should prove quite easy as regards the accurate registration of the unit as you are using an identical block each time you print. However, you may now wish to introduce another motif, possibly superimposed on the first print, in which case you should make sure that your first block is a perfect rectangle. Place tracing

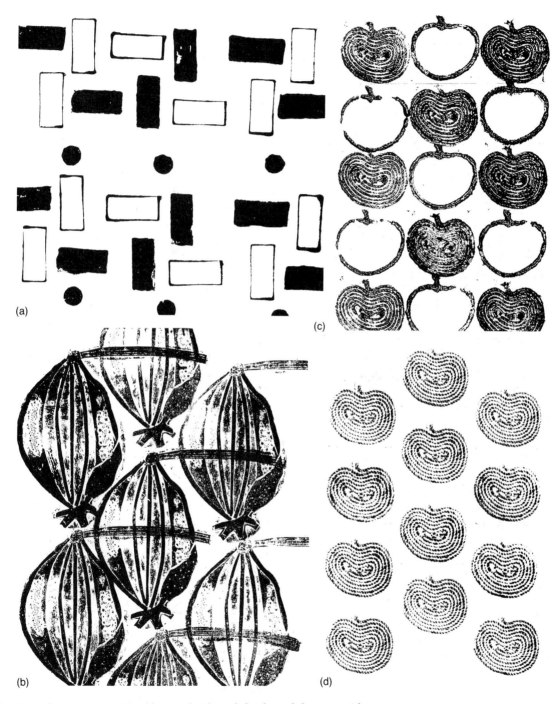

Printed patterns. (a) Matchbox ends, the solid side and the open side.
(b) Paper blocks. (c) and (d) String blocks.

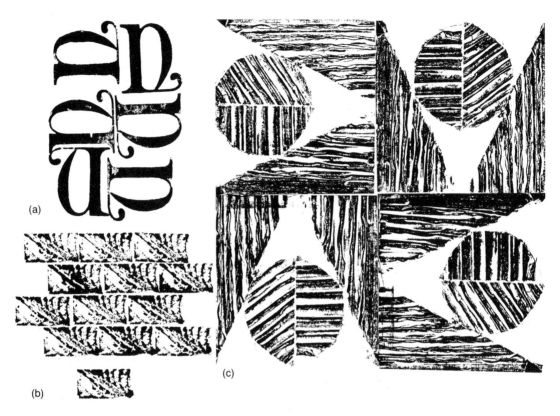

Printed patterns. (a) Wooden letterforms. (b) Wood endpieces. (c) Shapes cut from corrugated paper, the unit rotated on its axis.

(a) Hessian. (b) Cork. (c) A doyley.

paper or thin paper over the block and, using a dark wax crayon or a soft pencil, make a rubbing of the block, ensuring that you include the background corners even if these are not part of your design. Alternatively, you can take a print in a dark ink, also on tracing paper, allow it to dry and then use this as a guide. Make sure that you have the four corners of your design clearly marked, place the reversed tracing paper over carbon paper and draw the design firmly through,

transferring the image onto your new material of card or paper.

Cut out or assemble your new pieces of material and, if necessary, use the tracing to draw an accurate guide for the positioning of the second block within the common rectangle. Glue all the parts well. Each block should now be exactly the same in area and the parts arranged so that they will print and register accurately. If this procedure is followed, block two or any successive blocks

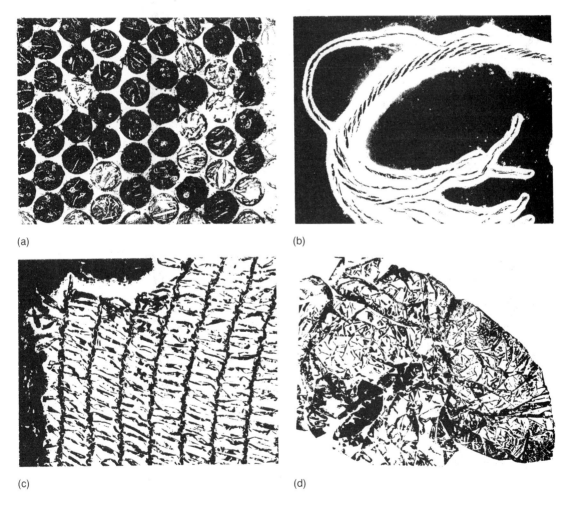

(a)

(b)

(c)

(d)

(a) Bubble pack. (b) Thread. (c) Plastic netting. (d) Crumpled paper.

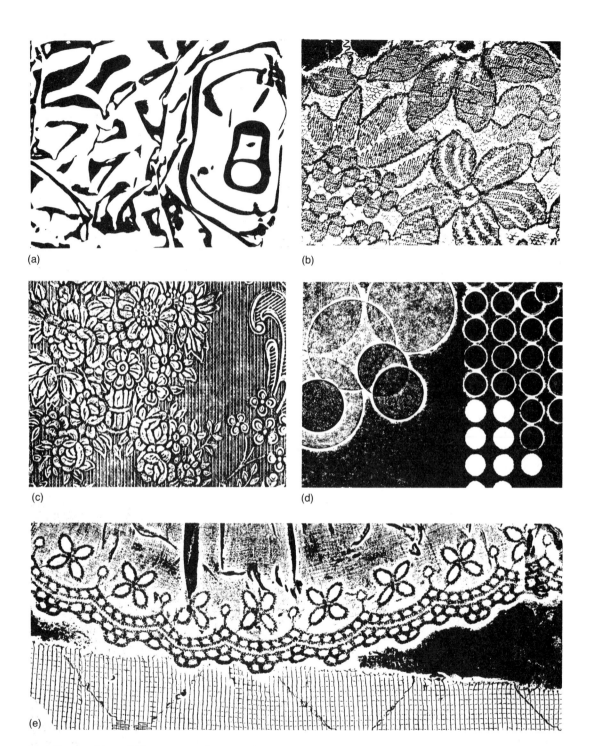

(a) A flattened can. (b) Lace. (c) Wallpaper. (d) Gummed labels. (e) A cotton border and net.

should fit exactly into your grid. Always put a mark in one corner on the back of the block or mount. This will help you to avoid mistakes in positioning when you are printing ink-side down, which is the preferable method for pattern-making. (*See* pages 106–81 for advice on printing on fabric.)

PRINTING FROM A COLLAGE BLOCK

Most materials, securely fixed to a baseboard of wood or thick card, will create an effective and efficient block. The subject matter can be abstract or geometric or pictorial and representational. Very fluffy textiles, such as wool, should be avoided, as should sharp or spiky surfaces. Many rich and varied textural effects can be achieved with easily obtainable and cheap materials.

As you may be using more than one type of material, you must try to achieve a common height as too much variation will give you an uneven print, or even a surface that is impossible to print. When the inked-up roller is passed over the block only the highest areas will receive

the ink. Softer rollers or brushes will transfer the ink to areas that are just below the surface. If you are burnishing the collage block by hand, you will have more control over printing the areas that are slightly below the block's surface. When using a mechanical press you have less control when producing a print from a collage block with variable heights.

View your block in section at eye level and see if there is any great discrepancy in height. If any particular material you want to employ falls below the common height of your collage, you can place layers of card or paper underneath to raise it. Make sure that all parts are fixed securely. If not stuck down completely, parts of the block will adhere to the inked-up roller and you will not only have a messy roller but a spoiled inking area and a very difficult repair job to do to your collage block. Whenever you use glue, spread the adhesive generously on the back of the materials and on the part

Assembling a collage block.

Print from the assembled collage block.

receiving the materials, right to the edges. Lay on weights, if possible, to ensure that the collage block is completely stuck down. Do not be in a hurry.

When using threads or string, coat both the base and the material with glue. Secure the thread at one end with a pin and lay carefully in stages, using a scissor end or brush end to manoeuvre the thread into place. If a line is to be fairly fine, shirring elastic is manageable and will produce a good number of repeat prints, if, for example, you are making greetings cards.

When the collage block is completed, it can be sprayed with a dilution of PVA glue or matt emulsion paint. This creates a good resist and is necessary if you intend to use water-based ink or paint. If you are using oil-based inks, when dry,

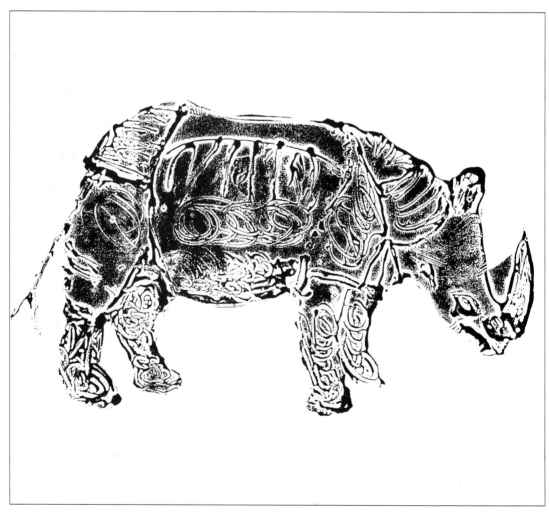

A masked print from a glue-block. A student's work based on the Dürer woodcut.

these form a non-absorbent and durable surface. This allows you to produce a quantity of prints. If you wish to produce over a period of time a number of print-ings, it is advisable to mount your collage block onto a firm backing of board or thick card or thin hardboard.

MAKING A GLUE-BLOCK

As well as being an adhesive, PVA glue can be used in its own right to make a relief block. It has its own characteris-tics and can be expressive both as a linear medium or to create textural effects. It can be trailed by using the spout provided by some suppliers, or dripped from a washing-up bottle. With practice, you will be able to use the trailer to make a line-drawing. If spread in large areas quite thinly, the glue can be combed, smoothed or swirled. You

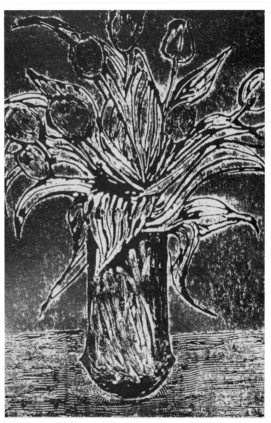

A glue-block print by a student, based on first-hand observation, using the trailer to create the lively flowing lines of the tulip flowers and leaves.

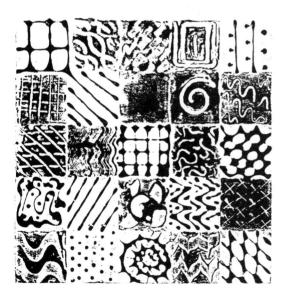

Glue-prints made from trailing, scraping and impressing with various objects.

can use a plastic glue-spreader that has a serrated edge, or you can make your own tools, such as a piece of card with teeth cut out of one edge. A group of wooden toothpicks gives well-regulated parallel lines, akin to the metal cutting tool of the wood engraver. Glue has a flowing, spontaneous quality of its own and provides the printmaker with many rich and varied marks.

If the glue trail is very high and proud the background will receive less ink. This gives a contrast of tone with the dark line and the lighter background. Trails of glue

37

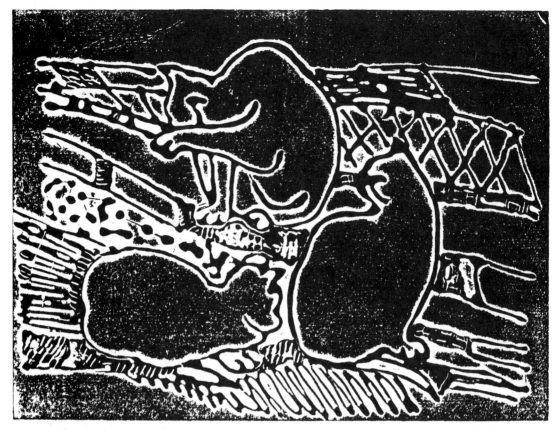

Cats on a Patterned Rug, a glue-block print by a student.

take a long time to dry completely; the surface hardens but underneath it may stay wet for some time. Always ensure that the line is quite firm and hard before printing as a squashed trail may not be the effect you want, and could spoil a good roller.

The glue-block should be made on a firm backing sheet of card or wood. Thinner papers will tend to cockle with the water content of the glue, making the finished block harder to ink up evenly and print well. Oil-based inks are preferable for this technique and the combination of this and the natural water-resistant qualities of the PVA make the block very durable. When the block has been used for one colour, once dry, it

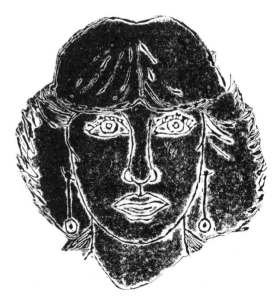

A glue-block portrait, a masked version by a student (16 years).

Standing Figure, printed from a glue block by Val Franco. The block was inked up in several colours using small rollers.

Standing Figure (detail), printed in one colour.

can be used again for other colour variations, either inked randomly, or one colour on top of another.

Although a printing method on its own, glue can be used successfully in conjunction with card or lino-blocks. It combines particularly well with lino but you must de-grease the lino before applying the glue. If this is not done, the areas of glue may come off after you have taken a few prints and have to be replaced. Some printmakers roughen the surface of the lino first so that there is more of a key to hold the glue.

MAKING CARD AND PAPER BLOCKS

Card and paper can be used to produce inexpensive and effective blocks. They can be used as a single flat-surface block, or as a built-up block using several layers. The first method is a useful design exercise as it requires an awareness of line and space. Draw a simple design on to a piece of card. This should be thin enough to cut with a sharp stencil knife or scissors. The design should be bold rather than intricate. Cut carefully along the drawn lines and spread the pieces out, experimenting with the spaces left in between each shape. If the card is

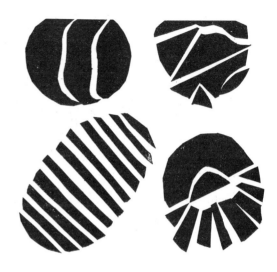

Expanded paper circles.

Inked-up folded paper and print.

light-coloured, lay it on a darker background so that you can see the separate shapes more easily. Replace the pieces close together but vary the spaces in between each shape so that they do not touch.

If you decide that your design would make a good print, glue the shapes down well onto a stiff backing of card. If you are still experimenting, try removing some whole shapes from your arrangement; you will soon discover which ones are significant and cannot be discarded. Experiment first by using one colour printed onto some coloured papers, or dark ink on light.

The second method of making a paper block is a built-up technique using layers of card or paper. Most types of paper are suitable and offer a variety of surfaces and textures. The thickness of the layered paper must be considered. As in the collage block, if one area is much higher than another it will prevent the ink from reaching all the other parts. In

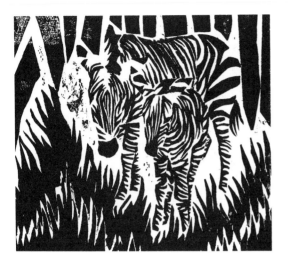

Zebras, a print made from expanded and discarded paper shapes, by a student.

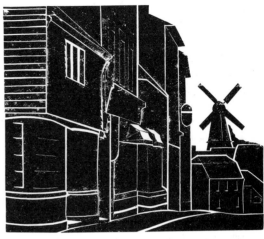

High Street and Windmill, printed from expanded and discarded shapes, by a student.

principle, the highest part of the built-up block will print the darkest because it receives the most ink and pressure; the lowest will be fainter, receiving less ink and pressure.

The number of prints that can be taken from a block of this kind is more limited than those taken from lino or wood, but a coating of diluted PVA glue will help to make it more durable. Oil-based inks will harden the block's surface when they dry, and the choice of a firm baseboard will also help to preserve the block for continued use. This is a good method for producing illustrations for posters or cards. Letter forms should be cut with care and glued down very securely. Letters or numerals, or any significant shapes, must always be reversed. Check the reflection of the shapes by looking in a mirror which will show you how they are going to appear when printed.

In addition to the flat shapes and the gaps in between these, you can also add lines and texture by indenting the block.

This entails using a sharp point, such as a compass point, scissors edge or a ball-point pen, and drawing firmly to make deep score marks in the block. These must be deep enough to be below the surface which is to receive the ink. You can also make small but deep indentations by stamping a point into the surface. The tools used for indenting should not have a burr but be smooth, otherwise you will find that you drag up the surface of the card or paper.

The only tools and materials you will require for making a paper or card block are: a cutting knife, scissors, glue and glue-spreader, card, paper and backing board, and some tools for indenting. Sometimes you will choose to keep the tonal, textured part of your print, which is the background. At other times, you may prefer to have a clean image without any printed background showing, in which case, after you have inked up your block, you should cover the background with a mask.

(a)

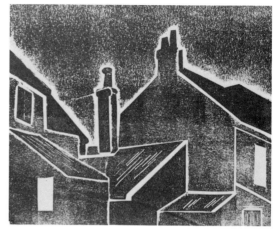
(b)

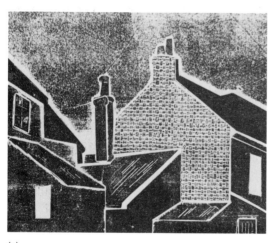
(c)

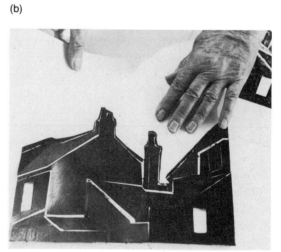
(d)

Paper-block houses.
(a) A progressive rubbing of the paper block.
(b) The first-stage proof.
(c) A print after adding textured paper.
(d) Laying on a mask over the inked-up block.
(e) The final masked print.

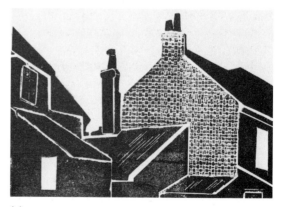
(e)

Making a Mask

1. Take a print from the inked-up block onto a thin piece of paper that is at least as large as the whole area of your block.
2. Cut out the printed image leaving about ⅛in (3mm) all round the edges. Discard the print and retain the frame.
3. Ink up the block ready for printing and then place the mask over the block so that only the built-up inked areas are exposed. The background is then completely covered.
4. Take the print, remove the paper and then peel off the mask directly, as it will stick to the block if left on too long.
5. It is advisable to cut more than one mask so that if you tear the first one or soil it, you will not have to stop printing in order to cut another.

MAKING A CARD JIGSAW

Although you tend to associate jigsaw blocks with woodcuts by Munch and Gauguin, a less sophisticated version can be made using card. The thickness of card is important; it should be thin enough for cutting with scissors or a stencil knife, but thick enough to be manageable when inking and printing. It is best to experiment first with tools and card before drawing out the image.

The design should be planned bearing in mind the need for simple shapes and that shapes that are too small will be hard to manoeuvre when printing. Trace the finalized drawing down on to the card allowing a frame area on all four sides of at least 1in (25mm) width. Cut carefully along the drawn lines, making sure that you cut right through the card. However fine the cutting tool, the width of the

blade will appear as 'white' lines on your printed image. You can fill these lines in by inking very heavily, then blotting off the excess ink. Alternatively, you can patch it in by hand using a mask and fingers. Most printmakers let the characteristic border of exposed paper remain.

Each piece of card is inked up in the chosen colour, using oil-based inks in preference to water-based inks, as the latter tend to soften unprotected paper and also dry more quickly than oil-based. The inking of small areas is not easy. It helps to place the card shapes on a piece of tissue paper or newsprint and then pass the inked-up roller over the card, taking both card and tissue up together. Try and ink up in one sweep in one direction. The tissue backing can then be peeled off before positioning the card in place. If there are only a few sections the block can be assembled completely inside the uninked card frame. This requires care and a pin or compass point will be needed to position each inked-up piece in place. If there are many parts, it may be necessary to do the print in stages. The pieces you have inked-up first may dry out by the time you have completed inking the rest.

If using this method, it is essential to have some kind of registration. If the frame is glued down on to a board and the printing paper hinged to the top of the board, accurate registration should be made. If printing more than one image, you will have to make sure each time that the paper falls exactly over the frame and inked-up pieces. Ink up two or three card shapes which abut and position them within the frame, starting at one edge. Print, and then allow both print and card to dry before proceeding. You need to keep all the shapes within

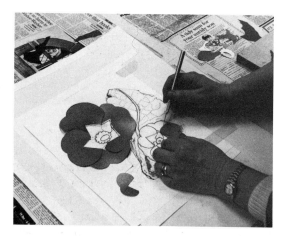

Positioning the inked-up card pieces on a traced-down guide.

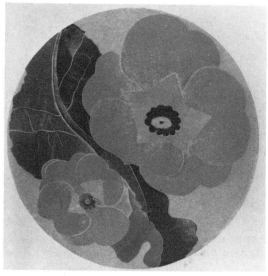

Primula, a coloured jigsaw print on a yellow background by Anne Weald.

the frame, whether inked-up or not. This ensures a perfect fit and no movement as you print.

It is important that you start by making a very simple, basic design in order that you can devise your own method of inking and printing. Too many intricate and awkward shapes make the whole process frustrating. The dried oil-based ink will seal your card pieces and they will enable you to produce further prints. There is no shrinkage but the card should be thick enough to avoid any buckling. The frame can be used as a coloured border if you wish, and can be either inked first or last, but you should remember to always put all the pieces inside for each successive printing.

Primula has been printed from card using the jigsaw method. Before the designed pieces were cut, a circle of card, the same size as the design, was printed in soft yellow. This was to be overprinted by the assembled jigsaw card block. The

result is that the cut lines between the shapes appear as yellow and merge in with the colour mood of the printed image.

Because of the difficulties in inking and printing, jigsaw is a technique which needs much care and patience and should be selected with caution. What are the advantages? Firstly, you can get very fine, even lines with the action of the cutting knife. Secondly, you can ink each card shape in separate colours, and inks can be graded in different directions, not just from one side to another. Thirdly, the cut lines can be colour controlled by inking up your background panel in any colour you choose. The printing can be done with a press or hand burnishing, and in both methods the printing paper is laid down onto the inked-up assembled pieces.

3 Drawing and Cutting into Blocks

MAKING A BALSA-WOOD BLOCK

By its nature, Balsa-wood is very soft. It is easy to impress, indent, or score, giving quite fine, negative lines. If you require larger areas of white, some of the lino or woodcutting tools can be used effectively. However, the surface has a tendency to splinter so a linear approach to the image is preferable.

Balsa-wood comes in varying thicknesses. The planks are narrow in width and, should you want to make a sizeable block, several pieces will have to be joined together. Even if using a single piece, it is best to glue this down onto strong card, leaving two projections of the backing at each end. This enables you to work on the surface with confidence. The material is brittle and can snap if you are scoring deeply. By glueing it down, you can pierce right through to the card backing without damaging the block. The 'ears' at each end of the block enable you to ink up right to the edges, which helps you to keep your hands clean when handling the block during printing. This extension of the backing is also used by printmakers using wood or lino, particularly when they are inking right to the edges of their block.

Darken the Balsa-wood with a little dark ink, such as a permanent writing ink or indian ink. Alternatively, you can roll the wood up with a very light application of

An indented Balsa-wood print.

A Balsa-wood print. A safety-pin, paper clip, nail file, key, etc., were impressed into the wood.

the block and pressure applied. If there is no press available, stand on the block, having first placed a board of firm material, such as hardboard or block-board, on top. Alternatively, you can hammer objects such as nail-heads or hard plastic, but always place a sheet of firm material or a block of wood between the object and the hammer in order to avoid an actual hammer mark indenting the surface. Practise first on a small piece of Balsa-wood, experimenting with shapes, depths and patterns.

The material has a definite grain and this should be observed, particularly if you intend to clear away some flat areas. Splintering can be reduced if you cut the edges of your shape with a sharp blade – a stencil knife or craft knife – then clear

oil-based printing ink, or you can apply it with a small piece of rag. All inks must be allowed to dry. If you are transferring a drawing, secure the tracing with tape, place a sheet of chalked paper between the tracing paper and the block, and draw very lightly using minimum pressure. Too much pressure will indent the surface of the Balsa-wood block.

Tools for Balsa-wood blocks are not specific. They can be knitting needles, skewers, points of compasses, or scissors. Lino gouges can be used for clearing areas but these areas will print as textures, as you are unable to lower the thin wood sufficiently to give a perfectly clean negative area. Of course, you can mask these out, if required, with paper masks, but the natural quality of this material, its softness and grain, lends itself to small linear images.

Another way to create shapes and patterns is to indent the Balsa-wood with hard objects, such as keys, coins and clips, which are laid on to the surface of

A Balsa-wood exercise using a hard pencil and compass point.

up towards the first cut, flicking away the pieces carefully. This is better than trying to clean up rough edges afterwards.

Oil-based inks must be used as the wood is too porous for water-based. Inking should be done very lightly, both in quantity and in touch, particularly if you wish to exploit the fine grainy texture. Too much ink will fill in the fine lines very quickly. You may find that you have not indented deeply enough, in which case you can go over these lines again making them deeper. The first inking will sink into the block but if you have taken some proofs and allowed the block to dry, rather than clean it, the surface will be sealed. The best way to clean the Balsa-wood block is to take one or two proofs without re-inking, or moisten a rag with a little white spirit and rub the block gently until all the ink is removed.

MAKING A PLASTER BLOCK

Blocks for relief printing can be easily made from plaster. They are built up on a flat base and the design is cut into the smooth surface. Builder's plaster, or the tougher plaster, gesso, is poured into a wood or cardboard frame. The gesso is made by adding a strong glue to the plaster mixture. Pearl glue, soaked and then heated in a glue-pot is ideal. Plaster blocks can also be made from Plaster of Paris. Use equal quantities of water and powder and always add the powder to the water, stirring the mixture thoroughly to remove any bubbles or lumps. Reinforcement can be added to any of these mixtures. Pour only one half of the plaster mixture into the prepared frame,

then, before it sets, place a piece of wire mesh on the surface and pour on the remaining liquid. If the base of the frame has a sheet of glass or metal placed on it, the turned-out plaster block will have a ready-made very smooth surface. If you want to impress objects, you would have to remove the block from the frame while still damp but stable. The marks made by impressing, or drawn areas, will have to be made fairly quickly, before the plaster has set hard. It is difficult to work freely on the hardened surface but it will take most cutting tools readily, and gouges and gravers cut or scratch well, as do many improvised tools.

Coat the uncut block's surface with black ink so that the cuts show up clearly as you work. Some printmakers coat the finished block with shellac so that the absorbency of that block is reduced when using paint or water-based inks. It also makes the cleaning of the block after inking much easier. Fresh plaster can be added for corrective work and smoothed down with fine sandpaper.

Hand burnishing or very gentle foot pressure is best for printing the plaster block as it tends to be fragile. Glueing it to a piece of board will make it more

A plaster-block print.

durable and if you are intending to print it ink-side down, using it as a stamp to be printed onto fabric, the backing will assist you to print and position more efficiently. Remember to have a pad of newspaper packing, or a layer of blanket if printing on fabric. Soft, thin papers are suitable for making prints by burnishing, with a protective piece of paper between the block and the burnishing tool, to prevent tearing. Screw-down presses can cause cracking, as can cylinder presses. When you have finished printing from the plaster block it can be inked up in your chosen colour and kept as a decorative piece of artwork.

MAKING A WOODCUT

Woodcuts are made by cutting into a block where the grain runs parallel to the length of the board, in other words, the plank-side. It is a highly individual material with strong characteristics of its own. It promotes a direct quality of working and the printmaker can make good use of this. This directness is sometimes misinterpreted by unreceptive people as crudity and poor technique.

In the 1890s the inherent directness and simplicity of the woodcut was used to great effect by Gauguin and Munch. The German Expressionists, Ernst Kirchner (1880–1938), Erich Hechel (1883–1970) and Emil Nolde (1867–1956) among others, were attracted to the stark qualities of the material and produced aggressive designs much influenced by primitive art. This group of artist-printmakers can be seen as the catalyst for the twentieth-century woodcut revival. This has a following to this day in Europe, Australia and the USA.

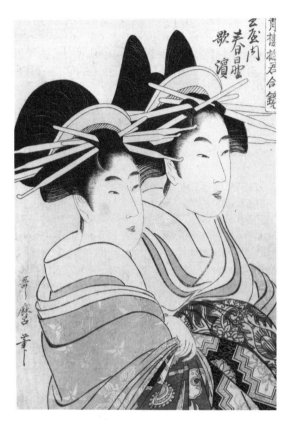

Two Courtesans, a coloured wood-block print from the late eighteenth century, by Utamaro.

Almost any kind of wood can be used for woodcuts; lime and poplar can be cut easily, oak and nutwoods are harder and, therefore, more difficult to cut, pearwood is tough, with a consistent hardness which gives you an even strength of cut, and other fruit-woods is also suitable. However, the printmaker should always be on the look-out for any pieces of wood such as old cupboards, drawers, ends of orange crates, the leftovers in a wood yard or from DIY. Old pinewood is beautifully soft and if painted or varnished can be stripped with a proprietary brand of stripper. Rubbing down

may be necessary, and if the plank is very uneven, the wood must be levelled off. This is particularly essential if a press is going to be the method of obtaining your printed image. Power tools, with a sanding disc, are very useful in the preparation of old wood for printing.

The characteristic of a contemporary woodcut is its boldness. Those cut by the master craftsmen of the fifteenth and sixteenth centuries were blocks of great detail and miraculous skill. These craftsmen took the art of woodcutting, as far as skill is concerned, about as far as it could go, achieving tone with parallel lines and cross-hatching. These skills were equalled by craftsmen in Japan, in the first part of the seventeenth century. The artist and carver of the block collaborated to produce a mass of printed images for the delight of men and women. These prints were made for artisans and tradesmen and the merchants of the middle classes. The images began as black outlines to be hand coloured, but later developed into prints made from several blocks, some using more than one colour. A finished copy of the design was given to a craftsman who pasted it down on to a block of seasoned cherry-wood, planed along the grain. A variety of fine chisels and cutting tools were used to carve the block, to leave the design standing out in relief. The unwanted parts were cut away and the block was ready for printing in reverse.

Felix Vallotton (1865–1925), the Swiss artist and engraver, produced 145 woodcuts, as well as working as a commercial wood engraver. He owed much to Japanese art, as did Van Gogh (1853–1890), Degas (1834–1917) and Beardsley (1873–1898). Gauguin's woodcut prints were rougher and sometimes more tonal. His technique was crude, deliberately choosing to emulate the early, more primitive Japanese prints, rather than the refined and familiar works of Katsushika Hokusai (1760–1849). Gauguin used the same basic cutting tools as he used for relief sculpture: a knife and a carpenter's gouge. He also employed tone by lowering the block with sandpaper and dotting the surface with needle pricks. Munch followed in the steps of Vallotton and Gauguin and, using his own ingenuity, took the art of the colour woodcut still further. The character of the wood and the saw marks, were used to great effect. He deliberately selected planks of pine and spruce with well-defined grain and textural interest. He often divided his wood-block into sections as a jigsaw. The separate pieces were then inked up in different colours, reassembled and printed at one time.

Michael Rothenstein is widely known in the United Kingdom as an innovative printmaker and influential teacher in all forms of relief printmaking. After a long life devoted to the art of printmaking, he has returned to woodcutting, producing large, vivid images, sometimes with the addition of hand colouring.

Alternatives to actual wood planks are plywood and other man-made boards. These vary in thickness and in surface and, before attempting any cutting, you should first experiment with various tools. Plywood or multiply boards are sometimes put together with a very hard glue. This will soon blunt your gouge and, it is best to keep by tools especially for woodcutting. If you sharpen them regularly, you will avoid the annoyance of finding that you cannot begin a linocut as the tools have become blunted with this more taxing medium. However, the

A print from sawn plank-wood showing grain.

plywoods, blockboards and laminated boards serve their purpose. They are easy to have cut to the size you require, are relatively light to handle and have their own quality of surface. Plywood gives you a silvery, finely broken-up, black print where uncut, and its softness enables you to draw controlled lines with tools such as compass points, craft knives and scissors, much as in the Balsa-wood block technique. There is still a grain in this type of wood as well as plank woods, so when having a piece cut, make sure that you have the grain going the way you want. It is easier to cut with the grain, rather than against it. Many plywoods, because of their softness, tend to splinter as you cut. To avoid this happening you should draw firmly along the top edge of your line with a knife or indenting tool. You can then cut up towards this line with a knife or gouge, flicking away the wood when you reach the pre-cut part.

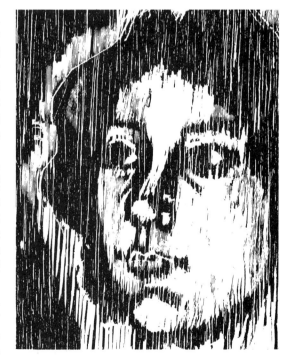

A detail from a plywood print, showing vertical grain and multiple-tool cutting marks.

50

It is possible to cut down layers so that you achieve some kind of tonal variation, the higher areas receiving more ink and pressure. The soft and fibrous nature of man-made woodblocks lends itself to indenting, and shapes made from metal or card may be hammered or pressed into the surface to give totally white, unprinted areas. If your printed image requires an area of completely flat colour, you can use stencils or combine the woodcut with lino.

When starting to make woodcuts it is better to experiment with many kinds of woods, tools and techniques before embarking on a project with a planned outcome. The actual wood will inspire and direct your print, and its very unpredictability is a large part of its challenge and reward.

Preparation

Timber that has been found in old buildings or comes from discarded furniture may be partially decayed but these parts can be trimmed off and the remainder cleaned well, stripped if necessary according to the maker's instructions and then sanded. Unlike the blocks needed for wood-engraving, woodcut blocks do not have to have a very smooth surface, they need only be level and reasonably flat. The texture of the wood describes the type of cavities it has, and the grain is the fibres that run parallel to the tree's trunk. The figure refers to the pattern of growth rings on the end cut. If the wood has been bought from a timber yard, it will be seasoned but will have to be acclimatized to the workroom. Sudden temperature changes should be avoided as it may cause the plank to warp or even split. Really weathered older pieces can

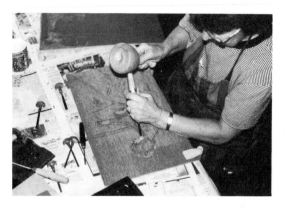

Using a mallet and chisel to cut a plywood block. The small clamps are lined to prevent bruising.

be force-dried by placing them near a radiator or in any warm area.

There is no actual maximum size for a woodblock; it depends on your intended method of printing. If you are not using a press with a limited bed size, but hand printing, then the size is immaterial. Planks of hardwood are usually 12in (30cm) but these can be glued together or tongue and grooved to make a larger area. Sometimes a piece of hardboard or strong cardboard as backing will suffice to make an efficient join, using plenty of woodwork adhesive and pressure with clamps. Put card pieces under the clamps to prevent bruising. Softer blocks cut from open textured woods may need hardening and this can be done with boiled linseed oil. This also prevents any warping. This oiling has the added advantage of making the surface more sympathetic to oil-based ink. The surface of the wood must be well sanded before the oiling and plenty of time left for the absorption to take place before any cutting is done.

An unsanded, unplaned but level block may provide you with exciting textures. Cracks, blemishes and knots may

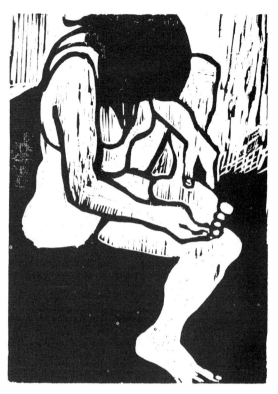

A blockboard cut.

Tools

Any knife which feels well in your hand is suitable, providing the blade is firm and sharp. The European knife has a 1in (2.5cm) cutting edge but the point is mostly used. It is held like a pen but sometimes you may need to use two hands. This knife is used with a firm pulling action towards your body. There are two types of Japanese cutting knife, which are used for the traditional, very fine lines that are to be found on Japanese woodblocks, and are made in several sizes. More commonly used in the UK are basic craft knives. These can be combined with the same tools that you will use for linocutting, these being 'V' cutters or scrives, sometimes referred to as veiners, and 'U'-shaped tools called gouges. They can be set into mushroom-shaped handles, or straight handles as in conventional wood carving tools. A mallet or the palm of the hand is used to drive the cutting edge into and along the plank. The block must be fixed to a rigid working surface with clamps so that there is no movement, but if smaller tools are used – the kind that are set into mushroom-shaped handles – there is no need for this.

become an important, considered part of your final image. To bring up the texture you can use a stiff wire-brush or scrub with steel wool moistened with hot water. Alternatively, you may decide before cutting to abrade the surface in part by filing or scratching or charring the surface. Although the actual block may look exciting after the treatments you have made upon the surface, it is important to remember that it is the actual print that has to work, and that any interesting effect must be sufficiently stable to last out your edition. All textures should be made to endure the printing process. The pressure and amounts of ink used will also need to be carefully monitored.

Some printmakers like to use a bench hook, others prefer to be able to turn the wood as they work, changing direction. A bench hook can be made very simply by taking a flat board with a strip of wood nailed to each end, one on one side, one on the reverse. Another strip of wood can be added down one side, usually the left to form a right angle, which provides further stability, but this is not essential as the bench hook will hold the block steady while you are cutting and when you need to use both

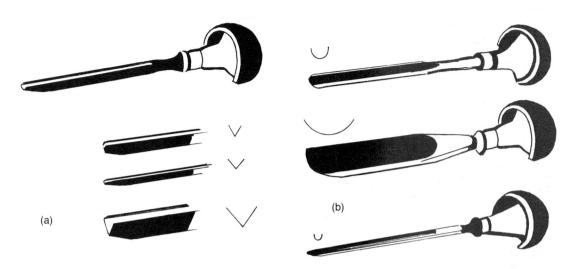

Cutting tools. (a) 'V'-shaped tools. (b) 'U'-shaped gouges.

hands for extra pressure. At all times, the free hand must be behind the cutting one. Bad cuts can occur if the tool slips, and the temptation to assist the cutting by holding the wood in front of the tool must be resisted. Remember that a blunt tool will not only tear the wood but inflict a nasty cut to yourself also.

The traditional knife is held in the hand so that you make a diagonal cut about 45 degrees into the block, away from the edge of the line. Reverse the block and make another cut at a similar edge, removing a V-shaped piece of wood. All this kind of cutting must be done so that the base of each cut line is wider than the top printing area. If any section is undercut, it will be in danger of breaking off under printing pressure.

'V' Cutters

Whereas traditionally the knives are used to cut away unwanted portions of the woodblock leaving narrow lines to print, the 'V' tool can be used both as a drawing tool to cut uniform white lines, and to remove sides of positive black lines. It is very much a case of personal preference whether you use the knife or enjoy the more sweeping action of the 'V' tool. The 'V' tools come in a variety of sizes. The blades can vary from being quite open and shallow, or narrow and deep. Both sides of the 'V' tool are straight and are bevelled on either side. The chisel-type tool needs a steeper angle of cutting than the lower attack needed by the 'V' cutter. The flat of the hand can be used as an improvised mallet if more pressure is required. When starting woodcutting, two 'V' tools should be sufficient, a wide shallow one and a narrower deeper one. Wood carving or sculpting tools are useful but should be used with clamps and a mallet.

Curved Gouges

The 'V' tool is in fact a 'gouge' but the description is used more often to describe the hollow ground cutter with a

A print from blockboard used as a test-piece for 'V'-tools and gouges.

curved edge in the form of a scoop. The heavier gouges are designed to be used with a mallet but smaller ones are available, set in mushroom-shaped handles. As well as being useful for clearing away unwanted areas of the woodblock, the gouge has its own unique mark and can be used to create tones and patterns with closely grouped small cuts. The angle of attack is fairly shallow except where a total clearance is wanted. Large white space will need careful clearing, but a hard inking roller will help to keep these areas clean when rolling up.

The actual density of wood can vary considerably so be well prepared for the resistance to change. Slipping and over-running are common hazards and where you have important lines already cut, always try to cut away from these. If the 'V' lines have been cut deeply enough, cutting up to these with the gouge will be comparatively easy, but care must still be taken, particularly if the incisions have been made across the grain.

For general-purpose cutting you will need two medium-sized gouges, one medium width and one narrower. A wide, flatter one can be used for clearing larger areas, known by some printmakers as a 'JCB'. The flat chisel is not essential but is useful for clearing away rough uneven areas or a portion to be completely white. It can also be used to bevel edges of lines or the block itself. Always direct the chisel along the grain and not against it. Tools can be bought separately or in sets, usually of five or six assorted blades. Some have the smaller straight handles and come with a sharpening stone and a small baren (Japanese). Most of these tools are made from tempered steel and are ready sharpened, but some may need honing before use. Woodcarving tools, the kind used with a mallet, are generally available from hardware stores, sold in sets or individually.

Sharpening

Tools should be kept sharp throughout the cutting process, both for working

ease and the more pleasurable sensations derived from their use. It is possible to cut a block with dull tools but these may slip, causing damage to your block and to yourself. If the tools are tearing or bruising the wood's surface you must pause and sharpen them at once.

A Carborundum or India stone is used first. Add a little thin machine oil and grind down any irregularities. The blade of the cutting knife is laid down flat on the stone and then raised slightly so that the chamfered edge is parallel with the stone's face. Use the other hand to press the tool down firmly as you move it evenly, forwards and backwards. Any burr can be removed on a harder stone such as an arkansas or washita stone. Lay the unchamfered edge flat on the stone and take it two or three times along its length. Test the tool on a spare piece of wood to see if it is ready for cutting.

The 'V' tools are sharpened in a similar way, by leaning the bevelled edge onto the stone's face and moving forwards

Brighton Dress, a woodcut by Carol Walklin. 'V'-tools and gouges were used, with some areas partially cleared to give tone and texture.

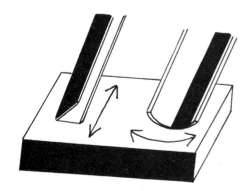

The bevelled edges of the 'V'-tool are laid flat against the lightly oiled sharpening stone, making sure that the angles correspond. The 'U'-tool is rotated as it is moved across the stone and held at the same angle all the time, with the bevel kept flat.

and backwards. The opposite angle is treated in the same way. You can slightly oil a small V-shaped stone and then place it in the angle of the 'V' tool and move it firmly up and down to remove any burr.

The sharpening of the hollow gouges involves quite a different process. The cutting edge is bevelled on the outside

Pig, a woodcut by Patricia Jaffé. The absence of any background gives emphasis to the skilfully cut image.

and it is this part that must be held against the stone. The tool must be kept at the same angle as you roll it, using your wrist, from side to side. Use the other hand to hold the blade of the tool onto the flat surface of the sharpening stone. Any burr can be removed with a slip-stone, which is also used to sharpen gouges that have the bevel on the inside edge.

Transferring the Design

Most printmakers make some kind of preparatory study for their printed image but, because of the nature of the wood-block, a very rigid design is not recommended. A rough plan of the main lines and masses is useful, but this should allow for an individual response to the wood itself. Each printmaker must sort out his or her own methods; if needing to

transfer a design, it is possible to either draw directly onto the block or make a tracing. The latter enables you to reverse the design which is needed if there are significant parts, such as a known building, or letterforms. If you are unsure, hold the original sketch in front of a mirror and check if it looks right. This is how your print will appear.

Another method of transferring your design is to paint a thin layer of white poster paint over the whole block and then paint or draw the design in a dark tone; the white areas are then cut away. If you are using an actual tracing, turn it over so that it is in reverse, and fix it securely to your block with tape. Slide a piece of carbon paper underneath the tracing. The colour of the carbon should be dark enough to contrast either with the whitened or stained block. Do not use a hard pencil or pen as these will

indent your wood if soft and the indentations made by these will print as white lines. Use a soft pencil or crayon and keep checking that you are using enough pressure to transfer the carbon. The drawing should be a good guide but you must allow for the fact that a pen or pencil will give you a different mark from that made by a cutting tool. The drawn lines should not be slavishly imitated when cutting, rather they should be there to be interpreted, altered according to the demands of the wood itself, even omitted if necessary.

If the woodblock is to be used for more than one colour, the drawing must be reinforced with a spirit-based pen or indian ink. This will resist any washing-off materials, such as white spirit, which

Hedgerow, a woodcut by Margaret Wilson.

The Necklace, a plywood cut by Pat Kettle.

have been used to clean up after printing. You will probably want to make some trial proofs as you work and will need to make sure that your drawing or guide-lines remain throughout this procedure. Regular proofing may seem to be tedious but until you become more experienced it is often quite different to envisage the difference between the appearance of the cut block and the printed image. All such progressive proofs should be kept, and preferably numbered, as it is interesting to see the stages of cutting and development. If inks are not available, a rubbing can be made. Hold a piece of thin paper firmly over the block and rub a dark coloured wax crayon or heel-ball steadily in one direction. The impression you obtain will not be as good as an actual print but will give you an indication of the progress of your cutting.

Many novice printmakers overcut at

first, removing too much of the wood and are afraid of leaving large areas of black. Sometimes experimenting with scraperboard is helpful, or painting with white paint onto black or dark paper. The rich, uncut or textured blacks are something to be valued and retained rather than destroyed. The very earliest woodcuts were planned as a framework with the unprinted areas left unprinted for hand colouring, but the woodcut as we know it now exploits the qualities of the very wood itself, not using just outlines, but shapes and textures as well.

Corrections

Minor slips and overcutting can be remedied by immediately glueing back the splinter or piece. Small imperfections can be cured by using a drill and bit and replacing the area with a piece of dowling glued in place. Scratches or bruises can be filled in with plastic wood. These should be proud of the surface and rubbed down level when dry. This is much easier to do before the block has been printed, as once it has any oil on its surface it is almost impossible to fill. If the hole is not roughened well before being plugged, the filler can fall out during printing. A larger spoiled section can be replaced with a complete block of wood similar in shape to the faulty part. The gaps can be filled with plastic wood and the completed correction sanded down when dry.

Offsetting a Woodcut on to Lino

If you intend to combine your woodcut image with lino, or to use more than one block, you will either have to use a master tracing or offset the design. Offsetting is the transferring of the printed image onto an uncut block of new material so that the combined printing will be in register, each print fitting accurately over the other.

Have your lino or wood ready and if possible have the new material at least 1in (2.5cm) larger on each edge. Ink your block well and take a print on to tracing paper or acetate. Lay the print face downwards onto the new block, positioning it carefully. Alternatively, you may find it easier to lay the new block down onto the upturned wet print which is lying on a firm flat board. Holding down the new block, slide your other hand underneath and turn both board and block over in one movement. You can then print or burnish off the printed image. Carefully peel off the print at one corner only, checking that all the ink has been transferred. If it has not, replace the paper and continue burnishing. Pay particular attention to the corners and edges. Trim the blocks when they are dry so that they are identical to the master block.

Inking

The choice of roller and inks, pressure control, and type of paper all play a part in the final printed image from your woodcut. Soft rollers made from plastic will tend to go lower down on the cut block and pick up more texture than a firmer rubber roller. Similarly, a quantity of soft packing will push the printing paper down into the recesses, picking up any ink that may have been transferred there. Inks can be applied with brushes, sponges or leather dabbers, and the inks can be either water- or oil-based.

Social Worker (1), a two-colour print using wood and lino, by Colin Walklin.

The blocks should always be cleaned well before any inking or proofing, as small pieces of cut material will mix with the ink and spoil both the roller and the inking slab. Use a toothbrush to clean the cut block thoroughly before inking up. The woodblock should be completely cleaned after printing but not over-wetted. Store the blocks in a cool, dry place, wrapped in several layers of paper and quite flat. If you wish to re-cut a block which has been darkened all over with ink-stain, dust a little talc or French chalk over the whole block, then wipe the top surface carefully with a slightly dampened cloth. This will restore the contrast between the raised positive areas and the parts you have already cut away.

Other Materials

Hardboard is cheap and easily obtainable material for relief printmaking but it has a resistant nature. Its uniformity of printing surface is similar to lino but it is not as bland. However, compared with plank-wood's characteristic grain, the surface of hardboard is dull. Similar tools can be used as those used for woodcutting, but its smooth, hard surface necessitates very sharp tools and these tend to blunt quickly. A sharp metal point, such as an etching needle or scraper, will provide textured scratched areas. The cuts will have to be shallow even if the hardboard is mounted on a backing board, but it does have a good printing surface for large, flat areas of colour. A stiffish ink is recommended and hard rollers. Always scrub the newly cut block with a toothbrush before inking and printing so as to remove any small particles.

Chipboard has its own surface texture and can be cut with a sharp knife and gouges. Controlled use of a 'V' tool is not easy. Softboard needs a very sharp knife as it tears readily but it too has its own texture and can be dotted with a punch or nails to produce a stippled patterning on the printing surface.

Plywoods vary in thickness and in surface. Most wood-yards and timber merchants will have off-cuts and you can experiment with different woods and tools to see what effects you can achieve. The grain is not always obvious but, if buying a cut size for an image, check first that you have the grain going predominantly from top to bottom if you intend to cut freely. The normal sweep is diagonally

Russ, a woodcut by Carol Walklin.

MAKING A WOOD ENGRAVING

As a printing medium, wood engraving is both immensely satisfying and demanding. It requires drawing ability, considerable manual dexterity and good eyesight. A tiny block can be both powerful and commanding with its dramatic contrasts of black and white. Some printmakers use more than one colour; others prefer to use monochrome, exploiting the tones, gradations and textures of the medium to give great subtlety and 'colour'. It probably appeals more to the particular and deliberate rather than the spontaneous and innovative, but many wood engravers enjoy other methods of artistic expression, such as linocutting or sculpture. In the work of Gertrude Hermes, one can see a tremendous variety of skills and a sympathy for each of the media she has chosen. With equal mastery she sculpts, carves or engraves, employing a wonderful combination of vitality and austerity.

The printmaker who is short of time and space may welcome wood-engraving as a technique which does not involve prolonged periods of work and can be done almost anywhere. You do need a level table top, as it is important to have free arm movement and not have to stoop too much, and good lighting is important too.

Once completed, the wood engraving block is very durable. Those made by Thomas Bewick (1755–1828) in the late eighteenth and early nineteenth centuries are still being used to produce perfect prints of his small masterpieces. It is reputed that in excess of nine hundred thousand impressions have been taken from one block. He is sometimes credited

across the block, to the left or right according to your cutting hand. You may find there is a tendency for splintering at either side of your travelling cut if cutting against the grain.

Electrical power tools can be used to clear larger areas or to make controlled marks. For safety, clamp the blocks firmly before using a power tool; also there can be a loss of accuracy caused by the vibration. Electric tools vary in size, the smaller ones being the types used by dentists and glass engravers. Many of these tools are battery driven but all have the disadvantage of vibration and limited control of mark-making.

The Croft at Gunnister, a wood engraving by Claire Dalby.

with discovering the 'white-line' technique. Even if he was not the actual originator, he certainly made greater use of this method than any of his predecessors. Instead of clearing away either side of the black lines, he created the image with the white lines themselves, sometimes creating discontinous lines with a flick of the tool, but describing his subject in light against dark more often than in dark against the light of the page. This departure from the mere facsimile approach gave his blocks, and those of his school, a greater sparkle and liveliness.

Before starting any work for wood engraving, the design should be considered carefully, more so than with other less exacting forms of relief printmaking. There is no room for indecision and the planning should recognize the qualities and limitations of the medium. You will have a woodblock already prepared for cutting, as the skills needed for creating that smooth, level surface are those of a specialist craftsman. Woodcuts, which are cut from the plank-side of wood, employ a great variety of woods and surfaces, but wood engravings, which use the end-grain, require the essential polished surface because of the method of cutting. The cutting tools are designed for the end-grain, and to produce the fineness of the mark required.

Polished end-grain boxwood, plywood and plank.

Small pieces of wood are useful for the beginner. Scraps can be used as experimental pieces so that each mark can be practised before it is made on the block proper.

It is vital to look at good examples of engravers' work, both from the past and present, and note their use of the tools. The composition of the image must be right; a bad design will not be saved by excellence of technique. It is important to plan first, to sketch out ideas and simplify, to consider if the design will appear as a rectangle or be vignetted.

The Block

The quality of the block will be apparent from the grain, which should be close and even. A crooked grain may prove to be very hard, whereas an open, wide grain may be an indication of softness. There should not be too many specks, particularly light ones, as these tend to shrink and become lower. The blocks should be stored in a moderately dry place and on their side edge; this prevents warping. Central heating can cause a very dry atmosphere but this is preferable to damp air. Hard woods that have close grain are box, pear, hornbeam and lemon-wood. Box is the finest but also the costliest. These are the traditional materials and still the best in many respects, but some contemporary engravers use man-made materials, such as Perspex or acetal, which have the advantage of cheapness, size and consistency of surface but are slightly brittle and the tools tend to slide on them. It is possible to engrave on metal about ¼in (6mm) thick, but it is not a comfortable medium to use, as it is tiring for the eyes.

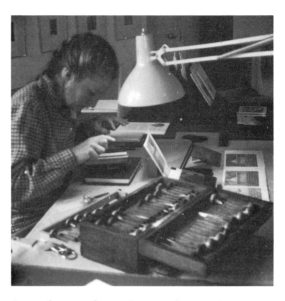

A wooden case for storing wood-engraving tools, used by Edwina Ellis.

Tools

Some engraving tools are designed for engraving lines and some for clearing spaces. An engraving tool is a simple rod of steel, with one end sharpened to a cutting point and the other inserted into a handle. The section of the rod determines their difference. One group is called 'gravers' and 'spit-stickers'; the second group are tint tools and multiple-tint tools. With the variations that these provide, the engraver can delineate, texture, and cut lines and specks. The space-clearers are round or square 'scorpers' and chisel tools.

Gravers

The belly of the graver is sharp, enabling the point to cut very finely, using a light touch. The depth of cut can be altered as it moves through the wood; the greater the depth, the wider the line cut. By

altering the angle of the tool, the width of line will be determined. The graver is also used for pecking out little specks of wood to make various textures. There are square and lozenge section gravers.

Spit-Stickers

These have sharp bellies and also sharp backs with curved sides top and bottom. They are used for texturing, for cutting single curved lines and for a series of curved, closely spaced lines.

Tint Tools

These are designed to cut lines of even width. The line is predetermined by the width of the tool's point. For a wider line, a wider tool must be used. The tools taper very slightly towards their belly, so if pushed deeper into the block they will cut a line a little wider. Multiple-tint tools are rectangular in cross-section with a series of grooves running along the belly. Therefore, the cutting edge is serrated, each serration cutting a line of the block. In very skilled hands, this tool can accelerate the cutting of flat tints and also adds to the engraver's vocabulary of mark-making and stippling. However, it is not the most important of the basic set of wood engraving tools.

Scorpers

You will need these space-clearing tools. They are round-ended or square-ended and can be used to clear, to make broader lines than those achieved with the gravers, or to stipple. Both kinds are made in a variety of widths. Another space-clearing tool is a chisel-type. This may be used for smoothing a scorped-out area or

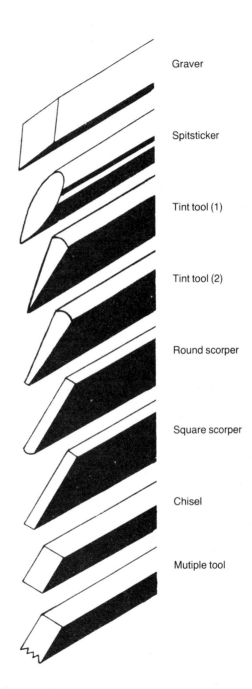

Graver

Spitsticker

Tint tool (1)

Tint tool (2)

Round scorper

Square scorper

Chisel

Mutiple tool

Diagram from *top to bottom* of a graver, a spit-sticker, two types of tint tools, a round scorper, a square scorper, a chisel and a multiple tool.

for bevelling the edge of the block where a clean white area is needed.

The wood engraver, George Mackley, recommends the following as a good first selection of tools:

1 lozenge graver.
1 medium spit-sticker.
2 tint tools, 1 fairly fine and 1 broader.
1 medium round, or 1 medium square scorper.

Engraving tools are numbered on the side nearer the handle, the lower the number the finer the tool. When buying tools you should have them trimmed to the size that fits your hand comfortably.

Sharpening a graver.

Sharpening the Tools

If the tools are not kept very sharp, they will slip on the smooth surface and not bite. A slip can cause serious damage to the block and repairs are very difficult, often impossible. If there is any skidding, you know that the tool needs to be sharpened at once. If you test the tool's point on the thumb-nail it should catch a little, but a spare piece of block can be kept for the purpose of trial cutting and testing, and will give a more accurate indication of the tool's actual sharpness.

Sharpening can be done on an oilstone – one with a fine surface such as a hard arkansas is best – using a thin clear oil. The tool is held with its belly upwards, the cutting face flat on the stone. Keeping the face flat is the key to successful sharpening, and any rocking must be avoided as this will result in a curvature. Time is well spent getting the pressure firm and flat before rubbing the tool forwards and backwards with an even rhythm.

Care of Tools

Tools that are not to be used for some time should be lightly oiled. They should always be kept protected so that they do not rattle against each other. This can be done either by using a box with compartments, or a fabric roll with slots for each tool. It helps the beginner to mark the tools in such a way that they can be recognized quickly, and picked up without having to examine the point each time. It makes for better efficiency if the tools are coded, e.g. marking the handles SC (scorper) 1, SPK 2, and so on.

Other Aids

Other equipment should include a leather circular sandbag. This provides a surface on which the wood engraving block is easily turned as you work, with a swivelling action. When cutting sweeps or curves the sandbag helps considerably to avoid jerkiness. It also helps by raising the level of the block above the work

surface giving you more room to hold the block in your free hand, controlling and steadying the movements. Much of the skill of the cutting involves the use of both hands, more so than in woodcutting or linocutting, and it is the mastery of this coordinated movement that is recognizable in the pose and action of the engraver. If you do not have a sandbag, you can raise the level of your block with a book, covering it with a wrapping of fabric. Some printmakers have found an

A detail of *Brick Kilns, Ruabon* by Claire Dalby.

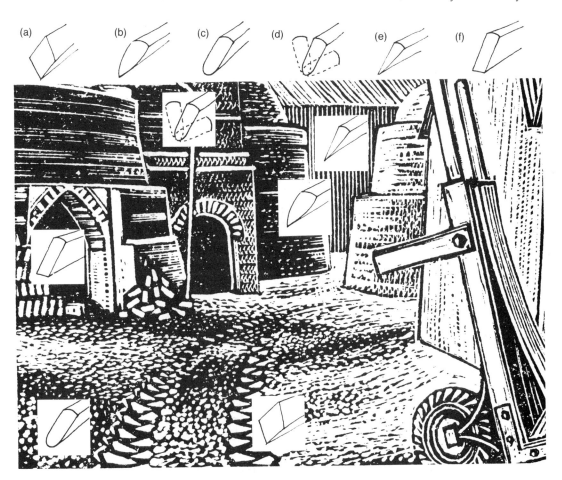

An enlarged detail showing typical marks made by the wood-engraving cutting tools. (a) A graver. (b) A spit-sticker. (c) A round scorper. (d) A rocked scorper. (e) A tint tool. (f) A square scorper.

old handbag helpful, padding it out to imitate the shape of the sandbag. If you cannot acquire or afford the best, you will need to invent.

Another aid is a magnifying glass. This can enlarge portions of the block where you wish to do some fine cutting or texturing, or you may wish to examine your work more closely before continuing. It is necessary for the glass to be mounted high enough to clear the raised block, so it should be on a stand or stem. Good lighting is always important but be aware of the heat from the bulb as this may cause a block to crack if it has a fault. Engraving is a pleasanter process with these aids, obviously, but if you are without them then you must work within your limits.

Transferring the Design

The block must be prepared for transferring your design on to the surface. It needs to be either lightened or darkened so that you can see the guide-lines. You should aim to transfer your drawing accurately, making it legible, and the block should be in a state where you can see what you have engraved. The method taught by Joan Hassall was:

1 Trace the drawing onto tissue paper with a B or F pencil.
2 Whiten the block with a little white gouache or poster paint applied very quickly and thinly.
3 Turn the tracing over and secure it well with tape over the edges.
4 Rub soft pencil all over another piece of tissue paper and slide this under the tracing. Then draw your guide-lines through, using a 2H pencil but not pressing too hard.

(a)

(b)

(c)

(a) The original drawing for *Brick Kilns, Ruabon* by Claire Dalby. (b) A progressive print. (c) A final proof showing increased lightening in several areas.

5 With a fine nib and indian ink, rein-force the traced-down drawing.
6 Make a firm pad or dabber and bang a thin layer of black printing ink all over the block. Rub this off immediately so that you have an all-over grey surface with the darker drawing showing through.

Another method is to apply black writing ink with a rag to the block's surface. It dries darker so be very sparing. Trace the drawing down using light or coloured dressmaker's paper. Draw over this with a pen or hard pencil and go over the drawing with pen and undiluted ink. An alternative to this is to paint with white gouache and a fine brush. You can either paint the positive lines which are to be left, or the areas you intend to remove. Be careful not to use the paint too thickly as this creates an actual printing surface. Beginners should experiment to find which method suits them better. Usually the areas that are being removed will appear lighter and the effect will be similar to that achieved by printing with dark ink on paper.

Cutting

Beginners tend to go through a stage of gripping the cutting tool tensely with their fingers, which prevents them from driving it with the whole arm, if at all. You should keep the tool very nearly still, turning the block against the tool, or, if cutting straight lines, you should nudge the tool forward a little at a time. If you push too hard with the cutting hand, or turn the hand around so that the right elbow gets further and further from the body, you will have less control.

The mushroom-shaped handle has a flat side which should be uppermost; the curved part fits into the palm of the hand. The little finger hooks under the recessed rim of the handle and the cutting point is guided by the thumb and index finger. Whichever way you hold the tool the principle is to drive it with the heel of the hand and the fingers acting as a guide.

A common fault with those new to wood engraving is to overcut. Always work slowly. Try to postpone taking any inked proofs as long as possible as this tends to make the brightness of the contrast between cut and uncut areas less.

White spaces can be cleared in two ways. You can outline the area with a graver or suitable tool and clear away just the edges of the area with a scorper until finally the centre part is cleared. Alternatively, you may find it better, depending on the shape of the area, to outline as before but to clear the middle area first, and then continue up to the outline. The first method ensures that the clean outline is preserved as you can follow it carefully with a round scorper. This groove will be a protective line as you clear other areas.

Clear away the unwanted parts sufficiently low enough to miss the inking roller. When you are printing you may be using a soft roller which may reach down lower than a harder one, picking up areas which you wish to remain un-inked. If hand burnishing your print, you will have greater control.

Printing a Wood Engraving

There are many variables with inking the block as it depends on the kind of ink and roller, and the block's demands. It is even more important not to over-ink

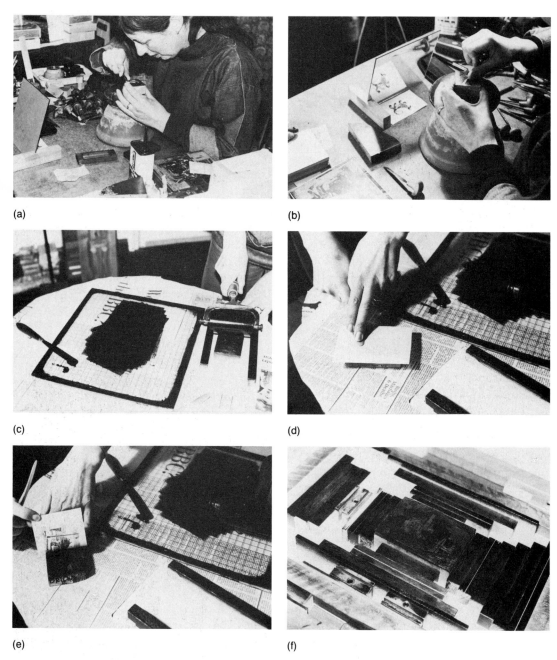

(a) Claire Dalby chooses to raise her sandbag to the correct height for her by resting it on an inverted flowerpot. (b) A mirror tile placed in a slotted piece of wood enables the engraver to see the original drawing reversed. (c) Oil-based ink is rolled out onto a glass slab and, when evenly coated, the roller is passed over the wood-block, using two bearers of the same height. (d) The printing paper is placed carefully on to the inked-up block and burnished by hand. (e) During the process of burnishing the paper can be inspected to check the quality of the printed image. (f) When using a press, the block is locked into a chase with furniture and quoins. (g) (*Opposite*) The secured block is placed on the bed of the press ready for inking and proofing.

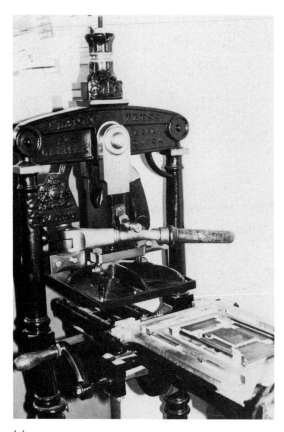

(g)

edge. The roller should always have firm contact with the block but not have excessive pressure, as this will force the ink into the cut lines, which can spoil their crispness or make a textured area fuzzy. If you need a proof, after inking and printing wipe rather than wash the block, and try to keep the lowered areas as clean as possible. Puff a little talc or French chalk over the block and wipe over the surface with a very slightly dampened rag. The powder in the recesses will bring back a little of the original contrast.

Basically, you cut white lines or areas from a darker background. The solid

Malvolio, an engraving on lemon-wood by John Lawrence.

than it is with woodcuts and linocuts. The oil-based ink should be a thin, satiny film on the slab or board and the roller coated evenly. Once the block is inked, it is best to have your own system of inking. This will ensure that you have covered the whole block without having to examine it closely each time. Make a sweep in one direction, then turn the block and go across again. Use the roller lightly and make several sweeps in one direction, recharging the roller if necessary. Pay attention to the edges, bringing the roller up onto the top surface from the side, then across, ensuring that you complete the sweep right to the other

Jacobs in Shropshire, a wood engraving by Sarah van Niekerk. The engraving demonstrates a typical combination of shrewd, unsentimental observation with technical virtuosity.

areas can be broken up with textures in the form of lines or dots, grouped in such a way that you achieve tones of 'grey'. Tones are made with the tint tools or with the graver. Lines can be closely spaced and of an even width, or variable with even spaces. You can have groups of like-sized dots, which create stippling, or a mixture of large and smaller dots, varying the spaces and groupings.

Each tool is capable of performing two main operations: cutting out an area and creating lines. These lines can be broad, narrow, curved or straight, according to the engraver's needs. You may need a combination of more than one tool to get the effect you want. There is always a tendency to broaden a line as you cut, because the tool makes more of a downward movement as it travels forward. If

you want an even line, you must hold the tool at a steeper angle, pushing so as to engage the tip in the block until it reaches the depth of the intended line. Then lower the handle carefully until you have the normal cutting angle and keep this constant. If you still have a taper at the start, turn the block around and cut a returning line to the starting point.

For straight lines, the block should be held firmly on the working surface and the cutting tool driven steadily forwards. When you want a curved cut, you will need to alter direction and, here, the sandbag will enable you to rotate the block with your free hand while the tool is kept constant. This requires much practice and coordination. The spit-sticker is the best tool for this kind of cut, but is also used for lines that vary in width. To taper off, if using the graver, lower the handle gradually as you approach the end of the cut, so that the point slowly rises and then lifts clear.

Burnishing a Print

A toothbrush handle, a teaspoon or a wooden modelling tool are all suitable for making a burnished print. Your engraved block should have sufficient ink on its surface to hold the printing paper so that it will not slip. You can rely on this ink to hold the paper quite still but it also helps to place other blocks of wood around the engraved one to make a level platform on which to lean as you work. The thin, smooth paper is laid carefully over the inked-up block and another piece should be laid over this to protect the printing paper from tearing. Also the ink sometimes comes through the thin paper and is picked up by the burnishing tool, causing smudging if there is not

another layer of paper. Although this is on the reverse side of the printing paper, it can show through. Another reason for taking this small precaution is that it helps you to avoid pressing down into the cut hollows of your block. If you are aware of large areas like this, substitute a piece of thin card as backing, but it must not be so thick that the contact between the burnishing tool and the inked-up block is too remote.

You can check your progress by carefully peeling up one corner of your printing paper, while holding the rest down firmly so that it does not move. You may find that all is well or that you need to

Don Quixote Paints from Life, a wood engraving by Luther Roberts.

Two Clementines, a wood-engraving on Delrin acetal resin by Edwina Ellis. The sequence of colour overprinting has been considered carefully by the artist by proofing in different order. The final one was blue, red, yellow.

The final print.

apply further pressure. With larger blocks, such as lino or wood, it is possible to re-ink parts but less easy when working on a smaller scale.

Clean the block, roller and slab well as

soon as you have completed the printing process. The prints can be hung up to dry or left flat, ink-side up. Do not over-wet your block as you clean it and use a soft toothbrush to loosen any ink that has got into the hollows. Ink left to dry in these spoil the block for any further printing. Pay particular attention to any texturing, such as stippling and pecking.

The papers used for hand burnishing have to be thin but they can vary in quality from humble newsprint to expensive Japanese papers. There are a variety of good imitation Japanese papers to be had; some are brilliant white, others have interesting lines and specks. It will very much depend on your image which you choose for your final edition. If you have a press, you may choose a smooth paper, such as a Somerset HP. This has a treated surface but is not as hard as a commercial coated paper, which is unsympathetic for the kind of work done by the artist-printmaker. If you are selecting a paper which is rough or soft, it will print well if dampened first. This will make it much

Rape of the Lock Canto 111, a wood engraving by Peter Forster. The editioned print was made from three blocks but each one was reduced, giving a more elaborate final image.

more receptive to the ink (*see* Paper on page 121).

Some contemporary printmakers also work in colour and their wood engravings are rich and exciting. It is an exacting way of working and most have learned through other relief techniques, such as linocutting, how to handle the complications of colour printing. Register, overprinting effects, the use of the paper colour, and many other factors make the process of coloured wood engraving something for the beginner to look forward to, but not to attempt too soon.

MAKING A LINOCUT

Sometimes described as a twentieth-century development of the woodcut, the linocut is too often spoken of in negatives. It is said that it has no directional grain, it cannot produce fine lines as it is rather soft and crumbly, has no imprint, and so on. However, many artists have found this medium to be sympathetic as well as challenging and have taken it from the 'kindergarten' to the artist-printmaker's workshop. Lino exists as an art material in the twentieth century but was known as early as the sixteenth. In the 1850s, a floor-covering was made of a mixture of ground cork and rubber mounted on metal sheets. Later the rubber was replaced by oxidized oils, one being linoxyn, hence the name. By the 1930s, there were twenty factories in the UK producing linoleum but now there are only three in the whole of Europe, in Scotland, Holland and Germany.

Wallpaper designs were produced from lino-blocks in Germany in 1890 and it was used as an art medium in the USA and the UK in the early 1900s. In London, Claud Flight (1881–1955) became interested in colour printing from lino after seeing work produced by the young pupils of Franz Cizek in Vienna from 1918 to 1930. This medium appealed to him and his students at the Grosvenor School of Modern Art as it suited well their futuristic style. A major exhibition of British Linocuts at the Redfern Gallery, London, in 1929, led to an even greater following.

The other link with the history of linoprinting lies in Vienna again, with Kandinsky (1866–1944) producing nine linocuts in 1907. Lino reached the USA around 1910 where a group in New York

'Alas,' said Sir Lancelot, 'You have mischiefed me', a linocut by Edward Bawden.

made good use of its qualities for illustration. An Australian, Harold Brodsky, travelled between London and New York encouraging other artists to work in the medium, using it himself very freely and spontaneously, in contrast to the controlled, more abstract work by the Flight School.

Any student of relief printmaking will admire the work of Picasso who produced prints of amazing virtuosity but never tried to alter the nature of the material. He began by producing prints by cutting more than one block but found it hard to get accurate registration with perhaps six blocks. He was then introduced to the reduction method by the printer Arnera and found it a method much better suited to his style. He produced forty linocuts in one year (1959) but ceased in 1962. Prolific as always and starting when already seventy-seven years old, he produced twenty-four posters and 107 linocuts between 1952 and 1962.

Linocuts have been elevated to great aesthetic heights by many artists in the twentieth century. Of recent years, Edward Bawden (1903–1989) has made a huge contribution by gaining the respect of the discerning public for the artistic

value of the linoprint. Always a designer, his posters and illustrations have balance and elegance, but they also possess a touch of humour, an impish quality, which makes them endearing as well as noteworthy. His preliminary sketches were not finished drawings to be followed exactly by the cutting tool. The knife itself did the actual 'drawing' making white shapes out of black and patterns out of solids.

He spoke of lino as a 'designer's medium . . . giving a print a strong impact and a decorative quality. It seems that this humble material, so soft and characterless, can really offer features that are unique, results that have value.'

Like woodcutting, linocutting is very direct. Whereas in other printing processes, chemicals are used that give the artist-printmaker many unpredictable variables before the final image is achieved, with the linocut, the print-maker cuts his own marks by hand, and the surface is changed at once, ready to accept the ink on the raised, uncut parts. Therefore, the whole process travels from one stage to the next in an organized manner.

Lino and vinyls usually vary from about ⅛in (3mm) to about ¼in (6mm) thick. Battleship is the thickest and most hard-wearing. Lino is backed with canvas or hessian and can be bought in rolls or as tiles. Its quality will depend on its age as well as its thickness. Old stock may have dried out and be brittle. Some thick lino is crumbly and falls away with any fine cutting. Hard lino can be made easier to cut by careful warming on a plate-warmer, in a warm oven, on a radiator, on a hot water bottle or by using the heat from an angled lamp.

Off-cuts of lino from furniture stores,

New Baby (1), a linocut by Carol Walklin.

providing they are not less than ⅛in (3mm) thick and plain, are usually a good bargain. Any kind of texturing or patterning, unless intended in your planned image, will be unacceptable. Coloured flat patterns are distracting to work on but you can cover them with a thin film of poster colour before transferring or drawing your design.

The lack of grain in lino means that you are able to cut it in any direction with the same ease, unlike plank-wood. It is pliable and relatively soft to cut and it can be backed further by glueing onto stiff board. If the design is large and you have a big sheet of lino, backing is important, particularly if you are using the reduction method. With this technique, you will be reducing the lino to almost nothing by

the end of the process, and will need some firm support to keep it rigid and flat. Two small extensions of the card backing at opposite ends will enable you to lift the inked-up block without spoiling the surface or dirtying your hands.

The durability of the finished block makes it possible to produce long runs. I produced 1,700 prints from a mounted lino-block printed on a commercial power-driven press. Lino-blocks that have been mounted professionally will be type-high, that is 9/10in (28.3mm), which is the height of metal type. If you are doing bookwork, you will need the lino-block and the type to be of a common height if printed simultaneously.

Preparation

Lino that has been rolled up for some time will need flattening. If this is not done properly the block, even if it is a small one, will be very difficult to ink up and print accurately. Carefully measure the piece of lino that you need, making sure that you have accurate right angles. Draw out the area with a pencil or pen, then, using a firm-bladed knife and a straight-edged ruler, score the lino's surface. Bend the lino back on itself so that it cracks and you can see the backing. Keeping it doubled back cut down through the hessian cleanly. If you are cutting a small section from a large piece of lino, it is best to score the whole length with one cut so that you can bend it back completely and then cut off the piece you need. The remaining lino strip can be kept for later work. Do not try to cut quickly but keep cutting lightly over and over again until you are through.

The surface of the lino can be made smoother by scraping thoroughly with a

A detail of *Owls*, a linocut by Gertrude Hermes.

razor blade, using a little lighter fuel. This will provide you with a smooth surface for fine cutting. The character of lino lends itself to broad treatments, with big areas of colour and strong cutting and patterning. However, some printmakers are able to produce finer, more detailed work.

Another method of preparing the lino is to sand it down with a fine grade wet-and-dry paper. Single sheets must be wrapped around a block of wood and you should work consistently in one direction – rather than using a circular polishing movement – and remove any

Sea Horse, a linocut by Keeley Weald.

Mounting the Block

If you are mounting the lino-block, spread a strong adhesive, such as PVA glue, evenly all over the hessian backing of the lino, as well as a little on the board. Place the block down and apply a little pressure so that any excess glue will come out and be wiped off before you put it under weights or in a wind-down press. Any extruded glue that has not been cleaned away will be messy and can spoil other surfaces, so sandwich the block and board between newspapers before doing this. Hardboard can be used as a backing, instead of cardboard, and can also be made into a registration board. Some printmakers like this method because of the security it gives for the positioning of the block, which remains permanent right through the cutting and printing processes. If using this method you will need a piece of hardboard a little larger than your printing paper. Use the rough side of the board as this will key your lino better than the smoother side.

scuffs or scratches. Do not overwet the lino and avoid wetting the hessian backing. Pay attention to the edges and corners.

Finally remove all the dust and particles with a slightly dampened rag. Waterproof silicon-carbine paper can also be bought. This is mounted on to a block of firm sponge, with each side having a different grade fixed to its surface. These are particularly good as they give you a firm block to hold and provide even pressure when rubbing in one direction. Check also the edges of the cut lino, and remove any wisps of hessian backing as these will pick up ink when you are rolling-up and spoil your print.

Tools

The tools used for linocutting come in three designs: those similar to woodcutting tools with mushroom-shaped handles, those with straight handles, and the nib variety. The latter are the cheapest and come with the handle and a set of interchangeable cutting nibs. The screw-necked handle is the better design as the nib can be pushed well down before making secure. These nibs are fragile and if not inserted fully can bend or snap. Also they cannot be sharpened. Two or three tools made from hardened steel are the best buy, starting with these and

(a)

(b)

Kaftan, a linocut by Carol Walklin. (a) An ink and watercolour drawing. (b) A scraperboard drawing. (c) The final print.

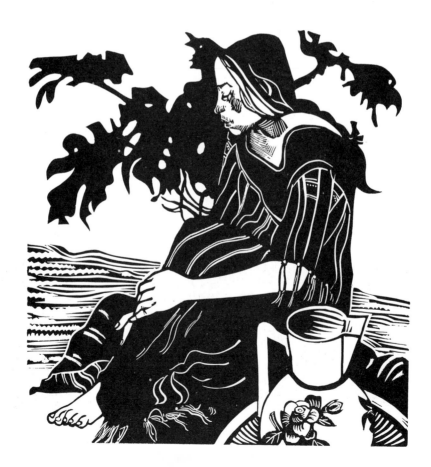

(c)

then adding to them as your work becomes more demanding. As in woodcutting, the tools are knives and gouges.

Knives

No knives are made specifically for linocutting but strong craft knives are suitable as are those designed for woodcutting, both European and Japanese. A knife used Western-style is drawn towards the body and used at an angle to make a single line. The second cut is made along the other side of the line, thus forming a 'V' which is then cleared away. Minimizing this angle is very important as any undercutting will weaken the raised parts, which may break down under pressure when printing. Always have the raised areas wider at the base to avoid this happening.

'V' Tools

'V' tools (veiners or scrives) cut V-shaped lines in a variety of widths and acuteness of angle. They are used to cut continuous free-flowing lines, to mark out the edges of areas to be cleared away, to texture by short flicks. There are about eight sizes but one deep one and a fine small 'V' are sufficient to start with.

'U'-Shaped Gouges

Generally referred to as gouges, the smallest ones have quite a deep curve and the middle range varies with depth and width. The largest one is wide and almost flat and is used to clear the large areas really low. The others can be used for more delicate clearing, scooped lines or texturing. The smallest is useful for texturing with groups of picks and dots. A medium gouge and a small one therefore would be sufficient for the beginner.

Sometimes the areas of cleared lino can provide a positive background such as in the *Sea Horse* print (*see* page 77). The areas of sea have received some of the ink from the roller, picking up the texture of the cut, cleared lino. Soft packing pressing the printing paper down onto this area has helped it to print. As a printmaker, always be ready to make use of what initially might have been an accidental effect.

Lino tools, except for the nib variety, will need regular sharpening due to the composition of the lino, and this should be done in the same way as those used for woodcutting.

Lines can also be made by scratching the lino's surface. The scratches must be

Linocut tool marks.

deep enough to show after inking and must be cleaned frequently during printing to prevent any clogging or build-up. You can also texture the lino with nail-holes but because of the plastic qualities of the lino, these must be drilled or driven in very deeply. A rotated tool held vertically will give you neat holes and a rocked tool will make a line with jagged edges, seen in the detail from the *Owls* linocut by Gertrude Hermes (*see* page 76). It is advisable to first practise with your tools using a spare piece of lino. It helps to warm it. If using an angled lamp to warm the lino, do not put the light too near the surface and go away, or you may scorch it and cause it to bubble up. If caught in time you can put pressure on the affected part at once, but if the bubble is too big you may have to organize your design so that this is a portion to be cut away. A hair dryer can be used or a plate-warmer, but hot water is not recommended as this will dampen the backing or the backing board. Certainly warm lino is a joy to cut and safer too, as the cutting tool is less likely to slip.

The Work Area

You should be seated comfortably, inclined over the block, with good lighting, and with space for movement. Some printmakers use a bench hook as for woodcutting. At all times, keep the free hand behind the cutting hand or you may cut yourself. The bench hook is suitable for small lino blocks but is restrictive for larger ones where you may want to rotate the block as you cut. Long curved lines will flow much better if the block is free to be moved around. Again, great care must be taken to keep the free hand out of the path of the cutting tool.

Wallpaper motif, a linocut by Edward Bawden.

A Single Block

The design for any printed image in any medium may not necessarily begin on paper. You can plan a design with care but then find that you have aimed for effects not possible in the particular medium that you have chosen. You will be able to anticipate hurdles when you are more experienced, and recognize the ones that are worth attempting and those that ask for alternatives. Any form of printmaking can be an innovative exercise and often it is the challenge of getting what you want that forces you to invent and experiment. If you try to imitate a painting or drawing, you will become frustrated; printing should not be regarded, whatever the medium, as just a means of reproduction.

The blank piece of lino may invite you to draw freely on its surface or you may want a more controlled start to your printmaking. Either way, it is a translation from a thought or sketch to a print. Your individual reaction to a theme, an object or a figure makes the work unique. Also the actual translation from idea to print produces a chance, along its route,

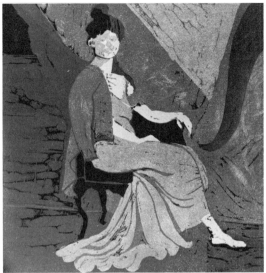

Model in a Long Dress, a reduction linocut by a student.

Still Life with Flowers, a reduction linocut by a student.

to experiment, for exploiting the tools and the surface you are cutting. Remember that you will be drawing with a knife or cutter, not a pen or brush.

Studies were made in pen and ink and in water-colour sketches for the monochrome linocut *Black Kaftan* (*see* page 78). These were made from first-hand observation of the seated model, dressed in a black kaftan, with still-life objects of a jug and basin set on a striped rug and a large potted plant. At first, the studies were representational, but progressed to a more selective approach. The colour studies were then translated into monochrome using scraper-board. (This material can be useful for preliminary work before finalizing the image to be cut, but in itself is a rather restrictive medium. It can be bought in two forms,

each a thin card coated with a fine layer of plaster. It is coloured black or left white. The former gives you immediate white lines when scraped away with a special tool or adapted knife or nib. If you need an indefinite (vignetted) edge to your image, then you can paint on the

The Workers, a linocut by a student (16 years).

81

white board with indian ink, just the area you wish to work on, and scrape into this to create your image. The sharp-pointed scraping tool reveals the white plaster, much as the cutting tool reveals the lighter lino or the resulting un-inked printing paper.)

Once the artist had decided on the size of the image, the scraper-board drawing was enlarged by using photostats. These were used to rearrange and select some of the elements in the picture. They were cut and stuck down, moving the pieces around until the design seemed satisfactory. Such experimentation can be very useful, giving the printmaker a chance to think beyond the original idea as well as considering the printing process at the same time. The pasted-up design was traced down and reversed, ready for drawing down onto the lino. You can reverse the pasted-up photostat by turning it over and, if you do not have a light-box, placing it over a window-pane so that you can see the image in reverse.

Transferring the Design

Tape the tracing or drawing into position over the lino and slide a sheet of carbon paper underneath. Use as many sheets as you need to cover the area or a careful movement of a single sheet, to ensure that all lines have been transferred. The lino can be whitened with a little thin poster paint rubbed over the surface. This makes the carbon lines show up well, but usually the contrast is sufficiently clear on the brown lino. You will have to de-grease the surface of the lino with some washing-up liquid to enable you to apply the poster paint evenly. The lines of your traced-down drawing should be reinforced with a spirit-based

pen (tested first with the solvent you will be using when printing), so that if you wish to proof in stages, you do not lose your original drawing when you clean off the ink. Rubbings instead of inked proofs can be made if you wish to check your progress, but these will not appear in reverse, unlike your final printed image.

A Single Block with More than One Colour

A single block can be used to print an image in monochrome but can also be used to produce a multi-coloured print. You will need a form of registration – which is described later – as you will be printing several times and will need to be able to position the paper accurately over the inked block.

A colour single block can be treated in two ways. The first is overlapping colours. Decide on where you want a colour and roll the ink over this area on the block. You will have to mask around any specific, clean-edged areas with a piece of thin paper. Always cut more than one mask in case of spoiling and, if you have saved previous proofs from this block, or rubbings, these will make ideal masks as they will be the exact matching image. The mask can be attached to the registration board or flapped over the lino-block, making the printing process easier. Cover a larger area of the lino than just the part you wish to print as this extra ink will help the paper mask to stay down in place.

A more haphazard approach using more than one colour, will give you other colours as they blend and overlap. This overprinting is often used by printmakers when they thin down their inks to a degree of transparency which exploits

one colour over another. With this method, the block is partially inked in one colour, then printed. The second colour is rolled on some areas of the block and printed over the first, which can be dry, or printed wet-on-wet if preferred. Wet-on-wet printing creates a merged blurring of the inks and can be used to good effect. If you want a clear overprinting or covering, each successive print must be allowed to dry before proceeding.

The second method is to ink up with small rollers several colours at one time, covering the whole block, and then print. It is a free technique and creates some blending where colours meet. The disadvantage is that the rollers tend to pick up a different colour after taking a few prints and must be cleaned before they spoil the inking slab. It is a good method for those hesitant about colour and can produce some exciting results.

Graded inks, either from dark to light shades of the same colour or from colour to colour, are some of the alternative ways of using a single block in an innovative way.

A coloured jigsaw print, a linocut by a student.

The Jigsaw Block

Several woodcutters have made use of the jigsaw method, and linocutters can use this process equally effectively. Each piece of lino is inked up separately and then assembled and printed at one time. This means that you can produce a multi-colour image with only one printing. The disadvantage of this method is that you are restricted to using relatively simple shapes, as the interlocking can be too complicated. Small pieces of lino are hard to cut and very difficult to handle when inked up and this can be frustrating. If there are too many pieces to fit together, the time taken to assemble them may mean that those parts you have inked first may begin to dry. The use of a retarder to slow down the drying process can help, but it is better to plan your design bearing in mind these problems, keeping the design bold and simple and with not too many pieces of lino.

However fine the cutting tool or sharp the scissors or snips, you will notice a white line between each of the printed shapes. This is the width of the blade that has made the cuts and cannot be avoided unless you over-cut each piece.

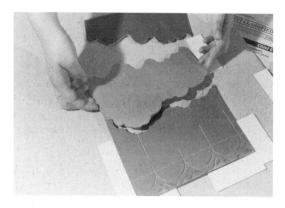

Assembling the inked-up pieces of the jigsaw.

The completed jigsaw positioned within the registration stops. A mask of paper in the shape of a flower has been laid on top of the inked surface. This will prevent any ink being transferred to the printing paper.

This is acceptable for the card version of this process but wasteful with lino. It is better to draw the complete image that you want on the lino and then to cut along these drawn lines.

The pieces should fit closely together but sometimes you may need to rub the edges down slightly to make a smooth fit. Allow a 'frame' of lino around your drawing out of which you cut your jigsaw blocks. You can then replace the inked-up pieces within this un-inked frame, which will hold it all together when printing. If doing a large print, a strong card frame would suffice; this can also be part of a registration board.

If a white line is not wanted, the overlapping process can be done, but artists like Katie Clemson and Philip Sutton make good use of these lines as part of their design. It is also possible to print an undercolour or to use a tinted or coloured printing paper; the line then will not be white but the colour of the laid-down ink or paper. Very heavy inking can reduce the white line but because of the amount of ink used the print will have to be blotted several times to remove the excess ink. If you intend to continue cutting your jigsaw pieces progressively and will be making further prints, you will need a registration board.

The Reduction Method

This method is recommended for the beginner. The advantages are that you use only one piece of lino but can print in many colours to achieve your image. In addition, registration is likely to be more accurate as you do not have to cope with variations in the cutting and matching of several blocks. Some printmakers glue their block down on to strong cardboard or hardboard, which means that, when printing, the only deviation will be in the laying down of the paper. If a good registration format is used, this should be accurate, giving you a sequence of colours all printed correctly in place. Your image can be planned carefully following a colour sketch, or you may find it better to draw a very simple design, directly onto the

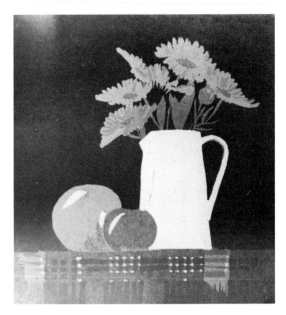

Still Life, a reduction linocut by a student on an introductory course. This first print is in five colours.

lino-block, and then to work through the colours, usually from light to dark. This method will help you to get used to the feel of cutting, inking and printing.

A pre-planned picture should not be followed too rigidly, but rather the tools and medium should be exploited to the full. Experimentation and ingenuity are the hallmarks of a good printmaker, but knowledge of the craft itself is essential for the beginner.

The obvious disadvantage of the reduction, or waste-block method, is that there is no going back and repeating or proofing the first colours, hence the rather frightening name: the 'suicide method'. At the outset you must decide how many prints you want to produce. If it is ten, then you would plan to print twelve at least. This allows for any errors, upside-down prints, smudges and so on. Some spare prints are always useful for correcting and colour tests.

Having prepared the lino and transferred the design, begin by considering if you need any whites on your image, assuming that you will be printing on white paper. Make your first cuts remembering that these lowered areas will not receive any ink and that the

The penultimate stage of a reduction block.

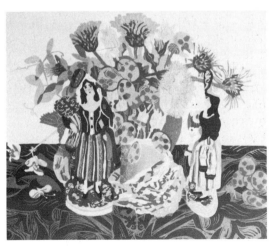

The final stage of a nine-colour reduction lino-print.

cut-away parts will be the colour or white of the printing paper. The block is then proofed up with your first colour and the print is examined to see if all the necessary cutting has been done. This should be done on newsprint or a cheap proofing paper.

The block is wiped clean should any further cutting be necessary, and when you are satisfied that it is complete at this stage, clean the block again with a toothbrush to remove any small particles of lino; do this before you re-ink or you will spoil the roller and inking slab.

Having mixed your first colour so that you have enough and to spare for your edition (the number of prints you require), make your first set of prints. Put these aside to dry, clean the inking area and roller and then clean the block thoroughly before cutting for the second colour. You have now started the process of a reduction linocut. It can be a satisfying technique but there is no opportunity for making any modifications, except by some corrective method such as stencils. The block you have just printed is about to be altered and you will not be able to repeat the first colour again.

The Method Involved in Producing Regatta

1 The drawing was transferred on to lino using carbon paper. The tracing was made with a ball-point pen, checking to make sure that the image was appearing strongly enough on the block.

2 The carbon drawing was reinforced with a spirit-based pen, which had been tested by drawing first on a small piece of scrap lino. This was allowed to dry, then rubbed hard with a rag dipped in white

(a)

Regatta, a reduction linocut by Colin Walklin. (a) The first printing in yellow with the white areas cut away. (b) The blue block proofed with graded inking to be overprinted over the yellow. (c) The blue block overprinting the yellow block. (d) Additional sail colours with some cutting but also some areas of lino left un-inked. (e) The final print with the darkest-toned colours and the etched lower sea area printed in indigo.

spirit, the solvent to be used with the oil-based inks.

3 Some white areas were removed first. (It is a good idea when making a print of this kind to have a small piece of lino beside you so that you can try out some cut-marks, experimenting with the effect of the tool itself.) Here some of the sails are made by exposing the white printing paper. The whole block was then inked up with yellow oil-based ink and the cut-away parts appear as white paper. This first proof was inspected to check the cutting and to see if the colour was suitable. The paper had been trimmed ready for the edition of fifteen final prints, so

(b)

(c)

(d)

(e)

eighteen sheets were prepared to allow for errors or testing.

4 After printing, the yellow block and inking area were cleaned and the prints hung up to dry completely. The block was then ready for the second cut. If you are attempting to follow this method to produce a print yourself it is useful at this stage to have another print alongside you as you work. It can be a spare proof

but not one that has been made prior to more cutting as this may mislead you. Do not discard these earlier proofs as they can be useful later for corrective work, but you need a proof now that is exactly the same as all those in your edition.

Many new to this method of printmaking find this stage confusing. It is tempting to ask, 'What will my next colour be?' This should not be considered at this moment. It is better to ask, 'Where do I want to keep my yellow?', the colour just printed. As you make your new cuts you will be revealing the yellow areas – the yellow sails in the case of the *Regatta* print – and it is irrelevant what actual colour will be covering the rest of the uncut block. Once you have experienced 'making yellow' or whatever colour last printed, you will find this process much easier.

5 Having cut the yellow parts away, the second colour that is to be printed can be considered, which in *Regatta* is a graded blue to suggest a horizon area. The now dry yellow prints are assembled and the printing procedure repeated as before. Testing the blue colour first on spare paper and dabbing it over the yellow with your finger, you will be able to see how one colour affects the other.

6 Often the first few prints are a little weak and it is a good idea to take one or two on proofing paper or the backs of old prints to help the build-up. The extra proofs can be used as stencils later, or for colour testing.

7 The graded blue is cut away and the block inked partially with a small area of red and another of blue. If areas of lino are sufficiently distant from each other, it is possible to print two, even three different colours simultaneously.

8 The dark green sail is printed, having removed the red and second blue areas.

9 Finally, the sea area is etched with caustic soda and the green sail removed.

Look at each print very carefully. At the start of each proofing, check whether bits of lino have been left upstanding where the area should be clear. Try to remove any of these unwanted parts away from your printing work area as the tiny flicked pieces of lino can get into the ink or on the roller. Clean the newly cut parts with a toothbrush and a dry rag. This ensures that you do not get pieces on the inky roller and that you do not reduce the build-up of the ink on the block too much.

As you gradually reduce the surface area of your block to almost nothing, you will find that the roller tends to drop down on to the cut-away areas. This means that you may have to cover these with clean pieces of paper or make a mask, placed down after inking. You can also make bearers of spare lino strips to support the roller either side of your areas to print. Too much pressure and soft packing may make your print embossed, so check the back of your paper and replace any soft packing next to the printing paper with card if this is happening.

Making a Multi-Block Lino-print

The multi-block process of printing can be used in a variety of ways. The blocks can be very small, as in the Easter card (page 150) and freely superimposed. Using transparent inks you gain the benefit of creating new colours, a yellow over blue giving a green, yellow over red, red over blue and so on. In the sunflowers image shown here, several greens were created

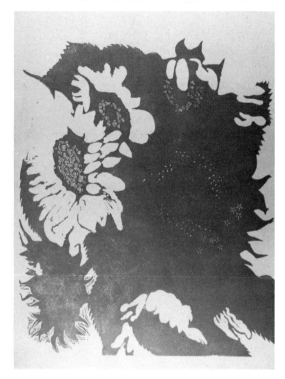

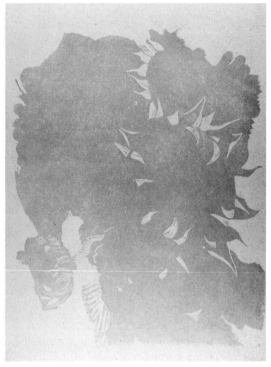

Sunflowers, a multi-block linocut by Carol Walklin. (a) The first printing after experimenting with both the cutting of each block, and varying the sequence of printing, the best results were obtained by printing the mid-green block first.

(b) The second printing: The yellow block is used extensively covering the exposed, white areas of unprinted paper to give a clear 'gold'. It also changes the first printed green where it overprints, so providing a second one. The yellow ink needs only a little thinning down to gain this advantage.

although only one actual green was printed. By cutting out white negative areas on each of the blocks in different parts, the combination of blue over green to deepen it, yellow over green to brighten it and yellow over a blue and green printing has enabled the printmaker to make a rich palette.

Multi-block is flexible and appeals to the printmaker who likes to explore the possibilities of a print rather than the step-by-step progress of a planned approach. With multi-block, you can cut and proof extensively, trying out different colours and, very importantly, different sequences

of printing. The order of printing is of great consequence particularly if you are thinning down the inks and utilizing the creation of new combined colours as described.

To understand the process, start with small pieces of lino and a simple design. Trim three small blocks of lino, making them exactly the same size. Cut from each one a geometric shape such as a triangle, a circle and a square. Draw them so that they will overlap when superimposed. With these three blocks you can experiment using three different

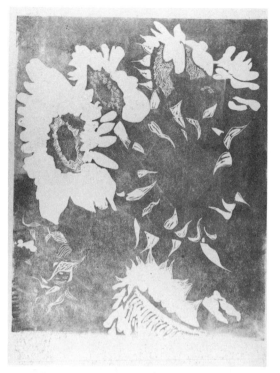

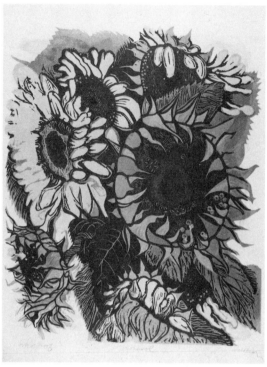

(c) The third printing: Although uncut, the outer edges of the final blue printing are soft as the inked-up lino is rag-wiped to make a more vignetted image, rather than a definite rectangular shape. Where the blue overprints the greens and yellow further variations of greens are made.

(d) The final printing. The completed print all four blocks. The dark brown has been printed last. This block was the original key block used as a guide for the other pieces of uncut lino. After proofing the several colours, the brown block was finally reduced considerably, completing the sunflower image with the addition of stencilled areas to the centres of some of the flowers using an opaque soft brown.

colours. Oil-based inks thinned down with a little oil or thinners will give you the benefit of overprinting. For instance, a yellow printed over a red will give you areas of orange where the two colours overlap. Try varying the sequence of colours, printing wet ink on wet ink and then print a set of proofs from each block as a single colour print and allow these to dry completely. Continue to overprint until you have explored many permutations, remembering to write down the order of colour proofs as you complete each one. It is not always easy to recall

how you achieved the finished print by looking at the final result. You need not use a registration block for this exercise. Draw around the lino-block on a sheet of paper, lay each block in this area and match the paper to the guide sheet carefully each time you take a print.

Preparing the Design

If you are using a picture that has been painted as a starting point, you must

Sunflowers (a) Drawing directly on to the lino-block with pens and brushes.
(b) The key block inked up in black proofing ink.
(c) A print is taken on to tracing paper.
(d) The tracing paper print is transferred on to the uncut lino pieces.
(e) When the printed lino pieces are dry, the surplus areas are carefully trimmed.

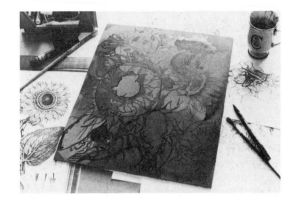

(a)

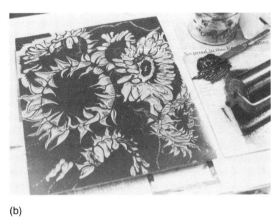

(b)

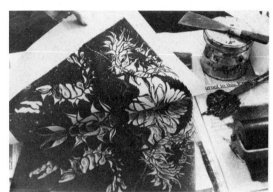

(c)

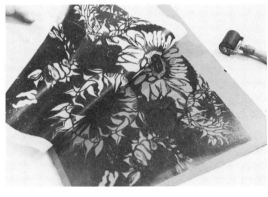

(d)

(e)

consider the suitability of this picture. Think entirely in terms of the lino, the cutting tools and the inks. Your finished print should be a translation rather than a faithful imitation of the original. The lino has its own qualities and limitations and these should be exploited. You will be 'drawing' with a knife not with a pencil, colouring with printing ink, not paint.

Four or five blocks are the average number used for a multi-block print but obviously this number can vary from one project to another. Artist-printmaker Blair Hughes-Stanton (1902–1981) would cut several blocks initially. When these were overprinted he would reduce some of them, cutting away more lino, and use again in another colour. These methods created very rich exciting images but are hard to decipher as separations. It is better just to enjoy their splendid final state. Sybil Andrews' (born 1898) work is much simpler technically, with clear separate shapes overprinted, and these shapes can be picked out easily.

A basic tracing of the design should be made unless you are drawing directly on the lino. It is possible to use this tracing to draw the relevant colour areas on each of the pre-cut pieces of lino. Make sure that you position the tracing accurately, and that the lino has been trimmed so that each piece is identical in size. Another method is to cut one block first; this is called the key block.

Key Blocks

Decide on the size of your image and trim one piece of lino to that size. Trace down your design, reversing the image if needed, or draw directly on the lino. Reinforce the lines with a felt-tipped pen (spirit-based). Cut away the lino either side of the drawn lines, leaving them raised, the unwanted parts lowered. These lower areas need not be cleared thoroughly for at this stage the block is for proofing only. Cut as many pieces of new lino for the number of colours you require, but make each of them at least 1in (26mm) larger on each of the four sides than the key block size. Ink up the key block liberally and take a proof on tracing paper or any paper with a smooth surface. Peel off the proof and put to one side. Take one of the pieces of trimmed lino and lay it flat, then position the wet print ink-side down carefully on to the lino. You may prefer to do it the other way, that is to lay the wet proof ink-side upwards, and place the new lino down over it, making sure that you have covered the proof completely. Slide one hand carefully underneath the sandwich, holding it together firmly with the other hand, and turn it over. If you are burnishing, you will need to use this method although walking over the back of the lino, having first placed a sheet of hardboard on top, can provide sufficient pressure. You are aiming to transfer the wet print back on to the lino with a margin of clean unprinted lino all around, and for the offset print to be clear enough to act as a guide for your cutting. Repeat this process until each lino piece has the offset image on it.

Sometimes your initial proof is sticky enough to be used twice without making a new one, but do not be tempted to re-use it if too weak, as it will not produce a bold enough offset image for your guide. You will have to clean off all of the ink, let the solvent dry and start again. It is probably better to ink up the key block again and take a fresh offset proof for each of the linoblocks.

Allow the blocks that have been offset to dry. The time for this depends on room temperature, amount and quality of ink, but they should be completely dry before you attempt to handle them. The key block from which you have taken your proofs should be cleaned thoroughly.

When the offset lino-blocks are ready, trim them carefully and accurately. When you cut your key block, leave a small portion of each corner uncut and make sure that when you burnish or print the offset image down you transfer these corners down onto the linoblock. These printed corners will help you to trim each block exactly as the key block, particularly if your design is a very open one.

Glue each block on to a backing board, remembering to leave two small extensions for easier handling, then allocate each piece of lino to a colour or colours. Write the colour or initials on one of the extensions, such as 'R' or 'red'. At this stage you are faced with a rather daunting repetition of your original cut, but as you work beside your plan you will gradually sort out the more obvious areas for each colour block. Do not attempt to make a complete cut on any single block. First cut away on all of the blocks any areas that you wish to appear as white paper. Do not overcut at this stage, for it is not until you begin to proof and cut that you will see all kinds of unforseen possibilities emerge.

On one of your blocks, you may intend to reduce it to only a small area which is to receive the colour. Before you cut any large areas away, try either wiping off the ink or covering the inked part in question with a mask of clean paper. If you do not like the result you still have the lino uncut and intact. Masking as you

Autumn Canopy, a free-form linocut by a student. The image is made up from overprinting three lino-blocks, one has the rectangular tree trunk and the landscape image, the other two have the canopy of leaves. The rectangle is printed in blue and the leaves in browns and gold. One leaf block has been used twice and the positioning has been free, laying inked-up blocks to paper.

proof is a very good way of 'trial' cutting. Make a note on each proof of anything you do like this, so that you can refer back to this stage and know how you achieved that particular effect.

It is possible to ink up with more than one colour on one block. This is a method which should only be used when the areas are not close to each other. If they are too near you will find it very frustrating if you overshoot, and the time spent wiping clear or having to ink with much care is better spent in taking the print through a second printing process.

93

However, it is often quite easy to ink up a small separate part or parts, as can be seen on the sailing boats in the *Regatta* print.

You do not have to print a whole edition at one time, as in the reduction method, but can break it up into convenient sessions. You can store the inks if you mix up sufficient quantity for the edition, and store the blocks flat and in not too dry an atmosphere until you want to use them.

The Direct Method

Although linocuts and woodcuts use the positive method – that is cutting away what you do not want to print leaving the raised areas to receive the ink – there is another way of using the same technique but with a different result. The image is drawn directly on to the lino with brush or pen or traced down. The piece of lino from which the print (opposite) was made was taken into the studio where the model was posed, seated on a dais. A brush and felt-tipped pen were used to make the drawing directly onto the lino and, once completed, no further drawing was added. All the drawn and painted marks were cut out with the cutting tool exactly as they appeared, leaving the undrawn parts raised.

Some printmakers like to whiten the lino with a wash of thin poster paint before drawing, but this is entirely a personal choice. It provides greater contrast as you draw but is not something which is essential.

Ink up the cut lino-block with opaque white ink or a very light colour and print down onto a black or dark-toned paper; the image will come back very close to the original drawing. The background

Direct drawing and cutting on lino. Printed in white ink on black paper.

can be any colour providing that it is darker than the printing ink. It is a chance to experiment.

Picasso used this direct method in another way. After cutting with his sweeping and flowing style, he inked up the whole block with white oil-based ink, and then printed this down on white paper. When dry, he flooded the whole paper with black drawing ink which soaked into the unprinted exposed paper. The oil-based ink rejected the drawing ink and was hosed off (in his shower it is said). The final print has fine, flowing lines and an interesting texture created by the rejected ink.

With this method, it is important to print the white or light-coloured ink very densely and evenly. After you have

(a)

Rushbearers. (a) A conventional print using a dark ink on a light background, illustrating the effect of a directly cut block. (b) The lino-block printed as intended using white ink on white paper. When dry, the print was flooded with drawing ink and the excess washed off.

(b)

Seated Girl, a directly cut lino-block by Pat Kettle. The cut block was inked up in black ink, and netting and paper shapes were placed on top. A print was taken and the pieces removed from the block. Without further inking, another print was taken.

printed your image, add a complete frame of rolled ink all around the rectangle, covering and protecting the surrounding paper. If you do not do this you will have a ragged and untidy ink-soaked edge. It is a challenging method but obviously requires a good, heavy paper which will handle well when saturated with water. The damp paper will also need stretching or flattening under weights between sheets of blotting paper to prevent cockling.

Etched Lino

The method of etching lino was discovered by accident. Cooking cleaner fell on to a lino-covered kitchen floor and began to burn away part of the surface. This has since been used in a controlled way by printmakers as a means of acquiring textured areas differing in character from the cut or scratched marks made by tools. It makes the grained nature of the lino even grainer, and also provides a

95

Lino that has been protected with wax-resist and etched with a solution of caustic soda.

A detail of a print that has etched shapes and fine raised lines, which have been protected with trailed melted wax.

tonal quality to the print as the etch can be controlled sufficiently to give degrees of depth.

Cooking cleaner (sodium hydroxide) is sold under various proprietary names and is a jelly-like substance. The usual care must be taken when handling the substance. A saturated solution of caustic soda made from crystals, obtainable from hardware or DIY stores, is stronger and correspondingly more hazardous to use. The average strength of solution would be one teaspoonful of caustic crystals to about half a pint of water. The chemical reaction of caustic soda with water creates heat and the jar in which you mix the solution should be suitable. The mixture should be left to cool before using on the lino-block. Always add crystals to water and not the other way around, and also wear protective gloves. Prepare the solution in, or near, a sink.

Protect the areas of lino that you do not want etched with a resist. This can be of wax, etching stop-out or a wall of Plasticine. Clean and degrease the lino scrupulously, particularly if the block has been used before with oil-based inks. Use methylated spirits or kitchen scourer with a little water or a very thin dilution

of the caustic mixture. This treatment will make the lino readily accept the etch. Stop-out is efficient if used liberally, and its viscosity helps to make vigorous dry-brush strokes. Melted wax can be dripped or brushed on, and a tjanting (a tool used for batik) enables the printmaker to draw fine flowing lines of resist. Make your wax by melting candle pieces or beeswax in a secondary container in water, put over a low heat until runny. An old tin containing the wax, placed in a saucepan of boiling water, is the safest way but make sure that the pan does not dry out. The melted wax should flow freely through the tjanting, and a cloth should be held under the spout to catch the drips as you transfer the resist to your lino-block.

Areas can be isolated by making a wall of Plasticine, ensuring that the wall is fixed firmly to the lino to prevent seepage. An alternative to these positive marks and areas of resist is to draw into the material. Cover large areas with a good layer of melted wax or stop-out. When dry use a sharp tool to scratch

through the hardened wax or stop-out. Brush the etching solution over these exposed parts so lowering them.

Timing plays a part in this technique as the depth of etching will depend on the time allowed for the etch to bite. Some printmakers protect the back of the lino as well as the raised areas, and immerse the whole piece of lino in a bath of solution. If the protection is not adequate, this method can be destructive. Whatever method you choose, it is advisable to apply resist to all edges of your block in case of any arbitrary dribbling.

It is necessary to test both the solution and the preparatory oven cleaner. Take several small pieces of lino and draw out some squares on each one. Number them and apply small amounts of resist, the same on each patch. Write on each one the times of exposure, for example, one hour, five hours, overnight. Wash off each patch

after the time has been completed, avoiding the others. Use cold running water. Any etched areas will need washing and scrubbing with a coarse brush until all the broken-down surface of lino is removed. Stop-out resist is removed with white spirit and the wax with a blunt knife and gentle heat. The heat can be applied with a hair dryer using newspaper and scraping, or you can place layers of newspapers over the block and remove wax with a warm iron. This latter process must be repeated until all traces of wax have gone.

Etching is a very good way of texturing a print when the subject matter, such as rock faces, seascapes, landscapes and so on needs a less bland approach, but the printmaker must treat the technique with great care and take all sensible precautions. Any inadvertent splashing of the solution must be washed off in cold water immediately.

Relief Etching

Although you will be using methods associated with the intaglio process of preparation, relief etching is printed as a wood or linocut, that is by inking up the top, raised surface areas. Some printmakers print their image by combining both methods by rubbing etching ink into the depressions and wiping the plate surface clear. Then they take a hard roller coated with block printing ink and pass this lightly and evenly over the metal plate. This produces rich and interesting effects but it is not an easy process. It requires an etching press with cylinder action and blankets so that the lowered parts of the inked plate can be reached.

However, the printmaker who wants to add another dimension to his linocut

Detail of etched lino showing scratched-through light lines that have been produced by drawing through the resist of stop-out varnish.

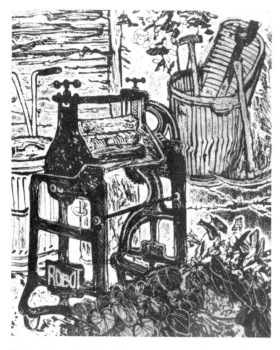

Urban Cat, a relief etching and linocut by Carol Walklin. (a) The completed print. (b) The first stage lino-block printed in light grey with wiped area. (c) The second lino-block with areas inked up in different colours.

can use the etched qualities of the metal – dissimilar to those of etched lino – if the facilities are available. In *Urban Cat* the printmaker has printed the etched plate first, offset the image onto two pieces of lino, cut these in simple shapes and over-printed them using very transparent inks. The dark 'etching' shows strongly although printed first. The final touch has been to add the rose-pink and the tawny cat colours by rolling through small stencils cut from an early proof made on newsprint.

The equipment needed is a metal plate (zinc or steel), brushes and pens, a tray for the acid, an acid solution and protective clothing. The resist can be etching stop-out or any greasy mixture. Lithographic ink has been used for the *Urban*

Cat print and drawn on a steel plate. An 18-wire gauge metal is suitable for relief etching. Zinc is softer than steel and bites more quickly and sometimes has the protective backing ready-made. The back of the plate has to be protected from the acid and any plate must be painted with a good coating of stop-out solution or covered completely with a sticky-backed plastic sheet such as Fablon.

The metal plate must first be degreased with methylated spirits or vinegar. A finger mark will be greasy enough to form a resist and will appear, although weak, as raised lines, receiving some of the ink from the roller. After degreasing use brushes or pens to paint or draw your design directly on to the plate, remembering that the printed image will appear in reverse. Completely cover the metal where you want it to appear as the printed image – you are making positive marks – protecting it from the acid, and thus leaving it as a raised surface.

If you have been working on woodcuts or linocuts for some time you may find that it is difficult to change from cutting

A detail of *Urban Cat*. The etched steel plate shows the grainy texture of the etched metal, the very fine drawn, positive lines and the white, negative, scratched lines.

away what you do not want to this positive approach. Think only of the drawing or painting that you are making and for the time being forget that any printing process is involved.

When you have covered all the areas you want protected, try drawing back into the dry ink. Scrape into the solid areas with a sharp tool such as a compass point. This is not to scratch the surface of the metal but to expose the surface so that the acid will reach it, and bite. Very fine 'white' lines can be achieved in this manner. Once you are satisfied that the image is complete, check that you have backed the plate and paint a little stop-out varnish along the edges of the plate.

Use a dish made of plastic polythene or stainless steel or a wooden tray which has been coated with several coats of bitumen. If the plates are small you will be able to use a photographic developing try. Remember always to pour water into the tray first. Add the acid with great care so as to avoid any splashing and never pour undiluted acid into a dry tray. Respect the hazards of the acid and always work either out of doors or near good ventilation. Do not use glass bottles as the heat generated by the acid can shatter these. Most acid mixtures act faster in warmer weather conditions and the fumes given off as it bites are very poisonous. The brownish gas (NO^2) should not be inhaled and if not wearing a respirator hold your breath when inspecting or feathering your plate.

Recipes

Zinc plates: 10 to 20 parts water to 1 part nitric acid.
Steel plates: 7 parts water to 1 part nitric acid.

Pour the water in the tray or dish and then add the acid gently from a glass or stainless steel measure. Rock the tray very gently to agitate the solution. Using rubber gloves, slowly lower the plate into the acid mixture. Rock the tray gently or use a feather to stroke the surface of the plate. This stroking will be necessary later on when bubbles form on the plate's surface and they must be dispersed so that the biting is unimpeded.

There is no hard and fast rule for the timing of this relief etching process. Therefore, you will need to inspect your plate at regular intervals. Make two strips of metal, coat these well with polyurethane varnish and bend them into a hook. Use these to raise the plate, letting the acid drain off back into the tray. It is in order to wash the plate at this stage so that you can inspect it closely, feeling the surface with your finger nail, as well as looking closely at the bitten surface. Never let the plate drop back into the tray but lower it gently if you think it requires more biting.

The plate can be bitten in one session, which will give you one raised layer and one lowered bitten area. If you require any subtlety of tone or a gradation you will have to remove the plate, wash and dry it thoroughly and then continue to cover other parts of the exposed metal. These protected areas will have been lowered a little before the second application of stop-out and will eventually print as a 'grey'. The first protected parts, if correctly covered, will print the darkest. Those parts which have been exposed to the biting process the longest will consequently be the lowest areas, and will receive the least amount of printing ink.

This approach using tonality is very demanding and it is better to exploit the characteristics of the metal and the act of biting. In the case of steel, it is surprising how a frail, drawn line can be retained, such as illustrated in the detail of the rose bush in *Urban Cat*, where the fierce nature of the etching process has not destroyed the delicate drawing. The etched parts of the metal have a grainy quality and the incised lines are crisp. These positive lines and other qualities could not be obtained in lino or woodcutting, although lino can be etched and printmakers of considerable skill employ their own personal dexterity.

The completed plate should be rinsed well and dried before proofing. The backing should be left on as you may wish to bite the plate further after proofing. Roll the plate up with a hard roller and oil-based ink. A hard roller will deposit ink only on the higher areas of your plate. If you want to reach down lower, making greater use of the grainy, bitten surface, use a softer roller or have much softer packing when taking a print.

If your final image is to be a combination of lino with the relief etching you can take an offset print from your etched plate. Use the same method as described on page 91. When planning your edition you may decide to print the metal plate last over the coloured lino-prints. The order of printing is very important; some printmakers have found that the best sequence is to print the metal plate first and then to superimpose the lino-blocks, using thinned-down, transparent inks. This can result in a pleasing, glowing print. However, each printmaker must find his or her own solution by experimentation, always being sensitive to the original concept.

Your image may have to be reversed if there are significant parts which need to

be the right way round. It is interesting to note that William Blake (between 1788 and 1820) created his own solution to the reversal of printed letter forms. He produced a series of illuminated books written and printed by himself. It is not certain exactly how he achieved these. It is possible that he wrote the text and drew the illustrations on a paper coated with an etching ground on the reverse side. The paper was then pressed against a prepared piece of copper, transferring the image and lettering as a back-to-front drawing. The plate was then immersed in acid and bitten away, leaving the lettering and illustrations in relief. When printed the image was reversed back again to its original form. It was a laborious way of producing the printed pages but the results were both rich and harmonious as the marriage of text and picture was uniquely successful. The pages were quite small – about 3in (7.5cm) by 4½in (11.5cm) – and printed singly, some in colour. The final touches were made with hand-colouring by himself and Mrs Blake.

Relief etching provides an exciting addition to the range of techniques for the printmaker but it is one that requires the right equipment and safety precautions. You should only use this method if all the criteria can be met. Always wear protective clothing, work slowly and carefully and ensure at all times that you have good ventilation.

4 Other Methods of Printing

MONOPRINTING

For a long time, there has been a debate as to whether the monoprint is in fact a true form of printing. Because it is an unrepeatable image some experts have deemed it not a 'print', *per se*. However, in the present decade, the monoprint has become accepted by nearly all the major national and international print competitions since, although it may not be repeatable, it does involve the transfer of ink to paper and the reversal of the original drawing or painting. Many print-makers find it a rewarding technique that has, like any other medium, its own disciplines and challenges.

Monoprints are also referred to as monotypes; they can be made in three basic ways, within which there are variations: random effects, monoprint drawings and transfer (blotted) monoprints.

Random Effects

These are often exciting abstract images created from the practical act of cleaning up an ink-slab during the printing process. When you have been using more than one colour on your slab and begin to wash up with solvent, the movement of the knives and rags make swirls and patches of intermingling colour. A sheet of paper placed upon the colour will blot up the ink. This gives a haphazard result, but if you choose you can control it to greater effect with scraping and wiping.

A random blotted monoprint. The ink has made marks that suggest trees and hills.

Do not use too much solvent for a controlled print as this will soak into your printing paper, but the ink should be sufficiently tacky to blot off well. The choice of paper will influence the result of your print: if it is a hard coated paper it will be less absorbent and the wet ink will behave more explosively; a soft paper will soak up more ink so that the image is more diffuse; and a dampened paper will be even more receptive.

The illustration shows a random print with several colours which have been printed on to a sheet of art paper with a shiny surface. The interaction of ink and paper has created quite precise shapes and the whole has a suggestion of wintry trees and rock formations. These random prints can be put by and used for experimental work, perhaps with a very bold and simple woodcut or linocut as an overprint in one dark colour.

Monoprint Drawings

For this variation you need a smooth surface such as glass, metal or plastic. This is inked up with a very thin coating of oil-based ink (water-based tends to dry out too quickly for this process).

The choice of paper is important as it must be thin enough for your drawing tool to press through to the inked-up surface. A duplicator paper is a good choice for experimental work and finer papers can be used when you have gained confidence.

Roll out the ink so that it is satiny and without any pieces of skin or fluff on the surface. To test whether you have the correct amount, take a sheet of your printing paper and let it fall lightly onto the ink. Lift it up and inspect the underside. Tiny specks of ink are acceptable but if there are definite smudgy patches then reduce the ink. Use a clean roller to remove any excess ink, or wipe the ink slab with a dry rag and roll up again, covering the inked area evenly. Avoid using any solvent at this stage as this will prevent you from getting a smooth coating and you will need time for the solvent to

A monoprint drawing by a student (13 years).

evaporate. It may seem over-cautious to make these fine points but, if you get the ink consistency wrong, you will either have a disappointingly weak image after drawing, or a print with several unwanted inky areas. Time and care spent now will not be wasted.

When you are satisfied with the ink, make a paper frame for your print, the cut-out part being the size of the planned picture. Tape the frame over the ink slab. Your drawing can be just an idea in your head or some direct observation but, if you wish, you can make a light drawing on your paper as a guide. Tape the printing paper at the top over the frame but do not start to draw until you have collected your drawing tools and made a bridge. The bridge is to prevent you from leaning on the inked area and can be improvised with a piece of strong card or a piece of wood, supported at either side by some books. You do not want to be too far away from the paper as it is hard to draw freely; have just enough gap so that you do not make unwanted marks.

Making a monoprint drawing using a bridge.

103

The tools for drawing can be anything providing they are hard enough to press through the paper and not too sharp so that you pierce the paper. A full vocabulary of lines can be produced by knitting needles, pens, pins, scissor and compass points, and different grades of pencils. Card edges, your fingers and modelling tools will give areas of tone. As you try out the different drawing tools, lift the hinged paper and inspect the result; the paper will then fall back in position. This is not for registration, but to ensure that any further drawing will fall on to parts of the slab that still have fresh ink on them. Each mark you draw lifts the ink off, and if the paper moves you might be drawing over a used area and the new mark may consequently be weak.

The quality of the monoprint line-drawing is soft, slightly fuzzy and can appear sometimes like a lithographic drawing. If the paper you use is textured this also makes the broad areas of printing chalky in character, as if drawn with a crayon. The soft blurred quality of line is unique, but if you want really fine lines with sharper definition, a pinpoint or a needle set into a holder will produce this.

When you are satisfied that you have taken off all your ink with your drawing, remove the paper carefully and allow to dry. This does not usually take long as the amount of actual ink on the paper is small. You will have a reversed image from your drawing and on the ink slab you will see a negative image where the ink has been removed. Sometimes another print can be burnished from this if the ink has been a dark colour and is not all used up, as may be the case if you have made a simple line-drawing.

It is possible to use more than one colour. The initial inking can be done in

A monoprint drawing in red and green.

several colours so that you have a thin, multi-coloured slab. All the drawn lines will also be multi-coloured. Alternatively, add colours one at a time. While the first print is drying, clean the ink slab thoroughly, dry it and roll up with another colour. Replace the frame after testing the ink. Tape the dry print over the new ink and draw where you want the second colour. You can print several colours in this way but always let each print dry before proceeding to the next one, as some of the previous print is lost by offsetting back onto the slab. Too many colours can spoil a good monoprint, making the result heavy, and four colours are about the maximum, but printmakers should experiment to find out the best number for their particular needs.

The second version of producing a monoprint drawing involves the same basic materials: paper, an ink slab and oil-based inks, but more ink is applied this time. The image is wiped away from the inked-up slab with rags, brushes, drawing tools and dental toothpicks,

A monoprint using the wiping method with rags and brushes, and also using wooden toothpicks, by a student.

nylon and scrim make their own characteristic marks, and a little solvent on cotton or a bristle brush will make a cleaner area which will appear as the paper colour on the monoprint. Degas used rag to wipe his copper plates that had been coated with dark etching ink, but he also added ink with a brush as positive marks before printing on an etching press. He also added pastel drawing to some of these monotypes, particularly on a second, weaker print which had been taken from the initial plate.

The Transfer Method

This method is similar to the random method in that it is achieved by placing the printing paper directly down onto

Flowers in the Vallauris Jug, a monoprint by Mollie Russell-Smith.

etc., exposing the slab. Replace some of the ink with knives or brushes, but basically draw into the ink itself. Place the frame over the slab then the printing paper, and burnish off your print. The paper used can be thicker than for the previous method and it can be dampened also to make it more receptive to the ink. If you have hinged it to the frame and slab, you can replace it after adding more ink, and continue with the burnishing action until satisfied.

The type of cloth used to wipe the slab will give quite different results. Linen,

the inky surface and blotting off the monoprint image. It differs because the ink or paint in this instance can be carefully controlled. The image to be printed is painted on to a piece of lino, metal, glass or plastic, with oil-based inks or oil paint. Acrylic paint can be used so long as a retarder is added to prevent the colour drying out too quickly. The coloured image, when complete, is covered with the printing paper and passed through a press or whichever printing process is available. If the ink has been put on over-generously, it will spread out under pressure; this should be avoided. With the drawn monoprint, it is usual to ink the slab partially and use a frame to create the rectangle of the picture. With this transfer method, the whole inked or painted surface is to be the image, and so no frame is needed. The print will automatically have a clean surround.

If using lino, you can first print an all-over background colour. To do this, cut two pieces of paper to an identical size. Place the un-inked block in the correct position on one of the pieces of paper. Draw a line around the block and mark where the top of the paper is in relation to it. Ink up the block in a neutral colour, one that is harmonious to your planned monoprint, and place it back on the block guide. Lay the second piece of paper exactly over the first piece and take a print. Peel off the print and, if it is not strong enough or is patchy, repeat the process, being careful to match the paper each time. Mark the top of the print and leave to dry. Lift up the block but do not clean it. Paint the picture not too thickly with ink or paint. When complete, place the block into the drawn guide. Take the dry, printed background and match the

top and side edge of both sheets of paper. Hold the lower edge of the printing paper high and free of the inked block until you are sure that the two sheets of paper are in line. Then let the top paper fall down on to the block. If you keep the free hand high and the holding hand firm, you should achieve good registration. Never try to move the paper once it is down. If it is slightly off register it is possible to do some correction after the print is dry.

If the image is a little weak in parts, it can be touched up with more ink or paint while still wet. Depending on the quality of the paper, the print will absorb some of the oil-based ink. If too much oil has been used to dilute the colour, it may seep out. Dampening of the heavier papers can assist the receptiveness of the surface and, if trying to get a second print, a damp, soft paper will remove as much of the remaining colour as is possible. The plate or block is then cleaned ready for re-use.

Water and oil-based inks can be used simultaneously, or oil paints and gouache. When this is done, interesting textures are created by the antipathy of grease to water. Although all these processes might be described as painterly, they do employ the transfer of colour as a print on paper in quite a unique way, and offer the artist-printmaker a whole range of variations which can be both dramatic and subtle.

PRINTING ON FABRIC

In the Third World, craftsmen have been printing on fabric with wood-blocks for centuries. In the 1930s, lengths of hand-printed fabric were produced from

mounted lino-blocks, and this process can be used successfully today.

You will need a wooden base on which to mount the lino to facilitate handling and to keep the cut block rigid; fabric inks or dyes; suitable fabric and a printing table. The blocks can be made even more receptive to the ink or dye by flocking. A thin layer of glue is applied to the surface of the block and dusted with flocking powder while still wet. Once dry the excess powder can be blown away and the block is ready for printing.

The inks can be dyes, in which case you would use a sponge or felt printing pad, pressing the block down into the wet dye, but this is only useful when the block is comparatively small. For larger work, use fabric-printing inks, which come in tubes similar to oil-based inks used in paper printing, and can be applied with a roller. Inks with an oil base designed for paper are waterproof and can be perfectly adequate if you do not have those marked specifically for fabric printing, but they may not be as durable as fabric-printing inks or dyes. Dyes will require fixing by ironing or by a fixing agent sold with the dye product.

All fabrics should be washed and ironed before printing as they contain some kind of finish which, if left in the fabric, might affect the even distribution of the colours. Closely woven fabrics, or ones that do not have a too heavily textured surface, are best.

Fabric-printing blocks are always placed ink-side downwards onto the fabric and struck with a mallet if hand pressure is not enough. A simple printing table can be devised by covering a large piece of board or old table-top with several layers of blanket. Wrap the blanket right around the edges and fasten securely

A flocked lino-block printed on linen in two colours by Isabel Jeffries.

underneath. Cover this with a sheet of plastic sheeting and fasten in a similar way. If the fabric is fine, you may need to fix this down evenly with a little gum arabic, equal parts of gum to cold water. This solution should be brought to the boil, allowed to cool and applied very sparingly with a squeegee or thick card edge. When dry, iron on the fabric, making sure that the warp and weft threads are parallel to the edges. It is important that there are no wrinkles or creases in the fabric as these will affect the finished print. This coating of gum will last for only one printing session and should be washed off with soap and water. There are proprietary brands of adhesive but, if none are available, masking tape will suffice, again taking care to get the threads parallel before commencing to print.

If you want to use a very fine fabric, pin it over a piece of unbleached calico. This will soak up any dye that might flood through as you print. This should not happen if using the printing ink or dye sparingly. Again, all distortion of the threads must be avoided and the fabric must be stretched or pinned, using the

selvedge, if you have one, as the first, lower edge to be secured. Stretch the fabric upwards towards the opposite edge. Keep the selvedge parallel with the straight side of the printing table. Then stretch the fabric the other way, checking the direction of the threads.

When planning a repeat design, mark out your fabric with chalk lines. Rub tailor's chalk into thin string and stretch across the secured fabric, following a prepared plan on paper. Fix the end of the string firmly with a pin, stretch the string taut and pluck it so that it hits the fabric leaving a chalk line. Recharge the string and repeat the process making a grid. The chalk can be brushed off easily after you have printed. Two people working together can make this process easier.

The design should come right to the edges of the mounting block so that you have more control visually for positioning. As you cannot see the actual block, either mark one corner for indentification or paste a rubbing (the same way around as your block) on the upper face. This will help you to know where the image is falling. A trial run on paper is recommended, particularly if you are going to use more than one colour. Proofs on acetate or tracing paper are helpful if planning a design which involves registration or significant positioning.

An alternative to using a printing table is to use a platen press. This works well on smooth fabric, including synthetics, so long as they have been secured well and have the threads even and parallel. The blocks should be laid ink-side down and the fabric have some padding placed underneath, such as a rubber blanket or layers of newspaper.

Dyes can be thickened by adding cold-water paste. Make a thick and creamy-textured mixture of wallpaper paste, whisk until smooth, then add the dye. If keeping, store in a cool place adding a drop of washing-up liquid to the mixture.

5 Printing with and without a Press

THE WORKING ENVIRONMENT

To print efficiently you will have to give careful thought to the arrangement of your workspace. The corner of a living room can be adequate, or a kitchen table. If you intend to have a printing press the larger ones are very heavy and must have firm flooring. Smaller, proofing presses and wind-down presses can be secured to a strong table top or bench.

Your work surface may have to be used for drawing, cutting and inking, also for printing if hand burnishing. It should be sturdy and as large as possible. If using one table for all these processes you will have to clean down thoroughly after cutting and before printing, removing any lino or wood chips. Use a stiff brush for cleaning the blocks and sweep up any particles that otherwise might get into the ink. Plan the table-top so that you have all the inking apparatus to the left, the printing area in the centre, and the printing papers on the right side. The papers and prints must be stored flat and cleanly either on an open shelf, under a table or in a plan chest.

A good working environment should have space, natural lighting as well as artificial, easy access to water and an even temperature. You should make stands to hold the rollers so that they make no contact with any surface. They

A purpose-made drying rack using glass marbles. Gravity holds the prints in place between the marble and the socket. Prints can be hung back-to-back to double the number drying. Other methods include bulldog clips strung on a wire or screwed to wooden battens, or spring pegs fixed in a similar way. The metal clips should be lined or protective papers used to prevent any rusting.

can also be hung up on cup-hooks by inserting screw-eyes into the end of the wooden handle. Prints can be dried by attaching them to a clothes-line with wooden or plastic clothes-pegs. Moderately cheap ball-clip racks are also available from artist suppliers.

PRINTING PRESSES

There is no doubt that the Chinese practised printing in some senses of the word many centuries before it was known in

Europe. No press was used, the block being adjusted on a table before which the printer stood, having a bowl of fluid ink on one side and a pile of printing paper on the other. In his hand he had two flat-faced brushes, fixed on the opposite ends of the same handle. One brush was dipped into the ink and swept over the face of the block. A sheet of paper was placed on the block and the back of the paper was then swept lightly and firmly with the brush on the other end of the handle.

The earliest known illustration of a printing-press is dated 1507 and it shows an apparatus which is not very different from a modified winepress. The essential feature of the press is the flat board, later called the platen, which has a vertical movement. The platen is lowered onto the forme of type or, in the case of a pictorial image, the block which is positioned on a firm base. These two surfaces are brought together with the printing paper in between by means of a powerful screw. This very basic apparatus was refined, reaching its ultimate degree of perfection in the latter part of the seventeenth century.

Charles Mahon in the 1800s designed a much improved press as it was made entirely of iron, enabling a forme to be printed double the size of that done with the wooden version. In the same decade, an American designer discarded the screw action, previously the central feature of the hand-press, replacing it with a combination of powerful levers. This was called the Columbian Press and many exist to this day, still working efficiently and much sought after by printmakers throughout the world.

In the 1820s, Cope of London produced a new press called the Albion. The pressure was obtained with this design by an inclined steel bar which was forced from the diagonal to the vertical, so bringing down the platen onto the forme of type or block. Like the Columbian, the Albion Press is no museum piece but a genuine working press much treasured by their printer-owners.

In the late eighteenth century a press had been invented to couple together both paper and fabric printing. Adkin and Walker patented a machine which was similar to the modern rotary letterpress machine, printing on both paper and calico. About the same time, William Nicholson took out a patent which foreshadowed the most advanced printing machines of today. His idea was for an apparatus where the formes or blocks (plates) were to be fastened to a cylinder. The ink was supplied by another roller and distributed by several smaller rollers over the image. The paper was made to pass over the inked-up image on the

An Albion press

A wind-down press.

cylinder between another, covered with cloth or leather. From this basic principle most modern fast printing presses have been developed.

Producing relief prints with a press requires less time and effort than printing manually, but presses like the Albion and the Columbian are difficult to find and expensive to buy. Some art schools and Institutes of Adult Education have their own presses and run classes and workshops for all abilities. Because of the gaining popularity of lithographic methods, used commercially by many printers, it is possible to obtain proofing presses in varied sizes at reasonable prices.

Platen Presses

The bed of the platen press, such as the Albion, is propelled by the turning of the handle from its resting position to be directed under the centre of the platen. Sometimes there is a mark on the travelling bed which indicates the stopping-point. Some presses have a tympan, which is a hinged frame covered with parchment or canvas, and this can be used in conjunction with a frisket. The latter is used for registration, particularly bookwork. Special pins hold the printing paper secure and packing can be inserted

An Albion platen press.

between the two layers of the tympan. For printing lino-blocks positioned on a registration board and covered with appropriate packing, you do not require the tympan. The platen is lowered onto the block by pulling the handle towards you until it has reached the full swing. Never let go of the handle but return the lever to its resting position, still holding on. Leather or webbing straps drive the bed on rails which must be kept well greased.

If metal or wooden type is being used you will need a chase and furniture. This is locked in securely with special quoins and their appropriate key. If done properly, the chases can be lifted up and stored, making sure that the blocks and type are not damaged or bruised in any way.

111

A mangle.

Screw-Down Presses

A simple version of exerting vertical pressure can be found in the screw or wind-down presses. These are difficult to find now as they have antique value, but presses of this design are still made for the purpose of bookbinding. Any press with a screw action requires a sandwich of boards between which you place the inked-up block and printing paper. If the underside of the platen has been worn or is rusty and is therefore uneven, soft packing such as newspapers should be placed directly on top of the printing paper and under the top board. The platen is wound up to allow the sandwich to be carefully slid underneath, and then screwed down until tight. The screw is reversed and the boards with the print and block is removed.

These presses vary in size but it is possible to do a piece of work longer than the length of the platen by doing the printing procedure in several stages. With most presses of this kind you will get the best impression from the central area of the platen. If you release the pressure, slide the sandwich forward a little, screw down, release and repeat this feeding action, you can achieve a print of greater length. For safety, always secure a screw-down press to a table with two wooden battens about 2in (5cm) by 1in (2·5cm) nailed to the bench at each end of the press. If you cannot use nailed battens, place a piece of rubber-backed carpet underlay or a rubber non-slip bath mat underneath the press. This will reduce the danger of slipping when winding down the platen.

Cylinder Presses

Cylinder presses come in two forms. In one the roller passes over the inked-up block making the impression on the paper as it makes contact. These are proofing presses at their simplest and come in a variety of sizes. As printing technology progresses many commercial firms are discarding their proofing presses, which can sometimes be obtained by the artist-printmaker. They are efficient but difficult to transport and house. Smaller versions are still made by some craft and typographic suppliers.

The other type of cylinder press is used mainly for intaglio methods. These presses have two cylinders with a plank or bed in between. The block or plate is

placed on this bed and wound through with a geared fly-wheel. The two rollers remain in a fixed position and it is the block and paper that passes between them. Some of these intaglio presses can have their upper roll raised sufficiently to take a lino-block or wood-block, but others are more restricted. It is not the ideal method for printing relief blocks, certainly second best to a platen or proofing press, as the paper can slide with the squeeze of the pressure from the rollers. Placing bearers of the same height as the block to surround it can help, providing the whole bed area is filled.

A mangle works on the same principle and can be converted for printing relief blocks. Old mangles must have good springs which are still flexible and the rollers and bearings should be in good condition. Damaged rollers can be repaired with a sleeve of plastic or metal as there is usually greater wear in the centre of a much-used machine. If not too extreme, this can be compensated with soft packing placed next to the printing paper. A sandwich of boards with the block and paper in between is wound through to make the impression.

PRINTING WITHOUT A PRESS

Not everyone has access to a press and producing prints by hand is an ancient and efficient method, which has positive advantages as you have complete control over the pressure. The density of the ink on the printed image is obtained by the amount of pressure applied to that particular area. This regulation enables you to bring out any subtle tonal qualities which would be impossible if printed in one movement of a cylinder or platen press. A series of indentical prints are possible if you set up a working environment with all your inks and equipment, paper and masks – if using them – at the ready for the editioning session. If you cannot complete a set, make detailed notes as to colour mixtures or individual treatments of the block.

The process of printing by hand is usually referred to as burnishing or frotton printing. Burnishing tools are anything from a bookbinder's bone to the back of a spoon. Whatever the tool, it must be smooth. Many wood engravers use a modelling tool made from boxwood, polished with a very fine sandpaper. A clean inking roller can be used for larger areas, but the burnishing tool enables you really to feel the block and give special pressure to particular parts. A Japanese baren is favoured by some printmakers; it is a large bamboo leaf wrapped over a round flat lacquered plate made of many (up to forty) layers of paper glued together. The leaf is knotted at the back to form a handle, which is grasped firmly with all the fingers tucked underneath. The whole surface is pressed down on to the back of the printing paper and is used with a smooth, circular action, starting from the centre of the print and working towards the outer edges, keeping the baren quite flat all the time.

The Japanese printer traditionally sits on a mat cross-legged, and uses his body-weight to help him print. Alternatively he will use a table which slopes away from him, over which he leans. On some Japanese prints you can just see a faint circular rhythm to some of the printed colours, caused by the action of the baren.

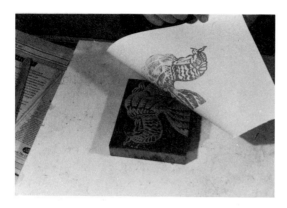

Inspecting the progress of the burnished print.

The printing paper can be held down with weights or taped to a backing board. Inspect the progress of the print from time to time by holding it down firmly at one edge so that it does not shift and looking at the underside. Let the paper fall back into place and continue to burnish if necessary. If the image is too faint in parts, flap the paper back, securing it with weights or tape, re-ink the part that requires it, replace the paper and continue to burnish.

Metal or wooden spoons are efficient burnishing tools; modelling tools are best used with two hands, so secure the printing paper well before starting. One hand can control the pressure while the other guides the tool. Always protect the back of the printing paper with another thin sheet so as to avoid tearing or smearing should some of the ink come through. A dusting of talc will help to reduce the friction between paper and tool.

Standing Pressure

Large blocks can be printed with standing pressure. All you need for this is a pad of newspaper under the block and a level surface. The inked block is placed down and covered with the printing paper, more newspaper, then a sheet of cardboard or board is laid on top. Tread evenly all over the block and inspect the print before removing the paper. The procedure can be reversed by placing the inked-up block face down onto the printing paper, treading over the back of the block. If the block is unmounted and flexible it is possible to get more ink off this way, but each printmaker must devise the method best suited to the equipment available and the premises.

Very large linocut images have been produced by using a garden roller. It is reputed that a well-known artist placed one of his lino-blocks in the middle of the road and drove his car over it to make the print. This is feasible providing that you place a board over the whole block and some kind of incline to take up the pressure. I devised another way of printing outsize blocks by placing the inked-up lino-block on the floor on a piece of hardboard on which had been drawn a guide-line for the placing of the block and registration marks for the paper, as there was to be more than one colour printed. The printing paper was placed in position and covered with some large sheets of newsprint, and a thick piece of card on top. A 4ft (1·2m) length of heavy-duty piping 6in (15cm) in diameter was positioned across the block at one end, and a large drawing board placed on top. I knelt on the board which was raised at the free end by my partner and was trundled forwards over the length of the block. In this manner the piping rolled over the whole area of the block giving a most acceptable print.

6 Inks and Rollers

INKING

After the relief block has been completed you will need to apply ink to the raised areas. Paper is laid on to the inked surface and an impression taken, or a print burnished by hand. The ink is transferred from all of the raised areas on to the printing paper. For this process you will need inks, an inking slab, palette knives or old knives, rollers, rags and solvent.

Inks

Two kinds of ink are suitable to print a relief block: water-based and oil-based. Both have their particular qualities and drawbacks and some are best used with certain types of block. The ink most used by contemporary printmakers for lino-cuts, woodcuts and wood engravings is oil-based printing ink, although the traditional ink for the Japanese wood-block is water-based and comes in the form of paint. These inks are made from dry pigment blended with a rice paste and applied to the wood-block with a special brush; no rollers are used. These classic blocks were made of cherry-wood, which does not swell when wet as much as some other woods.

Water-Based Inks

These inks tend to fade but if they are used for work such as greetings cards, letterheadings, etc, this tendency will not matter. Book illustrations are normally kept from strong light so can be printed with water-based ink if preferred. They are translucent enough to be printed over one another to create a wide range of other colours. Inks are cleaned with water and rag, but use cold water if using rollers that are covered with gelatine or plastic.

Water-based inks can be purchased in tubes, but if these have been manufactured for children's use in schools, they are made from coarsely-ground pigments that give an opaque print. Dilution with water or even an extender will not give the artist-printmaker any kind of translucency. They can be used with rollers but dry quickly, especially in warm weather conditions. Some artist suppliers do stock artists' grade water-based inks, which are sold in tins and tubes.

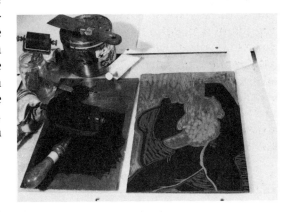

The working area ready for inking: inks on the left, the block in the centre and the printing paper on the right.

They have their own extender and tinting mediums but the tins tend to rust badly, particularly around the lids, and the inks are better transferred to small screw-topped jars with some plastic film between the lid and the ink. Artist grade tubes come in a wide range of intense, transparent colours and store well. Ordinary powder colour can be mixed with petroleum jelly to make a useful ink, particularly for monoprinting. Washing-up liquid added to powder colour is also a mixture that can be used with a brush or roller but should not be applied to card or paper blocks, as these rapidly become soggy and disintegrate. This ink-mix has fluid, painterly qualities, particularly if you blend in more than one colour at a time. De-grease new or previously printed lino before using any water-based inks.

Oil-Based Inks

This type of printing ink is a greasy or oily compound in which solid pigments are held in suspension and it is different in appearance and in composition from drawing inks. It must have good distribution and spread out evenly in a layer, not filling up the hollows and cut-away parts of the block, and must be capable of attaching itself to the paper's surface when the block is pressed upon it. It should also have those properties that will enable it to dry on the paper eventually, but not too quickly as this will harm the rollers and the inking slab.

Oil-based inks used in lithography, offset printing and letterpress are all suitable for relief printmaking. Letterpress inks are used the most and come in tins, tubs or tubes. The tubes are often labelled 'Block' or 'Printing Ink', but note

whether it says 'oil' or 'water', as they come in both forms. It is most economical to buy the basic colours such as white, black, scarlet, ultramarine, blue, yellow and crimson from commercial ink manufacturers, and to add to these the more expensive tubes of finer colours such as viridian, monastral blue, ochre, magenta and so on. Small additions of these to your commercial inks will give your palette a wide range. Pantone colours come in eight basic shades which can be mixed in various proportions. A chart provides a good guide to colour-matching with exact recipes.

Contact with air forms a skin on the surface of any oil-based ink, but if the tops of your tubes are kept well wiped they can be replaced more securely and no skin will form. Tins and tubs are more prone to skinning and you should always take the ink out carefully and replace firmly the plastic disc which some manufacturers provide, before putting the lid back. Some skinning may occur and these small bits get into the inking area and then onto the roller and finally your print, and should be avoided. Pieces of skin should be removed from the inking slab and the roller with a clean knife. If they appear on the print, lift them off very carefully before they dry, as once dried they will be immovable. The ink-specks show as a dot with a ring of unprinted paper around them. When you have removed the speck from the wet print, dab the space left with the finger-end or with a cotton bud, spreading the existing ink rather than adding any more.

If the oil-based ink is very stiff, it can be thinned with a variety of thinners. Use drops of etching copper-plate oil or a proprietary extender such as Tinteen.

Obtain really transparent overprinting by reducing the colour, not in intensity, but in density, using quite large proportions of reducing medium. A little light magnesium carbonate BP powder mixed with the ink will give it more body as the dilution tends to make the thinned-down ink slippery.

Oil-based inks dry by evaporation and absorption by the printing paper. Printmakers rarely find the need for retarders – that is a medium that slows down the drying process – but if working in very hot conditions that need may arise. Adding driers to accelerate the drying process is not recommended as the printed ink changes in composition, dries very hard and forms an impenetrable surface which is not ideal for any subsequent overprinting.

Inks are mixed on a smooth surface such as plastic, glass or metal. If the surface is light-coloured or a sheet of white paper placed under the glass, you will have a better idea of the colour values as they are mixed. More than one inking slab is needed, one for each colour and an extra one for use as a mixing palette. Another is used for rolling out the mixed colour. Mix the lighter colours by always adding colour to white. If you add white ink to a dark colour and it is not quite as you wish, there would be considerable wastage, as it would need enormous amounts of white to lighten the ink back to the colour you need. Little dabs of colour added to white ink or lighter colour is far more efficient. If there is a puddle of colour which is not correct, put it in a small jar and cover it with water to use at another time. Alternatively, place the ink in the centre of a square of kitchen foil, fold this into a packet and submerge in a plastic pot or jam jar. Cover with plenty of water as there will be some evaporation if left for any length of time. This will keep and may well be a useful start or addition to another colour-mix.

Old knives can be used for mixing the inks but a flexible palette knife or a decorator's paint-stripping knife are better for the actual blending, using a figure-of-eight action. Always use a completely clean knife when taking ink out of the tin. Skim the ink off the surface rather than digging down at the side of the tin or tub. Smooth back the plastic disc or covering before replacing the lid firmly.

The mixed ink should be taken up with a square-ended knife, spread as a horizontal line across the centre of a clean inking-slab, but not right to the edge. Look at the width of the roller you are going to use and this will give you a correct width guide. Begin rolling this out by passing the roller through the ink to the top of the slab but lifting it before you reach the end. Start again at the bottom and lift again as you reach the top. The roller will spin, and the repetition of this action will ensure an even coating of ink on the roller. Aim to make a smooth, even rectangle of ink, a square

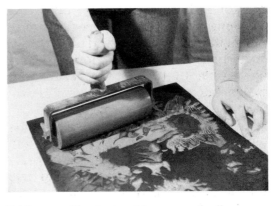

Inking up with a large rubber-covered roller.

the width of the roller but avoiding the edges. The reason for this is that some glass slabs have a rough edge and although these can be covered with a tape binding, they can cause damage to the roller. If you have the nearest edge of the slab covered with ink, it is all too easy to get this on your clothes as you work. A clean rectangle of rolled-out ink, with a clean surround of slab, combined with another slab with the stock of ink-mixture, is the ideal working environment. Do not replenish the ink by dipping the roller into the puddle of ink but use a knife as before.

ROLLERS

Rollers vary in their coverings and price. Hard-wearing rubber rollers can be used with both oil-and water-based inks. They can be washed with water or white spirit. Gelatine rollers are not ideal for water-based inks, partly because of the problem of cleaning as only cold water can be used. They are less durable than plastic or rubber and can be easily bruised or dented. Plastic-covered rollers get spongy with age and wear, but are all-purpose and can be renewed using the original frame. For large blocks or rough surfaces, the rubber covering is best, but the plastic kind is better if there is a need to get down into the lower surfaces of the block.

Wood engravers usually prefer a firm, plastic roller and oil-based inks and use the roller very lightly with a gentle building-up of the ink. Linocutters and woodcutters, with larger areas to cover, have a more vigorous approach. These blocks may need several applications of ink, recharging the roller, rolling in more

than one direction, and paying attention to the edges. The quantities of ink will vary according to the block's needs; a new block will need several impressions before the ink has built up well enough for an edition to be printed. The roller should make a hissing sound rather than a squelch as it passes over the inking slab; your eye and ear will tell you if you have the right amount of ink on the slab and disposition of ink on the roller.

Light-coloured inks show up well on a dark wood-block or brown lino. It is more difficult to roll up dark colours efficiently and you may have to angle the block to the light to see if you have coated it thoroughly enough and if it is ready to print. More than one colour can be inked up at one time providing the areas are separated from each other. This 'spot' inking is very useful if you have many colours to print, reducing the number of times the paper has to pass through the press. However, it can be a short cut you may regret if the coloured areas are close to one another, and the time wasted in wiping or avoiding parts of the block might just as well be spent taking the print through the press in a separate action.

Colours can be graded one into another, going from dark to light or colour to colour. This is a relatively simple procedure with exciting results. You need a roller wide enough to travel across the block carrying the inks, so that if you wanted to have a sky-colour at the top of your picture, followed by a lighter area blending into a mauve, and then a green, you would have to have a roller that can travel from left to right across the whole width of the block.

Mix the three colours and place a dot of each ink in the sequence you have

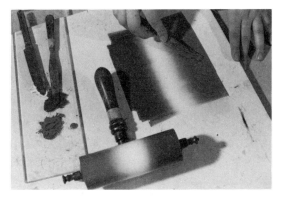

(a)

(b)

(c)

Graded inking. (a) Place the different coloured inks in small amounts across the centre of the inking slab. (b) Spread the ink evenly by rolling in one direction. (c) Transfer the gradated ink on to the lino-block.

planned across the width of the slab. Leave a small space in between each colour. Place the roller at the lower edge of the inking-slab and sweep it up nearly to the top. Start again at the bottom and begin to distribute the ink. Lift the roller, letting it spin but keeping it level. Move the roller a little to the right, then left, so that the blending is soft and complete. Gradually the colours will merge. It will take some practice but is worth the effort. If you do not have a roller large enough to cover the whole area you wish to ink, get as much of the grading as possible onto the lino, using a second roller to make up the area, using the same part of the inking-slab. Always replace the roller in exactly the same position on the slab.

Blending is a way of distributing several colours with several rollers, one for each ink, letting them merge and mix. This produces a soft effect but is hard to control when editioning. The merging increases with each print as the rollers inevitably pick up some of the neighbouring colour, and at some point the block and rollers will have to be cleaned and a fresh start made.

SOLVENTS

Water is the only solvent necessary for water-based inks or paint but it must be cold when used with plastic or gelatine rollers. Paraffin or white spirit will clean any oil-based inks and not harm any roller. Rollers that have not been cleaned properly are spoiled. Particular attention should be paid to the edges as if these are not cleaned thoroughly the ink will harden to form a rim which will leave lines on your block as you ink up.

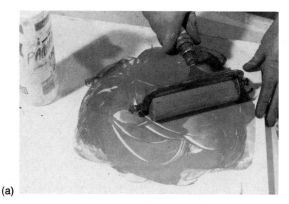
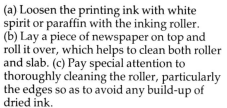
(a)

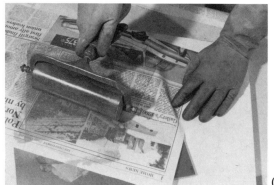

(b)

(a) Loosen the printing ink with white spirit or paraffin with the inking roller.
(b) Lay a piece of newspaper on top and roll it over, which helps to clean both roller and slab. (c) Pay special attention to thoroughly cleaning the roller, particularly the edges so as to avoid any build-up of dried ink.

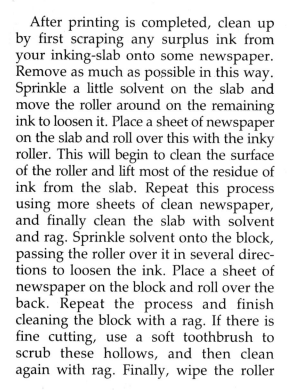
(c)

After printing is completed, clean up by first scraping any surplus ink from your inking-slab onto some newspaper. Remove as much as possible in this way. Sprinkle a little solvent on the slab and move the roller around on the remaining ink to loosen it. Place a sheet of newspaper on the slab and roll over this with the inky roller. This will begin to clean the surface of the roller and lift most of the residue of ink from the slab. Repeat this process using more sheets of clean newspaper, and finally clean the slab with solvent and rag. Sprinkle solvent onto the block, passing the roller over it in several directions to loosen the ink. Place a sheet of newspaper on the block and roll over the back. Repeat the process and finish cleaning the block with a rag. If there is fine cutting, use a soft toothbrush to scrub these hollows, and then clean again with rag. Finally, wipe the roller thoroughly, making sure that the edges are quite clean and free of any ink.

When cleaning, use a barrier cream or protective gloves and have good ventilation. Industrial hand cleaners are effective but the hands should be rinsed well after use. A washing-up liquid bottle makes a good container for solvent, enabling you to apply it sparingly, but never put solvent in a bottle that is associated with a drink. After cleaning is completed, have a large dustbin liner available in which to put all waste paper and saturated rag, and remove it as soon as possible from the working area, remembering that many of your materials are inflammable.

7 Printing Papers, Registration and Corrective Work

PAPER

Paper is made from matted fibres which have been brought to the right consistency by boiling and beating. The fibres can be from linen or cotton rag or from many kinds of vegetable matter, reduced to a liquid pulp. The sheets of paper are made in a mould, which is a form of tray with a fine-wire grid base, and the sides, the deckle, are removable. The wire comes in two patterns. One is 'laid' which can be recognized by slightly paler lines made by the thinning of the pulp where it touches the thin, laid lines, and the thicker chain lines of crossing wire, which can be seen when held up to the light. The other is 'wove', which has a much closer, more even mesh, and has an irregular mottled appearance.

There is no single type of paper that meets all the various requirements of the artist-printmaker. Therefore, selecting the right paper for the job is of great importance and is a practical as well as a creative process. The paper on which you print your image is as important as the quality of ink, the skill of the cut or collage, and the concept of the design. It is an integral part of the whole image. As the unprinted parts are as vital as those that received ink, the colour and surface texture must be considered with care.

Hayle Paper Mill, depicting paper-makers and a blanket boy.

Proofs can be made on cheap papers such as newsprint or duplicator. These prints are to inform you of the progress of the cutting or collaging, the state of your block or paste-up. All these progressives are useful and should be kept until the final print or the project has been completed.

The nature of your block and the character of the materials you are using will guide you to the right kind of paper. A coarse block such as a freely cut woodblock or a piece of driftwood will print well on a soft paper if the right pressure is used, which will pick up all the nuances and textures of the inked-up block. A fine wood engraving would be

121

unsuited to this kind of paper and needs a smoother surface for the detailed work to appear clearly.

The character of the block having been considered first, the printing process to be used should be your next consideration when deciding on the right type of paper. If you are hand-printing by burnishing, the paper must be thin so that the pressure lifts off enough ink to make a satisfactory final image, and there should not be too great a barrier between the burnishing tool and the inked-up block. If you are printing with a press, adjustments can be made with packing and pressure, but the actual surface of the paper still has to be taken into account. It is not only the colour of the printing paper that will alter the appearance of the printed image, but the actual surface.

Papers used for editioning relief prints range from fine Japanese hand-made papers to experimental papers such as sheets made from Brussels sprouts, montbretia and other fibres, which produce nubbly bits and texture. There are many European hand- or mould-made papers and these are used widely for editioning. Machine-made papers consist mainly of wood pulp and sulphite and have no great lasting value but are useful as proofing papers. Many of these discolour with age and grow brittle, but their value for proofing is great. Newsprint also has the advantage of being porous enough to use for blotting over-inked prints, or for blotting to reduce the shine or quantity of printed ink when editioning.

Japanese papers appear very flimsy but are in fact strong and almost impossible to tear. In order to overcome the toughness of a genuine paper of this kind – if you wish to tear down an edge –

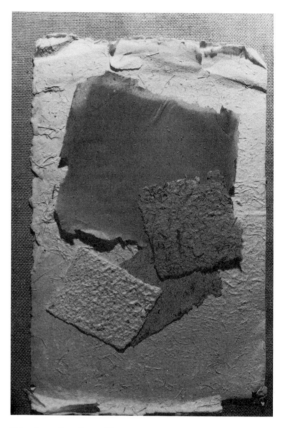

Handmade plant-fibre papers by Maureen Richardson including rush, onion, and apple with recycled paper. They are air-dried and pH neutral and have varied textured surfaces and thicknesses.

dampen along the fold, and leave it under pressure for a while, it can then be torn carefully. Do not overwet the paper or it will cockle. There are many colours and surfaces to be had as, although still fine, some Japanese papers are quite uneven with rough, speckled surfaces. A commonly used paper is mulberry, made from the inner bark of the paper mulberry tree. Other pulps are used but all have the quality of being strong and absorbent. Many of the papers are unsized which renders them more absorbent; this

absence of size is sometimes described as 'water-leaf'. There are imitation Japanese papers which are cheaper and come in quite a wide range of surfaces and colours and these are obtainable from printing suppliers who specialize in fine papers.

Printing papers for relief printing usually need to be of a uniform thickness and these can be found in the mould-made range. Watercolour artists use these as well but usually select those with a rough surface. The printmaker, with some exceptions, requires a consistent, smoother surface. Hot-pressed (HP) papers are smooth as they have been passed, dry, between metal rollers, the slippage polishing the surface. 'Not' papers are also subjected to pressure but are wet and separated occasionally with zinc plates and pressed mechanically. The imprint is created by the surface of the sheets of paper above and below. 'Rough' papers receive no special surface treatments but are allowed to dry out with the felts left in between the sheets, using their own weight as the only pressure. These three grades of finish are the basic ones but there are many variations also. Mould-made papers are usually made of fine quality raw materials and processed on a slowly revolving cylinder. They can be supplied as a continuous roll or as cut sheets with two sides deckled. If you wish to imitate the deckle on the trimmed sides, you can tear the paper against the side of a steel rule using a light pressure, and then burnish the rough edge with a smooth tool.

For maximum softness and durability, rag papers made from pure linen fibre were the best. Rags now contain many synthetic fibres using chemicals which can be detrimental, so pure cotton, similar to flax in construction, is now widely used for this type of paper. Many paper merchants and suppliers will provide small samples of their range of papers and it is advisable to obtain these so that you can consider the merit of each one in relation to your planned printed image.

The standard sizes for hand-made papers in the UK are:

Crown 15×20in (381×508mm)

Demy $17\frac{1}{2} \times 22\frac{1}{2}$in ($445 \times 572$mm)

Medium 18×23in (457×584mm)

Royal 20×25in (508×635mm)

Super Royal 20×28in (508×711mm)

Double Crown 20×30in (508×762mm)

Imperial $22\frac{1}{2} \times 30\frac{1}{2}$in ($572 \times 775$mm)

Double Elephant 27×40in (686×1016mm)

Antiquarian 31×53in (787×1346mm)

The weight of the paper is calculated by the ream (500 sheets), indicating its thickness. It is usual now to have the grades shown by the Continental method of weighing in gsm, which is grammes per square metre, although some mills still provide the equivalent in pounds. When choosing a printing paper, broadly speaking, less than 200gsm (100lb) is rather light, certainly for large prints, and 250gsm to 300gsm, (120lb to 140lb) per Imperial ream would handle well if you are printing an edition using several colours. A sheet of paper gets a fair

amount of handling when you consider that it has to be lifted up, positioned, run through the press or burnished, lifted again, hung to dry each time you print a colour, and must be sturdy enough to keep its freshness and not become 'sad' by the end of the editioning.

Unlike intaglio papers, which have to be immersed and soaked for some considerable time unless unsized, relief printing papers may not need dampening. However, some images may benefit by a softened surface and this can be done quite simply. It should be done indirectly, starting by placing sheets of newsprint or blotting paper a little larger in size than the printing paper on a flat non-absorbent surface. Spray this layer with water or sponge lightly until evenly damp. Place the printing paper, one or two sheets at a time, onto the dampened layers and continue in this manner until all of the sheets are stacked up. Allow about two sheets of dry paper to three or four dampened sheets, and finish with a dry piece of blotting paper before you place a pressure board on top. If you have a sheet of plastic this will protect the board.

Put heavy weights on the stack and leave. A few hours will suffice for thin papers but thicker ones will take longer to absorb the moisture. This is sometimes referred to as the 'book' method and can be ideal for small-sized printing papers.

Stack heavier, larger sheets of printing paper in groups of seven to ten at a time between well dampened blotting paper. Have a sheet of plastic or waterproof material on a large board and place the stack on this. Parcel up the stack then place another, similar-sized board on top and add weights so that you get an all-over, even pressure. This parcelling will keep the moisture in so you should get a thorough dampening.

Papers that have been over-dampened will cockle as they dry out unless under pressure. Etchings are flattened when they are still damp after printing. This is done by covering the inky print with tissue and blotting paper and placing it under heavy weighted boards. The blotting paper is changed, adding fresh pieces until the print is dry and flat. This cannot be done with a relief print, as the ink is still wet on the surface of the paper and would offset and stick to the protective tissue. Paper that has cockled before printing can be stretched flat. Re-dampen by soaking in water, blot all over to remove excess moisture and place down on to a flat clean board. Strips of dampened, gummed brown paper secure the printing paper to the board, and there should be as few bubbles on the paper's surface as possible. As the paper dries it will stretch and flatten and can be cut away from the board when the drying is complete. Never try to hasten the drying process as this will make the gummed paper lift and prevent the stretching. A print that has been made with oil-based inks can be stretched but obviously not one printed with water-based inks. Sometimes a finished print has been stored in a damp atmosphere and looks cockled and in this case the method described of dampening, gumming down and drying will bring it back to an acceptable state.

REGISTRATION

A colour print which involves either printing from one reduction block or

from a series of separate blocks involves accurate trimming and matching of blocks and printing paper. Any errors, however slight, will appear as gaps on your coloured image, and will be even more obvious around the outside edges of the print, appearing as separate strips of single colour. A single reduction block poses fewer problems of accurate registration than when using several blocks, but if you use careful tracings or a key-block to duplicate your basic design, it is possible to overprint complicated shapes satisfactorily. The trimming of each block of material is most important as any slight inaccuracy or fractional difference will result in misprints on your image, either as gaps or as unwanted overprinting.

The traditional Japanese method uses *kento*. Notches are cut into the actual block so that two edges of the printing paper fit perfectly into the depressions. This method is accurate but wasteful as the block has to allow for nearly the whole sheet of printing paper.

The Three-Pin Method

Small colour prints can be registered by using needles or panel pins. If preparing a lino-block, it must be mounted on wood or blockboard and the baseboard should be flat and large enough to accommodate the printing paper. Two or three long, thin panel pins, some screws and two battens are needed. The longer batten is screwed to the top surface of one edge of the baseboard. The pins are hammered through the second batten so that they point upwards when it is screwed to the baseboard, forming an 'L' shape. Each sheet of printing paper is placed over the inked block and is impaled on the pin points.

Base Sheet Method No. 1

Use a sheet of strong paper or board the exact size of your printing paper as a paper guide. Position the block on the guide as you wish it to appear, that is centred or a little raised from the bottom, considering the unprinted margins. Draw accurately around the block which is placed right-side up. After inking, place the block ink-side up within the guidelines. Pick up the paper by the shorter sides and lay one edge so that it exactly matches the paper guide. Keep the free hand high and the paper clear of the inked surface until satisfied that the sheet is in the correct position, then lower it carefully. Never try to adjust the paper after it has made contact with the ink.

Deckle-edged papers should be trimmed on the sides that make contact with any paper lays. This can be done either by total trimming, trimming where the card pieces touch, or by fastening masking tape at the contact points, which is removed after editioning.

Base Sheet Method No. 2

Take a sheet of card or board, which should be larger than the printing paper (about 2in [5cm] at each side). Mark out the paper area and the position of the block. Glue 1in (2.5cm) strips of card along one short edge where the paper will fall, and also along part of the longer side either as a continuous piece or as two separate strips. Check that they are perfectly square before fixing. To hold the block in position on the baseboard, glue two cardboard strips at one corner of the block to form a right angle. Add another card strip further along towards the end of the block.

(a)

(b)

(c)

(a) Positioning the inked-up block on the base sheet between the stops.
(b) Laying down the printing paper into the paper lays on the base sheet.
(c) Inspecting the proof before removing the paper completely.

Base Sheet Method No. 3

Instead of having two sets of register strips (paper lays and block stops), some printmakers prefer to glue down their blocks onto hardboard or strong card-board and use paper lays only. The blocks can also be nailed down onto blockboard using tacks, making sure that they are below the printing surface. This method of registration works particularly well for the reduction process, the block remaining exactly in the same position throughout the colour printing. Providing that the paper is placed accurately each time, fine detail such as a small area of white paper will be in perfect registration.

If you are using several blocks to make a multi-coloured print, it is more expensive to have fixed blocks with their own baseboards – one for each colour – but it does give them stability and helps to preserve them if you are editioning over a period of time. The position of each block and the paper lays must be identical. The alternative is to use base sheet

method No. 2, using the same stops for each colour block.

The Block to Paper Method

Place the printing paper face up on a board which has a few sheets of newspaper on it to make a softer base. Make a drawing as a guide of the exact shape and position of the block by drawing around it with a dark pencil or pen. Take up the inked block, holding it by the projections if it is lino glued on to a base, or by the thickness of the wood if it is a wood-block, in order to avoid any contact with the inked surface. Lean over the print so that you are directly above it and position the block into the guide-lines. After the first-colour printing, the paper with the dry printed image is laid printed side up, and the block with the new colour on it is again positioned carefully. This method requires a steady hand and eye and a degree of confidence but can be efficient. If you wish to print in the traditional way, i.e. with the pressure on to the paper and inked surface, the block will have to be turned over by sliding one hand underneath the supporting board, placing the other hand firmly on the back of the printing paper and turning the whole sandwich in one movement. It is now ready for burnishing or printing with pressure.

Type-High Blocks and Letterpress Proofing Presses

To make a stop for the paper when printing type-high blocks with or without type, glue small pieces of card on the outer edges of a wooden frame or strips of wood fixed around the block, at the distance of the margins of the printing paper. These must not be higher than type or block or they will damage the paper by embossing or piercing. They need to be just high enough for the paper to be stopped from slipping and to enable you to repeat each successive colour print in register.

Type and illustration blocks are usually locked into a chase, which is a metal frame fitting into the bed of the press with a locking bar. Wooden or plastic furniture and quoins lock the block into place. With this method, do not glue the card pieces but insert them before locking up the chase, being careful to check that they do not exceed the height of the block or type.

Letterpress proofing presses sometimes have a series of grippers which can be operated by foot or hand lever. Each block is accurately fixed in the bed of the press by filling the surrounding spaces with metal or wooden furniture held in place by quoins which expand when using the appropriate key. The grippers are opened and the paper inserted in the same position for each colour print.

CORRECTIVE WORK

Ideally the printmaker has made any corrections needed on the cut or collaged block at the proofing stage, but sometimes the final prints have a part that is not quite as planned. It can be that a colour is not happy beside another and needs separating, or a smudge has occurred on the margins of the printing paper. Small errors or blemishes can be dealt with quite efficiently and the saving of any stage proofs, or trial colour proofs, are now brought into use. Cut out the shape which you wish to correct or the

127

 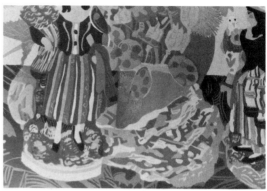

Correcting a print. (a) Transferring ink with a roller through a stencil which has been cut from a spare proof. (b) The tone of the china pot has been darkened where needed (detail).

area you wish to superimpose, allowing for the thickness of the paper by cutting the hole a little larger. This is now a stencil and if cut from an actual print will be easy to place down in the correct position. If you have a quantity of prints to do, use the original registration board, and hinge the cut-out stencil so that it falls accurately over the print for each correction. For small areas, use the end of your finger with very little ink. Try to dab as few times as possible and, when complete, blot off both sides of the stencil to remove any excess ink. If you do not do this frequently the ink tends to build up underneath the stencil and you will get a double edge to the newly coloured part. Have a pile of small pieces of newspaper beside you and blot both stencil and print as you work. Small rollers can be used to apply the ink in one firm sweep, blotting, after each print, both image and stencil.

If you have any finger marks or smudges on the surround of your finished prints, these can be removed providing the paper is of a reasonable quality. Use a hard eraser, rubbing with a very gentle circular motion, or take a piece of the finest silicon carbide finishing paper and work on the mark using a light circular movement over and beyond the affected area. Brush off any paper dust.

PROOFING AND EDITIONING

The time allowed for proofing is never wasted. The first proofs taken from a cut or collaged block can be in any colour and these are used for checking the progress of the work. Alterations or possible developments can be painted or drawn on these early proofs, and it is advisable to mark them with numbers or notes to record the sequence. Colour proofing is done firstly to check the registration and later to see the individual colours on their own and the effect when overprinted. This can be a lengthy process but can reveal unplanned combinations of colour. Dab out small patches of any coloured ink, mixed or undiluted, and write down the recipe for the mixture. Keep any

128

small amounts of mixed ink in foil parcels submerged in water. These samples can be used for further proofing or as a guide for making up the quantity for an edition.

Progressive proofs show all the printed colours as they build up and these should be labelled for future reference. As you print each colour and before cleaning up the inking area, roll a strip of colour on a piece of printing paper. Test the subsequent colours on the first rolled-up proof and repeat this process as you print.

The average number of relief prints in an edition is between twenty and one hundred. A printmaker may print only part of a multi-block edition at one time but, if using the reduction method, the edition will be completed. The edition size will be governed largely by the available resources, the demand for the prints and the enthusiasm of the printmaker.

Mr Quentin Crisp, a linocut portrait by Carol Walklin using two blocks, wallpaper and stencils.

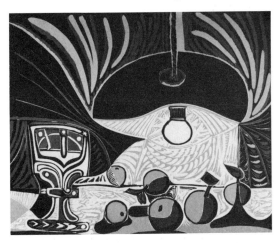

Nature Morte Sous La Lampe, a reduction linocut by Pablo Picasso, 1962 © DACS 1991. This print is in four colours and is typical of Picasso's work of that period when he produced prints of extraordinary extent and force. The value of the so-called 'duplicated art' of the print was assisted to better recognition by his compelling work in this field. The colours are gold, scarlet, deep green and black.

Completed prints are signed in pencil indicating the artist's approval and this is written under the lower right-hand corner of the image. On the lower left corner the total number of the edition is shown in numerals with the print number above it. For example 5/25 means the fifth print in an edition of twenty-five. This does not necessarily indicate the order of printing. A record should be kept of all the details of printing and numbering and, if a second edition is made, a Roman number II must be added after the number or title. The title of the print can be written either alongside the edition number or centred. Artist's proofs (A/P) should be identical prints from the edition and are usually 10 per cent of the total. Trial proofs are those that differ from the final editioned set but are complete in themselves.

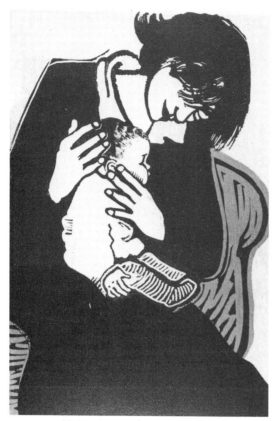

Old Dairy House, Arundel (detail), a linocut by Colin Walklin. A print in five colours using the reduction method. The woods behind the Dairy House are purple and the building is grey with touches of red added with stencilling. The trees, ivy clusters and car are printed in greens and a final blue-black.

New Baby (2), a relief print by Carol Walklin. The background first colour has been printed in ochre from an uncut piece of plankwood using masks to keep the white paper for the flesh and baby's clothing. The chair-shape is a linocut printed in terracotta and runs under the second lino-block, which is printed in indigo. Added texture has been obtained by printing an embossed wallpaper, using the same indigo, on the lower skirt area. A multiple wood engraving tool provides the fine lines on the infant's hair.

Moonshine, a linocut by Blair Hughes-Stanton, 1960. The artist preferred to call these kinds of prints 'lino-engravings'. Many required as many as thirteen printings with the blocks being printed then reduced and printed again. Much use was made of inks thinned-down with copper plate oil for greater transparency for rich overprinting. The main colours are dark green, black and red.

The Mowers, a linocut by Sybil Andrews, 1937 (Glenbow Museum, Canada). Her prints have a futuristic flavour, as did those created by her fellow students in the 1920's and 1930's who were taught by Claud Flight at the Grosvenor School of Modern Art, London.

Peacock Bird, a coloured woodcut by Michael Rothenstein, 1989. This artist revolutionized the traditional role of the printmaker with a new freedom of approach using any kind of printable media. About his own recent work he says 'There is a space I see as a sort of paradise in some corner of my mind.' His latest prints are large, strong images using a combination sometimes of watercolour and screen-printing, but the wood block usually dominates. *Peacock Bird* is printed in red, black, blue and orange.

The Starlings, a linocut by Gertrude Hermes, 1965, using three lino-blocks and some plank-wood. The vigorous cutting makes the swirl of the evening starlings almost move and the graded tones of the orange sunset disappearing into the purplish-black 'land' show how a print can be as expressive as any painted image.

CARE OF PRINTS

Some prints are mounted, others look better left free of any surround. A mount provides protection and keeps the print from making contact with the glass. The choice of mounting card is important as it can enhance or spoil the effect of the printed image. Strong colours should be

131

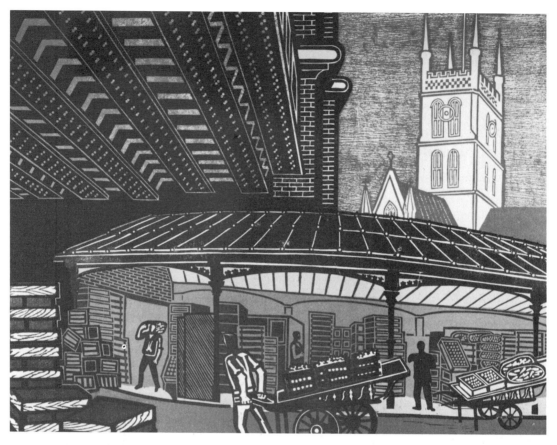

Borough Market, a linocut by Edward Bawden. Using only a knife, the detail
and beautifully balanced design create a scene both truthful and decorative.
The separate blocks are overprinted austerely yet capture so well the market
scene with its amber, glass-covered work area backed by the cool grey and
white spire under the black iron railway.

used with care and only with a very bold picture. The margin of card can vary but an average width would be about 2–3in (51–75mm). Make the lower border a little deeper than the other three sides. If not using a mount, place a spacer of thin card between the glass and the print. Fix the print to the backing board, not the mount, and secure with gum or tape; the unprinted edges of postage stamp sheets make ideal hinges. It is better to suspend

the print from a strip of gummed paper at the top edge only, letting it fall freely behind the mounting card. A cockled print can be professionally dry-mounted but it will be reduced in value and this should be done only if really necessary.

The print is framed and made airtight by fixing gummed brown paper all around the backing board. Masking tape can be used but does not act as a complete seal and will dry out in time.

8 Projects

PROJECT NO. 1: USING A STILL LIFE GROUP

Sometimes the setting up of a group of objects can be dull or uninspiring even though the things themselves may be attractive or unusual. If you study paintings and prints, you will notice the artist has put together objects that serve his particular purpose. This may be a comment, such as how he reacts to luxuriant foliage, brilliant colours, gentle soft fabrics, expressive stripes, reflecting shiny surfaces or repetitive patterns. The selection of the objects that make up the still life group is the first stage in the development of the idea. The second stage is the viewpoint which is also selective.

The Viewpoint

Make some viewfinders out of paper or thin card and cut out a square and two more rectangles of different proportions, not larger than 2in (5mm) on the longer side.

Arrange a big extended group of objects after building up several different levels with cardboard boxes and draped fabric. Do not use a background screen but create the group as a centre-piece. This provides many viewpoints with all-round access. The objects should be

A photograph of a still life group.

A pen and ink study.

133

A linocut printed in black, by Angela Watkins.

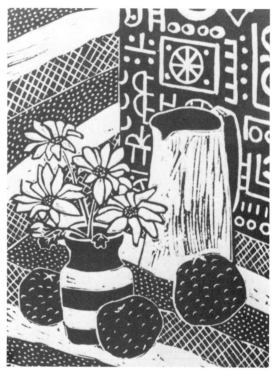

A linocut printed in dark blue, by Glenys Crane.

varied with jugs and pots different in shape, scale and colour. You can use fabrics of different patterns and surfaces, and add texture with basket weave. Plant forms can be twiggy and spiky or broad-leaved and glossy. A touch of incongruity provides interest, such as man-made objects in the form of drinks cans, tools, machinery.

Walk around the group using each of the viewfinders, varying the distance of the frame from the eye. The closer you hold the viewfinder to the eye, the more you will see of the group. Look for images that include part of several things rather than something centrally framed. Sketch out one or two of these versions keeping the proportion of the frame but working bigger.

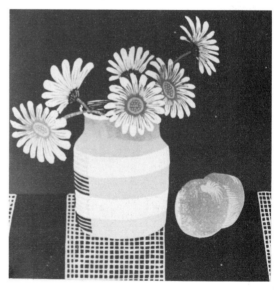

A stylized five-colour reduction linocut.

134

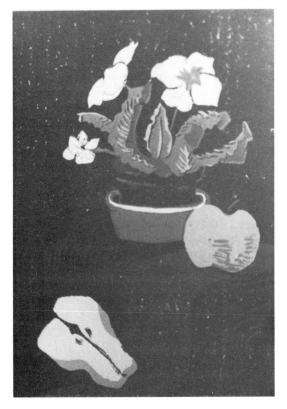

Flowers and fruit with an imaginary setting of a window, using a five-colour reduction linocut that uses the effects of the light source.

A primula and pear section, freely cut with lightly inked background texture.

Six-colour reduction linocut using lowered lino background texture, also cut and stippled texturing of the fabric areas. The apple shapes have been reinforced with inking through a stencil made from a progressive proof.

Bold shapes and simple cutting are used, with inked-up fabric to suggest a tablecloth.

Proof of a lino-block that has been overcut, leaving too much exposed paper background. Proofs were used to make a stencil so that transparent flat colours could be rolled through over the various still life objects, in several different colours.

Enlarging

If you want to enlarge any picture, here is a method for keeping it in proportion:

1 Contain your original image in a drawn rectangle.
2 Draw a diagonal line from the bottom left-hand corner of the rectangle, up and through the top right-hand corner.
3 Draw a continuation of the lower, baseline the width of your planned image.
4 Take a vertical line from the end of the new baseline and draw it until it reaches the diagonal. Continue this line across to the top left corner.

Still Life with Chinese Vase, a monoprint by Sheila Cox, in blues and oranges, with touches of red and fawn.

This new rectangle, whatever the size, will be 'in pro' to the original image. The same principle can be applied for reduction. Most High Street photocopying services can do both these processes mechanically.

PROJECT NO. 2: USING NATURAL FORMS

As a starting point, natural forms have an almost unlimited scope for the print-maker. From their use as actual blocks to the more sophisticated translation of them by planned images created by cuts

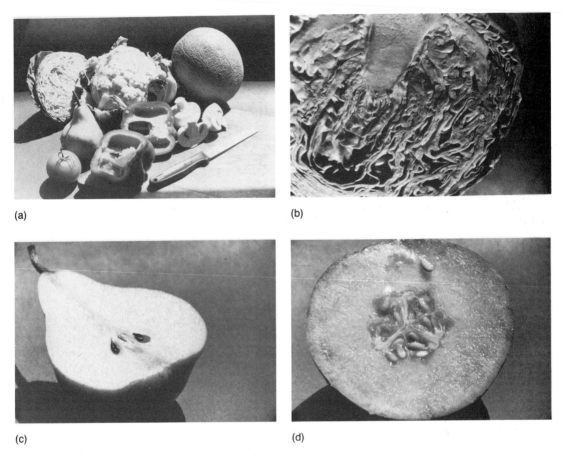

(a) A collection of fruits and vegetables for a study. (b) A cabbage section.
(c) A pear section. (d) A melon section.

and built-up blocks, they provide a cheap, accessible source of inspiration. Bark, leaves, shells, seed-heads, fruits and flowers are just a few examples. These can be treated in a representational way or abstracted, selecting the rhythms and patterns to suit your ideas.

Materials

You will need scissors, brushwork paper/ cartridge paper, newsprint, and PVA glue and spreader. For printmaking: water or oil-based inks (dark colours), rollers, tile or glass inking slabs, a knife, rag, solvent, newspapers and printing paper. For rubbings (frottage): dark-coloured wax crayons, frieze or lining paper and newsprint.

Making a Paper Block

Take a varied assortment of fruits and vegetables and divide some of these into sections; notice the difference between a horizontal and a vertical section. Observe the linear patterns and rhythms of growth, and the surface textures.

137

(a)

(c)

(b)

(d)

(a) A pepper section. (b) The drawing.
(c) Cutting the paper shapes. (d) A rubbing.
(e) An unmasked print.

As you begin to plan your paper block, think in terms of strong, simple shapes and bold lines, but be aware of any finer detail on the object you are observing. It helps to draw some of the natural forms so that you begin to know them better, even if the drawing is not necessarily

(e)

138

very specific; you are gathering information, not taking an exam. Do a final drawing either on a thinnish paper or tracing-paper, making it about 6in (15cm) wide in any one direction. Rub chalk into the back of the tracing and flick off the excess. Alternatively you can use a soft pencil.

Tape the tracing over a piece of cartridge paper and draw firmly with a hard pencil or ball-point pen so that your image is clearly shown. Remove the tracing and secure a second piece of paper behind the paper which has the drawing on it. Cut through both pieces, but just the outline, not any of the detail. You now have two identical shapes. Take the blank shape and paste it down very thoroughly onto a backing sheet of card, ensuring all the edges and any small projecting pieces are flat.

Look at your cut-out drawing and select another simple shape. Cut this out and paste it down on top of the glued-down silhouette. Proceed with this selection and pasting-down, building up the block. Do not have too many layers; stop at three. You can trim some of the shapes if you wish but, at this stage, it is advisable to keep the block simple. When you wish to add finer shapes or textured areas, you can use indentations to give 'white' lines, or employ glue as described on pages 37–9.

Once the parts are dry you may wish to see how your block progresses. Take a rubbing using thin paper and a wax crayon. This will be the same way round but your printed image will be in reverse. However, it is a good guide and from it you will have some idea of the general effect at that stage. The indentations and glue-lines will not show up as clearly as when they are printed.

In principle, the higher you build up your paper block, the darker it will print. Very dark areas can be achieved by glueing down a slightly thicker material such as thin card. A 'white' shape is made by cutting a complete area out of the backing as well as the actual block, but it is easier to use a mask, placing this down after the inking process.

(a) A mask taken from a print laid over the inked-up paper block.

(b) The final masked print.

(b)

(c)

(a) An artichoke section. (b) The drawing. (c) A print in white ink on black hessian with added stitchery in white threads and some glass and silver beading.

If you prefer an image with a clean unprinted surround, you can use a mask. Take a light print on thinnish paper and cut out the image plus an ⅛in (3mm) margin. This extra width allows you to position the mask more easily, and also allows for the thickness of the masking paper which comes between the inked-up block and the printing paper. Discard the printed image and fix the mask with tape to the paper block on one edge and in the correct position. Remember to flap the mask back before you ink up the block. After inking replace the mask.

Ink carefully, particularly where you have small pieces of paper or material, for at this stage you will find out if you have used the glue well, because small pips and seed shapes may appear on the roller or inking slab. Roll in one direction only, not forward and backwards, and then recharge the roller and change direction, until the block is completely covered with ink. A steady building up of the ink is far preferable to a heavy initial inking.

Developments

Take a well-inked proof on a smooth paper such as duplicator or tracing-paper. Place the wet print down on to a piece of prepared lino. Place in a press or use standing pressure sufficient to transfer the image on to the lino surface.

140

When this offset image is dry, it will serve as a good guide for either a monochrome linocut or a waste block-print using several colours. If the image is a bold strong one you can transfer it in the same way on to a piece of stretched fabric. When it is dry, you can embellish the print with stitchery and beadwork.

PROJECT NO. 3: USING PHOTOGRAPHY

Printmakers will sometimes find the photograph a source of inspiration. It may be a photograph taken by the artist for the purpose of translating into print, or the immediate reaction to a magazine picture, or a newspaper photograph glimpsed when clearing up the ink area. These can be excellent starting points – a snarling tiger, a flock of birds, ships, a flight of steps, deep-shadowed buildings, a fight, a sad figure and so on. The very fact that you have selected the picture means that it has caused some kind of visual reaction, be it appreciative, shocked, or whatever.

What medium shall I use? This question is usually the next step after the initial response to the photograph. A very subtle fuzzy image would be well translated with a printing method such as monotype or free inking, using water-based inks applied with a brush. An image with stark contrasts of black and white seems to ask for methods like woodcutting or linocutting. Fine detailed work and patterning can be achieved with wood engraving.

The translation from your own photograph has the advantage that you have already selected a particular picture with the possibility of making a print version.

Other photographs may be of less immediate use and be kept filed away for some later date. Envelopes or photo albums provide an efficient filing system but grow to an alarming size all too quickly. Often a moment passes and is lost if you have only drawing materials to hand, but a small unsophisticated camera can be used as a sketchbook, capturing a scene, a gesture, an incident, providing a trigger to and a reinforcement of your visual memory.

Some printmakers are competent photographers and can create images with their own camera that provide excellent starting points for their prints. The photograph of the Welsh seashore was inspired by the dramatic qualities of the subject. This mood was translated, not imitated, into a coloured linocut, produced using the multi-block method. The blocks were cut and proofed several times before editioning, using a graded blue, ochre, dark grey and near black.

The butterfly print was based on a colour photograph in a magazine. The lino-print was much larger than the original reproduction and used individual treatments to create a new version of the subject. The leaf blades were made with a small roller used with free sweeping strokes. The tones and colours are soft and subtle so that the patterned butterfly is in contrast. Two lino-blocks were used, one for the background with the main shapes cut out, and the other colours were printed from the second block using the reduction method.

The cockerel prints were both based on photographs taken quickly as the game-cock strutted on the window-sill of a farmhouse. Some pictures viewed the bird from the kitchen interior, others were taken outside with the bird looking

(a)

Pembroke Coast, (a) a photograph by Ianthe King. (b) The multi-block linocut she produced from it, in greys, blues and ochre. Graded inking is used on the horizon.

(b)

(a)

(b)

Butterfly, a linocut using two blocks by Kay Spink. (a) A small photograph in a magazine. (b) The linocut interpretation.

142

(a)

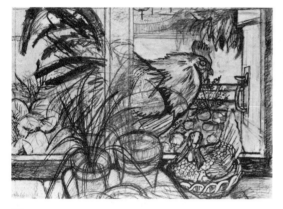

(b)

(c)

The Gamecock. (a) One of a series of
photographs used as reference.
(b) A drawing in charcoal and gouache.
(c) A reduction linocut in seven colours with
some graded inking (version 1).
(d) The key block used for version 2.
(e) The final print with two blocks. One as
a reduction print in six colours, overprinted
with the key block.

(d)

(e)

inwards towards the white china hen.
From this collection of photographic
images charcoal and pencil drawings
were made, working them up to the final
size. Version one was a total reduction
block with a rich grading of oranges and
browns in the body and brilliant blues
and greens in the tail feathers. The
second version used a different method.
The drawing was made directly on to the
lino-block with brushes and felt-tipped

Long-Tailed Duck and Whiting, a wood engraving by Colin Paynton. A fine example of rich textures and patterns created by the cutting tools. The suggestion of above and below the swirling water is made with a variety of marks, both white on black, and black on white. The pure whites on the ducks are areas completely cleared away, whereas the fish is silvery with very fine cross hatching. The artist-printmaker uses photography on site and also for reference where first-hand observation is not possible.

pens. The block was cut in an open fashion, creating an image similar to early woodcuts, making a framework reminiscent of the leading of a stained glass window. The completed cut block was inked up, an offset print made and transferred to a second, uncut piece of same-sized lino. The remaining seven colours were printed in sequence using

(Left) *Iron Bridge*, a reduction linocut in four colours by a student (16 years), using photographic reference in a magazine.

144

Beech Woods, a reduction linocut in five colours by Geoffrey Weald. Several photographs were taken directly into the sun to get the effect of the trees against the light. This was interpreted into a linocut using a variety of reds and deep greens.

PROJECT NO. 4: USING LETTERFORMS AND SYMBOLS

Materials

You will need scissors, brushwork paper/ cartridge paper, newsprint, PVA Glue/

spreader and a reference for birthday signs. For printmaking: water- or oil-based inks (dark colours), rollers, tile or glass inking slabs, a knife, rag, solvent, newspapers and printing paper. For rubbings: dark-coloured wax crayons, frieze or lining paper and newsprint. For spraying: aerosol metallic paint, newspapers and a cardboard box for the spraying area.

The Design

Find the reference for the birthday sign you wish to feature. Make drawings which will fit comfortably into a 7in

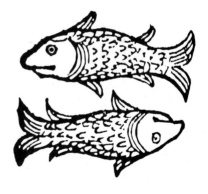

Two signs of the Zodiac, a woodcut from the fifteenth century.

the reduction method. The two versions have similarities of subject and scale but differences of viewpoint and treatment.

145

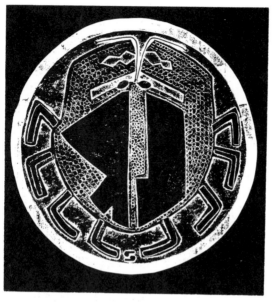

Cancer sign with the initials of the artist: LR, printed in black from a paper block, by a student (16 years).

Wrapping paper produced by a student. A wooden letter U is used as a repeat design overprinting blue and red.

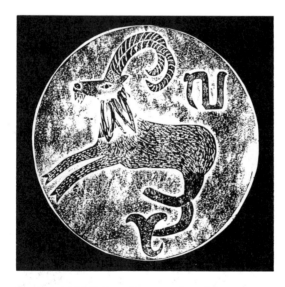

Capricorn, a birthday plaque produced from a paper block by a student (16 years). There is a good use of simple shapes and indentation. It is printed in blue.

(18cm) circle. Add initial letters if you wish to concentrate on the astrological symbol. Simplify the shapes so that they can be cut out easily, either with a craft knife or scissors. Cut out a circle of brushwork or cartridge paper and glue it down well on a stiff backing of thick card or board. Cut out the largest main shape of your design and glue it in position on the circle. Ensure that the glueing is thorough and that no parts are loose. Add more cut-out shapes to build up the paper block.

Place a sheet of newsprint over the paper block and make a rubbing with a dark wax crayon. This will give you some indication of how your layering is progressing. Add additional cut paper shapes

146

A rondel made from repeating card letterforms, A, T, and Y, printed in three colours, by a student.

A personalized carrier bag printed with a repeat of a decorative K-shape string block, by a student (16 years).

if needed but do not superimpose more than three. When you have finished glueing, indent both lines and dots with a ball-point pen or hard drawing tool and take another rubbing. This will appear the right way round but the print will be in reverse, so if you are using letterforms that are not symmetrical, such as R, B and S, turn them over before glueing them down.

When using water-based inks on glued-down paper it is important to seal the block with a waterproof coating of diluted PVA glue. Oil-based inks seal the block and, once dry, the coating of ink will make it more durable. The block can be masked after inking giving the printed image a clean, un-inked surround.

The paper block itself can be interesting, particularly if the relief is quite high and the shapes bold. If you wish to spray-paint the block, place it in a cardboard box which is on its side and spray

Printed fabric using a simple A-shape repeat, by a student.

147

Turkey, a linocut for a greetings card, produced from a single block with ink gradated from red to green.

A double birthday sign paper block printed in dark blue and used on a banner, by a student (15 years).

evenly. A window mount will complete the birth-sign plaque.

Single-colour lino-blocks also look well if painted or sprayed using matt white paint and when dry, rolled up with oil-based ink. This should not be done if you wish to re-use the block, as some texturing of the surface may have occurred.

PROJECT NO. 5: GREETINGS CARDS

Seasonal greeting cards designed and produced by the printmaker are inexpensive and individual. They can range from a very rich and detailed piece of cutting to the simplest of collage blocks. At a time of great standardization it is welcome to give or receive something that has been handmade and not mass produced.

The lettering of 'A Very Merry Christmas' can, in fact, be a design in itself. If the printmaker is not very confident about drawing letterforms, they can be traced from newspapers, magazines and advertisements. The tracing must be turned over and drawn on to the block before any cutting can be done. Lettering can appear as dark on light, or light on dark. It is simpler to cut away the actual letters rather than to have to cut around them.

A selection of greetings cards by students using a variety of methods.

Materials

You will need lettering reference, tracing paper, carbon paper, lino, cutting tools, backing board and registration board. For printing: Oil-based inks, rollers, inking slabs, a knife, rag, newspapers, solvent and printing card or paper.

The Design

Design the card to fit a standard envelope size so that it slides in easily when folded. The design can be printed on the actual card or on a separate piece of paper and stuck down. The card can be tinted or coloured as can the paper. If using paper, fold it into four, the design being printed in the bottom right-hand quarter and the lettering for the inside is printed or written, upside down, in the top left-hand corner.

If you have no press and are printing the cards by hand-burnishing, the flimsier papers can be trimmed and glued down onto a folded, sturdier card. Coloured tissue paper is very easily printed and if trimmed carefully can be pasted down onto coloured or white, thicker card. Thick card does not give a good burnished impression but standing pressure may be suitable for a lino, wood or card block design.

Greetings cards can be produced in

149

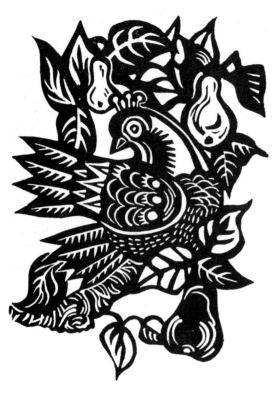

Partridge in a Pear Tree, a single block linocut suitable for hand colouring.

Geranium, a reduction linocut by Margaret Wilson. The greetings card was printed on red card by the reduction method, using a dark red and two greens.

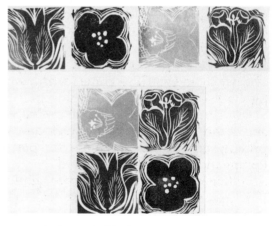

Easter Card, a multi-block linocut. Four separate units were cut and used in a variety of ways. Each block was inked up in a different colour and arranged either with partial overprinting, used as a band, or made into a square block. In this free-form design the printmaker can use many permutations both of colour and positioning.

quantity if using wood, plasticard or lino-blocks. Instant Printshops will provide inside wording if you do not wish to write or print any personal message yourself.

Registration

Even if using only one colour it is advisable to have a registration board for the correct positioning of the unfolded card. If using two or more colours, a board with paper lays and block stops is definitely an essential.

1 Cut a piece of lino 6 × 4in (15.2 × 10.2cm), which will be the finished size of the folded card.

150

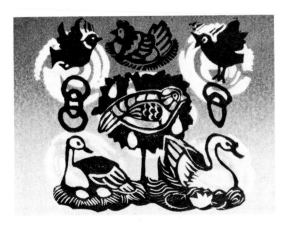

A Christmas card, produced from two blocks. The first block has five ring shapes cut away and was inked up with a gradation from top to bottom in scarlet to ochre. The second block was printed in a deep crimson when the first prints were dry.

Rubber Stamp design, by Claire Dalby. A double design cut from two erasers with a sharp knife and printed with oil-based ink.

2 Cut accurately the number of cards required to 12½ × 4½in (31.2 × 11.5cm), to include ¼in (6mm) extra around the finished design.

3 Fold one piece of card in half or measure it, open it out and glue it down on to the registration board.

4 Place the lino-block on the card-fold and draw around the block with a pencil. The pencil line will be a guide for glueing the card stops for the block.

5 Glue more card pieces along one edge and at the two corners of the stuck-down printing card to act as guides for positioning the printing paper or card.

6 When the prints are dry, score lightly if necessary, fold in half and trim off excess card.

7 Whether the card is portrait or landscape, the same method of registration is used.

A printing method for a card design which requires no accurate registration is to use several small units which are inked up in different colours and placed down, one at a time, but overlapping. This can be done wet-on-wet or allowing each colour to dry. They are roughly positioned between two parallel lines to form a band, and the patterns made make a pleasing card.

Rubber stamps, end-grain wood, lino and plastic make excellent small blocks, suitable for labels, repeat patterns on packing paper, or motifs for letterheads.

9 Mixed Media and Graphic Design

MIXED MEDIA

Actual materials suggest ideas – the lines and knotting of wood, the accidental images of a monotype – but many printed images come about by the conscious bringing together of several techniques. This marriage can be a happy one particularly when the artist-printmaker has used the characteristics of each method in a sensitive way. Often it is a challenge to achieve the effect you want: how can it be done, which technique will serve the purpose?

Using stencils can be ideal for corrective work over small areas of a print but they can also be planned when the total image is being considered. In the print of two girls (*Duo: Utamaro Girls*), the portrait was to be in lino but there was a

Duo: Utamaro Girls, a relief print by Carol Walklin, produced from a lino-block, a string block, stencils, wallpaper, and free ink-rolling.

At Bleeding Heart Yard: a tribute to the late Mr Stanley Lawrence, wood-block maker. It was produced from a linocut and paper blocks by Carol Walklin.

(a) A plasticard engraved block mounted on wood. (b) A plasticard block-print in black for hand colouring.

need for other methods where either a softer effect was wanted or a very linear one. The haloes of blonde and pink hair were created by overprinting the black print using rollers directly on to the paper. A stencil was cut for each head in order that there could be a certain amount of freedom in the rolling so as to avoid a hard edge, yet remain in the correct area. Varying pressure helped to add to the softness and the prints were blotted immediately to reduce the ink and shine. One jersey was made of a very loose knit and this would have been very tedious to cut, although the striped

Black Swans at Arundel, a linocut and screen-print by Jane Gray. The top block, cut in lino was printed over several layers of screen-printing, using Fishburn oil-based inks over J. T. Keep's Keeprint screen inks. It was printed on 210gm Fabriano 5, and the lino-block was hand-burnished with a wooden spoon.

In the Workshop, a paper block and wood-print by a student (16 years). It is printed in sienna and black, with a good use of bold shapes and clear indented lines combined with an actual print from a grainy piece of plank-wood.

trousers, difficult to 'draw' with cutting, proved satisfactory. The lines on the jersey were made with glued-down fine string, this was coiled and positioned onto a piece of cardboard the exact shape of the sweater, using a proof as a guide. When the glue was dry, the block was coated with a diluted solution of PVA glue to seal it and make it more durable. The completed block was inked up in a pale blue and printed over the black image, block to paper. Tiny areas of several colours were added to the braids by using a proof again and dabbing the inks through with the fingers.

In addition to relief and stencil methods

Wags Working, a plywood and lino-cut by Edith Hill. The lino-block is printed in a soft red on thin paper (imitation Japanese) and overprinted in black. The plywood block is hand burnished so as to emphasise the figure as a darker area, the background area appearing lighter in tone.

Social Worker (2), a mixed media print by Colin Walklin.

of mixed media, some printmakers combine relief etching and lino, or silk-screen and lino; *Black Swans* uses this latter. The inks for the screen-print stage are oil-based and so are compatible. In this image, the cutting is very strong and rhythmical, dominating the print, the screen-print serving as a background of light and movement.

Social Worker (2) uses many methods. Lino and wood, collaged string, inked-up crumpled paper, paper blocks, woodcut and an electrotype; all are combined to create the total graphic image.

ILLUSTRATION

Illustrations are the result of a partnership between the artist and the writer. The artist creates a pictorial comment on the words and contributes to the meaning or mood of the writing. For the writer to also be an artist, or the other way around, happens only rarely, such as in the case of Blake, Carroll, Lear; more often the two modes of expression are conveyed by different persons.

Ideally, the artist will create the means by which the illustration is to be reproduced, such as in a wood engraving – the days are long since gone when the artist handed over his work to another craftsman to cut or engrave. Yet today we have

parallels, as modern technology enables most original work to be 'translated' by means of photography or laser. Large works in wood or lino can be reduced in size and facsimiles of great accuracy produced. Many printmakers do commissioned work as well as prints for exhibitions and plan their artwork to be reduced when appearing in books or magazines.

There is still a place for actual printing blocks to be used alongside moveable type and the renewed interest in the private press is welcome. Well produced books on good paper, with fine printing and excellent binding, make wonderful vehicles for the artist-illustrator. We

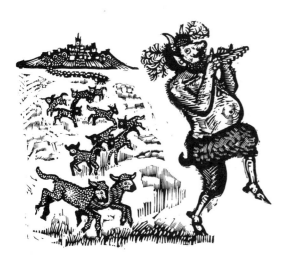

An illustration from *Food and Wine Adventures*, printed from a vinyl block, by John Lawrence.

The frontispiece from *The Adventures of Covent Garden*, a linocut by Carol Walklin.

155

Restoratives from *Hobbes' Whale*, a wood engraving by Simon Brett.

Sonnet CLV from *Shakespeare's Sonnets*, a wood engraving by Peter Forster.

might well agree with William Morris who said that the book if not perhaps absolutely necessary to man's life, nevertheless could give endless pleasure.

A book can be designed entirely by the artist-printmaker and be of small editions rather than mass produced. It can come as a short story or quote, with parts illustrated or with head and tailpieces. The balance can also be the reverse, with the text appearing more as captions to prints. It is a challenging project to take a theme and to pursue this in visual terms but also to have text matter to support it. A theme such as water, ages or dreams could provide a variety of interpretations, either with relevant quotations or with your own writings.

Those printmakers that use calligraphy may choose to combine both printed images and their own script. This can marry very well and can be seen in the

Theodore affrighted . . . a linocut by Carol Walklin from *Theodore and Honoria*.

work of Hela Basu who, although not a printmaker, brought an intriguing and well-balanced design to her work, using the letterforms and pictorial images in an imaginative and compelling way. The student can write the words in clear black and white and have this photostated in quantity. The quality of photostat paper has improved and will keep its colour, if not for posterity, for some time it seems. Images can then be made, blocks cut, and the illustrations be printed over the script. A simple two-colour linocut or combination lino and woodcut can have a directness and impact when combined with the words, perhaps overlapping these if transparent inks are used.

Cutting text into actual blocks is not easy and must obviously be limited in detail and quantity. However, if you wish to use type it can be purchased in small founts from a type foundry. A fount has all letters of the alphabet, numerals, and punctuation marks in proportion to their general use so that there will be more 'a's than 'q's. The design of the type is called a 'face' and there are literally hundreds of these. Each one has its own character and you should find one that is suitable to your needs and subject. Other equipment is necessary so it is perhaps better to compromise by typing out your text matter on a typewriter which has a good 'face' (the machine that has an interchangeable daisy-wheel is excellent) and taking your planned page, typed in position, to your High Street print shop. They will be able to make you copies in good black and white but can also offer you the alternative of actually setting your written matter and printing it. This will inevitably be far more costly. Whichever method you decide to use, do not forget to allow extra

An illustration for *Wind in the Willows*, by a student (17 years). It was produced from a four-colour linocut, using the reduction method.

The Hobbit, a linocut illustration in five colours, produced by the reduction method, by a student (17 years).

158

prints for possible spoilage or changes of heart regarding the pictorial image, the different colour schemes and so on.

The illustrations I have shown here are by artist-printmakers using the medium of wood engraving, with its fine detail, and lino which has been reduced photographically. There are also coloured prints by young students, produced by the reduction method, illustrating *The Wind in the Willows* and *The Hobbit* as part of their more advanced school work. Each brings the individuality of the artist to bear on the words but recognizes the discipline of the text matter.

RELIEF PRINTS USED IN GRAPHIC DESIGN

Actual hand-cut blocks were used for early book and magazine illustration and

The logo for *Divertimenti*, a linocut by Carol Walklin, used in various sizes on stationery and carrier bags. It was designed for a company specializing in cooking utensils and tableware, and based on their original boar's head painted sign.

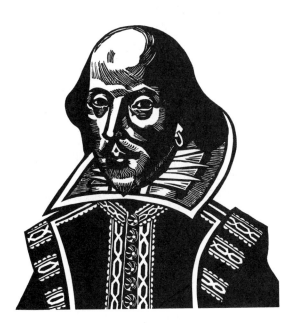

William Shakespeare, a linocut postcard by the Mullet Press, for the Globe Theatre Museum.

were made either from the craftsman's own design or were an interpretation of another artist's original work. Later, the cut block was preserved by making a facsimile metal plate called an electrotype, made photographically from a clean black print. The quality and character of the printed block is kept and the number of copies produced can run into thousands, which is appropriate for magazine and newspaper production.

In some rare instances, actual linoblocks have been used in combination with type, notably for the posters created for the Academy Cinema by Peter Strausfeld, which showed great skill in the free translation of stills. He produced at least 300 different film-poster designs over a

A Man Escaped, a linocut film poster by Peter Strausfeld for the Academy Cinema, London.

period of thirty years, which graced escalators and station platforms in London. Without exception, all these were printed from the artist's original lino-blocks and are memorable for their economy and sensibility. Speed was an essential factor because the notice of the film title, usually foreign, could be as little as twenty-four hours. Old wooden type was incorporated in many of the posters, which were produced at the premises of Ward and Foxlow Limited. The usual runs were around 300, but some perennials were used over and over again, and

Les Enfants du Paradis was printed about six times until the lino wore out. Most cinema posters use a photographic still from the film they are promoting, but the linocut images of Peter Strausfeld's gave each poster a unique identity. He said:

'Every film is different . . . I have found that they are all interesting for some reason or another . . . I see the film only once, I will then know the scene I want. When the film came late and the publicity had to be early, I had only a few stills to work from, plus an idea of what it was

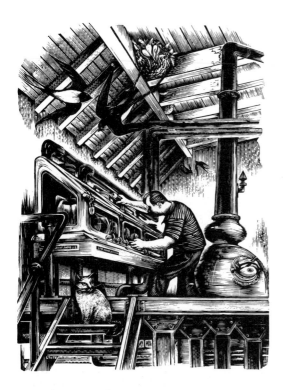

Duncan Macpherson, Stillman, a wood engraving by George Tute from a series of illustrations used in advertising Glenmorangie Malt Whisky.

all about . . . The printers curse me because it gets more complicated (colours) for them. I do more tricks with overprinting and underprinting. That is the fun really. You use three colours and make six or seven.'

Edward Bawden used linocuts for printing wallpapers and is well known for his lively book illustrations and prints, his posters for London Transport, *Kew Gardens*, *Chestnut Sunday* and *Pelican in St James's Park*.

In preparing his poster designs, Bawden

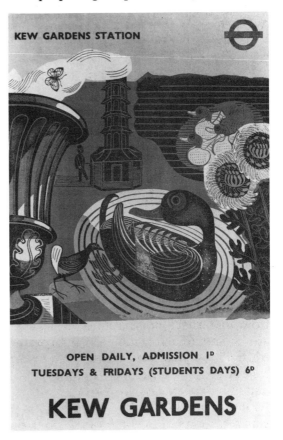

Dr Who, a linocut poster for Bradford Film Theatre by Carol Walklin. It is a black linocut overprinting a green photographic Dalek.

Kew Gardens, a linocut poster by Edward Bawden. This design is one of several commissioned by Frank Pick at London Underground in the 1930s.

161

The Humble Monument, a linocut by Carol Walklin, a postcard of a tomb in Southwark Cathedral, London.

EXHIBITION OF
AUSTRALIAN PAINTINGS
by Arthur C. Howard

Queensland House
393 Strand, London WC 2
August 29-September 22

would create a collage made from one large linocut for the whole design, full poster size. This master block would be printed down on to sheets of different coloured papers and when dry, these were cut up and stuck down as a collage. When completed, the finished collage was reproduced photographically. He made good use of pattern and repetition, when designing a mural for a Canadian

A poster for an art exhibition by Arthur Howard. It is a reduction linocut in five colours.

A linocut logo for a private press by *Mullet Press*.

The Cruel Sea, a linocut and photographic poster for Ealing Film Studios by Colin Walklin. The simplified interpretation of a still was cut in lino and overprinted in black on to a photographic background printed in blue-green. The title was in white and the cap badge picked out in deep yellow.

Pacific liner, by creating a whole forest from a single, linocut tree. Similarly, he produced a whole car-park image by repeating cuts of a single car in an illustration of Portugal in the magazine *Motif*.

Eric Ravilious made many wood engravings for the Curwen Press and the Golden Cockerel Press, and was also commissioned by London Transport and the BBC. His decorative style is the

(Left) A wood engraving by Eric Ravilious. It was an illustration for the series 'Country Walks' which promoted the Greenline Countryside Routes, commissioned by London Transport.

163

Noah, a children's poster for a school play, by students (13 years). The dove shapes made from paper were overprinted in transparent inks in yellow, magenta and blue.

Oliver, a children's poster for a puppet club, using a paper block and type, by students (13 years).

product of fastidious craftsmanship and his engraving skill that of the miniaturist. Small images can be enlarged to a considerable size when executed well and this is seen in the mural panels by David Gentleman, installed in 1979 on two platforms on the Charing Cross Underground.

Proofs were enlarged from the original engraving and screen printed onto plastic panels. In 1951, Thomas Bewick's wood engravings were enlarged to tremendous proportions as decorative murals in 'The Natural Scene' Pavilion at the Festival of Britain, London.

Relief prints can be seen today in packaging and publicity and are a welcome change from mere photographic reproductions. Fine-book publishers commission relief printers to produce illustrations and there is a strong interest in the private press both in the UK and abroad.

Glossary

Abstraction The mental process of forming ideas from characteristics and qualities common to the object.

Acid A corrosive liquid used for etching metal plates.

Acrylic Acrylic Polymer Emulsion-based printing paint, soluble in water but waterproof when dry.

Agitation The gentle rocking of a tray containing water or acid.

Antiquarian Paper size: 31in × 53in (79cm × 135cm).

Artist's proofs (A/P) 10 per cent extra or less of a total numbered edition of prints.

Asphaltum A composite mixture of asphalt rock and bitumen used to stop out or mask metal surfaces that must not etch.

Baren An instrument in the form of a slightly convex, circular pad covered with a bamboo sheath, used for burnishing the back of paper when printing from an inked relief block.

Bath An acid-proof container made of glass, porcelain or plastic in which metal plates are etched or bitten.

Bench hook An aid used by printmakers to steady the block during cutting, made from a wooden baseboard with one strip of wood along the top edge to hold the block in place, and another underneath hooking the board against the work surface.

Bevel To create a sloping or rounded smooth edge of a block or metal cutting tool.

Bite The etching action on metal or alkali on lino.

Blanket Felts used in printing intaglio plates on an etching press. Also the rubber-covered roller on a letterpress proofing press. Felt blankets used in the manufacture of paper.

Bled image The image extends to the edge of the paper with no margins.

Bleeding Oil or grease seepage spreading beyond the printed area.

Block Any material which is adapted, cut, or built up, to create a surface from which a print can be taken.

Block-Books Early form of illustrated book where text and pictures were cut together from the same block of wood.

Boxwood A superior dense hardwood made from the boxwood tree, prepared in end-grain blocks used for wood engraving.

Brayer (American term) A gelatine, composition, or rubber-covered roller for inking plates or blocks.

Bridge An aid used in monoprinting, which allows close work when drawing but keeps any other pressure off the printing paper. A piece of wood raised by supports at each end.

Brush inking Coloured inks, usually in the form of paint, applied to the block using brushes instead of rollers.

Burnisher A hand tool, of metal, wood, or bone, slightly flattened and highly polished, used for making prints by rubbing the reverse side of the printing paper. Improvised tools are spoon handles, smooth stones, etc.

Burnishing Rubbing the reverse side of

the printing paper, which has been placed over the inked surface, with a smooth, rounded object or a baren.

Burr The rough edge of a metal cutting tool.

Carborundum An abrasive in solid or powder form used for sharpening wood engraving and linocutting tools.

Chase A rectangular metal frame in which the composed type forme or block is locked in place with furniture and placed on the bed of the press for printing.

Clamp An implement for holding a block firmly on a work-bench.

Collage A block built up from various materials glued on to a backing board.

Colour print A print using more than one colour.

Colour separation A separate drawing for each colour to be used in the print. It can also describe printed colour proofs.

Coloured print A print where colour has been added after printing, usually watercolour or drawing inks.

Composite print A print made from a variety of materials and methods.

Composition The combining of a group of separate elements into a visual whole.

Commission A contract between artist and publisher. It can also refer to the percentage taken from a sale.

Copyright The right to reproduce the work of the artist.

Cross-hatching One set of drawn or cut lines crossing over another.

Dabber A soft-leather inking pad used to ink a block instead of a roller. A finger tip can be used for small areas.

Deckle Irregular edges of all four sides of handmade paper and the two of mould-made paper. False deckle is made by tearing or irregular cutting.

Decorative Patterned and ornamental, not figurative.

Direct cutting Cutting into a block where the drawing has been painted (positive cutting) or cutting freely into an undrawn block, leaving the uncut parts raised.

Direct inking Rolling an ink-charged roller directly on to the printing paper.

Double elephant Paper size: 40in × 27in (102cm × 69cm).

Driers Used sparingly with oil-based inks to speed the drying process.

Edition A set of identical prints taken from a block or blocks in the final state. These are 'cancelled' to prevent further printing. The total number excludes artist's proofs or any other proofs.

Electrotype Facsimile metal printing-plate made photographically from an original drawing or print used for work such as book illustration where there is a long printing run.

End grain The flat surface of a block of wood cut through the trunk at right angles showing the growth rings. End-grain blocks are especially prepared for wood engraving. Woodcuts are made on the plank grain.

Engraving Incising lines or dots into a hard surface of metal or wood with tools. If the printed image is made by filling the lines with ink and impressing these on to paper, this process is referred to as intaglio (e.g. copper engraving); where the image is obtained by inking up the raised surface, so that the incised or cut lines appear white, this is known as relief printing (e.g. wood engraving).

Etching The process of biting into a metal plate with corrosive acid solution to form a design to be printed on paper; also refers to the printed image.

Etching lino A means of creating tones and textures with a sodium hydroxide

solution (caustic soda), or proprietary oven cleaner.

Etching press Press for printing etchings and all other intaglio plates, operating on a similar principle as a mangle. Can be adapted for printing some relief blocks.

Extender Also referred to as reducing and tinting mediums. These dilute the pigment but maintain the intensity of colour. Medium copper plate oil can also be used.

Feathering Dispersing bubbles on the surface of a plate immersed in an etching bath.

Figure The visible surface pattern on a piece of timber.

Flocking Wool dust glued to a fabric-printing block to increase the amount of ink taken up when printing.

Foil A metallic paper used for preserving small amounts of printing ink or as a protective covering.

Frisket A metal frame attached to the tympan on a platen press which holds the printing paper in place.

Frottage A rubbing of an object or block placed under a thin piece of paper, using a wax crayon or pencil.

Gesso A paste-like substance made from plaster of Paris or chalk, and glue.

Glue Woodwork glue for sticking most materials. In diluted form PVA glue can be applied to porous surfaces as a sealer.

Gouge A small woodcutting tool with a curved or 'V' shaped cutting edge – more often applied to the curved variety – made in several sizes.

Grain Describes the direction of the fibres on the plank-side surface of timber.

Ground An acid-resistant coating of asphaltum or wax to protect a surface, or allow an image to be scratched through.

Gum arabic Plant resin dissolved in water, used for securing fabric on a printing table, and also the principal element in water-based inks.

Handmade paper Single sheets of paper with a deckle on all four sides. It is usually lightly sized.

Hardboard A man-made board that is smooth on one side. It can be cut and printed and is frequently used as a base-board for lino-blocks.

Hot pressed (HP) The smoothest of the handmade papers, with a slightly glazed surface.

Imperial Paper size: 22in × 30in (56in × 76cm).

Impression An image printed on paper from an inked or un-inked block. The indentation or imprint made in paper when high pressure is used during printing.

Indian ink A permanent pigment made of lampblack or ivory black, used for drawing.

Indirect printing An inked impression not made directly from the block on to the paper (e.g. as in offsetting).

Ink slab A large piece of glass, marble, or any hard non-absorbent surface on which printing ink is prepared.

Intaglio An incised or engraved design in a durable material which holds the printing ink. The print is made by passing dampened paper and the inked design, together, under great pressure through a cylinder press.

Japanese paper An unsized handmade paper made from mulberry bark and other long-fibred plants.

Jigsaw blocks Printing blocks cut up into sections, inked, and reassembled for printing simultaneously.

Kento A traditional Japanese method of registration.

Key block The block that contains the

master design and from which all the subsequent colour blocks are registered.

Laid paper Describes machine or hand-made paper which has light lines showing, caused by the imitation, or the actual impression, of the mould wires.

Letterpress The process of printing from relief blocks or type, or the printing press used for this process.

Limited edition A set of numbered, signed identical prints.

Line block A photo-etched commercial relief block with line and solid areas only, used in letterpress printing.

Linocut A relief print made by cutting lino with knives and gouges. It also refers to the actual print.

Linoleum A material composed of ground cork and linseed oil, backed with hessian, used as a block in relief print-making.

Lithography A planographic printing process based on the antipathy of grease or oil to water.

Makeready Layers of paper pasted underneath a block to even out irregular pressure.

Margin The border of unprinted paper around the image.

Mask A layer of clean paper placed on the block after inking, and before the paper is positioned, preventing ink from reaching the printed image.

Matt A dull finish as opposed to glossy.

Medium The main printing processes. The substance that binds or extends pigments.

Mixed media The combination of more than one printing method.

Monochrome A single colour not necessarily black.

Monoprint Also known as monotype, a method of making a design with ink or paints on a smooth surface and transferring the image on to paper. The single print obtained by this process.

Mordant Any corroding agent used to etch lino or metal plates. (Proprietary paint-strippers used for etching lino are alkalis).

Mount A protective card for prints, used either as backing for support, or with a cut window mount for protection and presentation.

Mounted block Where blocks are glued down on to a firm base to give greater stability and ease of handling (e.g. fabric blocks).

Multi-block The use of separate blocks for printing a sequence of colours.

Negative The reverse of the positive image. This term is sometimes used to describe the cut-away parts of a relief block, or the unprinted parts of the resulting print.

Not Describes the surface of paper, which has not been hot pressed or glazed.

Offset A transfer method taking a printed impression from one surface on to another.

Oil stone A whetstone used with oil for sharpening tools.

Original print One of a set of signed and numbered prints produced or supervised by the artist, not a reproduction.

Packing Sheets of paper, rubber or felt blanket, used to distribute pressure when printing. Harder packing would be firm card or boards.

Paper grips Small pieces of folded paper used to hold the two short edges of the paper when printing, so as to avoid dirty finger marks.

Plank Wood sawn parallel to the grain.

Planographic Printing from an entirely flat surface.

Plaster print A burnished print taken from a worked plaster block.

Plate oil A medium mixed with etching pigments, used in relief printing for thinning down inks.

Presses For relief printing: platen, e.g. Albion and Columbian; Cylinder, e.g. flat-bed or letterpress proofing press; and wind-down or screw presses. For intaglio methods, a press is used with a heavy flat metal bed on which the etching plate is placed under dampened paper, and passed between two heavy rollers.

Progressives A set of proofs showing individual separate colours and the effects of overprinting in sequence.

Proof A trial impression taken from the block for studying and correcting.

Registration The correct alignment of each block when printing several colours on a single sheet of paper, giving accurate overprinting.

Relief etching An etched metal plate which is surface printed.

Relief printing Printing an image from the raised surface of a worked block.

Rolling up Applying a layer of printing ink to the relief surface of a block with a roller.

Rubbings *See* frottage.

Scraperboard A stiff card coated with a thin layer of plaster with a layer of black ink, through which the drawing is scratched.

Screenprinting (Serigraphy) A print method using stencils.

Separations A drawing or a print, one for each colour.

Sealant Diluted PVA glue used to seal the surface of a paper block to improve the acceptance of ink.

Silhouette Representation of the outline of an image.

Solvent A solution used for cleaning the paint from line-blocks and metal plates: water for water-based inks, paraffin or white spirit for oil-based inks.

Stencil A piece of paper or protective material from which a hole or holes have been cut. Ink can be applied through the stencil directly on to the printed image, or the stencil laid down on to an inked block before printing, as a mask.

Stop-out A varnish used as an acid resist.

Texture A term describing the feel or appearance of a surface.

Thinners A medium for diluting printing inks; water for water-based, and copperplate oil (plate oil) or proprietary brands for oil-based inks.

Tinting medium Colourless ink used to reduce the strength of the ink and to make transparent tints.

Tympan A metal frame, covered with linen or canvas, fixed along one edge of the bed of a platen printing press.

Type-high The height of type 0.918in (23.3mm).

Undercutting The act of cutting away too much from the underside of the surface of a relief block so that it is left with insufficient support and may break down with pressure.

Vignette An image that is shaded off gradually into the surrounding unprinted or undrawn paper.

'V' tool A metal tool used in wood- and lino-cutting which is made in a variety of sizes and widths.

White line A line print in which the image appears as a white line on a dark background.

Woodcut A relief print from a block of side-grain wood (plank), cut with knives and gouges. Also, the worked block.

Wood engraving A printing process using a block of end-grain wood which has been engraved with a burin or graver. Also a print from such a block.

Further Reading

Andrews, Michael *Creative Printmaking* (Prentice-Hall 1964)

Bawden, Edward *A Book of Cuts* (Scolar Press 1979)

Binyon, Helen *Eric Ravilious* (Lutterworth 1983)

Silvie Turner (Editor) *Directory of British Printmaking Suppliers* (Estamp 1990)

Carey, F. and Griffiths, A. *The Print in Germany* (British Museum Publications Ltd. 1984)

Challis, Tim *Printsafe* (Estamp 1990)

Chamberlain, Walter *Woodcut Printmaking* (Thames and Hudson 1978)

Cirker, Blanche *1800 Woodcuts by Thomas Bewick & His School* (Dover 1962)

Daniels, Harvey *Printmaking* (Hamlyn 1971)

Dawson, John (Editor) *The Complete Guide to Prints and Printmaking Techniques and Materials* (Phaidon 1981)

de Sausmarez, M. *Basic Design: the Dynamics of Visual Form* (Studio Vista 1964)

Geiser, Bernard *Pablo Picasso: Fifty Five Years of His Graphic Work* (Thames & Hudson 1966)

Gesner, Konrad *Curious Woodcuts of Fanciful and Real Beasts* (Dover 1971)

Godfrey, Richard *Printmaking in Britain* (Oxford 1978)

Gilmour, Pat *Artists in Print* (BBC 1981)

Green, Peter *Introducing Surface Printing* (Watson-Guptill 1967)

Griffiths, Anthony *Prints and Printmaking* (British Museum Publications 1980)

Gross, Anthony *Etching, Engraving and Intaglio Printing* (Oxford 1970)

Heller, Jules *Printmaking Today* (Pitman 1971)

Illing, Richard *The Art of Japanese Prints* (Octopus 1980)

Kent, Cyril *Simple Printmaking* (Studio Vista)

Kent, Cyril *Starting with Relief Printmaking* (Studio Vista)

Leighton, Clare *Wood Engravings of the 1930's* (The Studio 1936)

Mackley, George E. *Wood Engraving* (Gresham Books 1981)

Michener, James *The Floating World* (Secker & Warburg 1954)

Munari, Bruno *Design as Art* (Penguin Books 1971)

Newland, Mary and Walklin, Carol *Printing & Embroidery* (Batsford 1977)

Rhein, Erich *The Art of Printmaking* (Evans 1976)

Rothenstein, Michael *Linocuts and Woodcuts* (Studio Vista 1962)

Rothenstein, Michael *Frontiers of Printmaking: New Aspects of Relief Printmaking* (Studio Vista 1966)

Rothenstein, Michael *Relief Printmaking* (Studio Vista 1970)

Simmons, Rosemary and Clemson, Katie *Relief Printmaking* (Dorling Kindersley 1988)

Sleigh, B. *Wood Engraving Since 1890* (Pitman 1932)

Sotrifer, Kristian *Printmaking: History and Technique* (Thames & Hudson 1968)

Tokuriki Tomikichiro *Wood-Block Printing* (Colour Books Japan 1980)

Walklin, Carol *Using Letters in Art and Craft* (Batsford 1974)

Wilson, David *Projecting Britain* (British Film Institute 1982)

Useful Addresses

SUPPLIERS

Atlantis Paper Co.,
(papers)
Gullivers Wharf,
105 Wapping Lane,
London E1 9RW

Arboreta Papers (Recycled),
St. John's Street,
Bedminster,
Bristol BS3 4JF

Ault & Wiborg Ltd.,
(inks & rollers)
71 Standen Road,
London SW18

BASF Coatings + Inks Ltd.,
(letterpress inks)
94 St. Albans Road,
Watford,
Hertfordshire WD2 4BU

Berrick Bros. Paper Merchants Ltd.,
(Modelspan tissue)
Unit 1,
Deptford Trading Estate,
Black Horse Road,
London SE8

R. K. Burt & Co.,
(papers)
57 Union Street,
London SE1 1SD

Coates Bros. Inks Ltd.,
Grape Street,
Leeds,
West Yorkshire LS10 1DN.

Anthony Christmas
(mounted Delrin blocks)
15 Robertson Road,
Buxton,
Derbyshire SK17 9DY

Daler-Rowney Ltd.,
(school-grade tools & general supplies)
Southern Industrial Area,
PO Box 10,
Bracknell,
Berkshire,
and
12 Percy Street,
London W1A 2BP

Dryads,
(school-grade tools, inks, lino, paper and
presses)
Northgates,
Leicester LE1 4PR

Falkiner Fine Papers,
(paper, and books on printmaking)
76 Southampton Row,
London WC1 7AR

Hunter Penrose Ltd.,
(presses, printing supplies, marble
drying racks)
62 Southwark Bridge Road,
London SE1 0AS

Intaglio Printmaker,
(general printmaking supplies)
62 Southwark Bridge Road,
London SE1 0AS

T. N. Lawrence & Son Ltd.,
(papers, artist-grade lino, wood, and wood engraving tools, sharpening service, blocks, inks and presses)
119 Clerkenwell Road
London EC1R 5BY
Mail order address:
'Flintwell' Iford
Nr. Lewes,
East Sussex BN7 3EU

T. J. Morgan (Barry) Ltd.,
(Delrin engraving material)
Ty-Verlon Industrial Estate,
Barry,
Cardiff CS6 3BE

Modbury Engineering,
(presses, removal and maintenance)
311 Frederick Terrace,
London E8 4EW
Tel: Chris Holladay 0171 254 9980

Nairn Floor Ltd.,
(lino suppliers)
PO Box 1
Kirkcaldy,
Scotland
KY1 2SB

John Purcell Paper,
(printing papers)
15 Rumsey Road,
London SW9 0TR

Michael Putnam,
(printmakes' supplies)
151 Lavender Hill,
London SW11 5JQ

J. Perkins Distribution
(Modelspan tissue stockists)
90/96 Greenwich High Road
London SE10 8JE
Tel: 0181 692 2451

Reeves Arts Materials,
(school-grade tools and general supplies)
PO Box 91,
Whitefriars Avenue,
Wealdstone,
Harrow,
Middlesex HA3 5RH
and
178 Kensington High Street,
London W8 7RG

Harry F. Rochat,
(supplies and refurbishes presses)
Costwold Lodge,
14a Moxon Street,
Barnet,
Hertfordshire EN5 5TS

Bob Stead,
(wood engraving blocks)
72 The Fryth,
Basildon,
Essex SS14 3PE

Winsor & Newton,
(school-grade tools and general supplies)
51 Rathbone Place,
London W1P 1AB

Yorkshire Printmakers and Distributors,
(mail order worldwide: all printing
materials)
26–28 Westfield Lane,
Emley Moor,
Nr Huddersfield,
West Yorkshire HD8 9TD

ASSOCIATIONS

Printmakers Council of Great Britain,
31 Clerkenwell Close,
London EC1

Royal Society of Painter-Printmakers,
Bankside Gallery,
48 Hopton Street,
Blackfriars,
London SE1

Society of Wood Engravers,
c/o H. Paynter,
PO Box 355,
Richmond,
Surrey

RELIEF PRINTMAKING WORKSHOPS

Bristol Printmaking Workshop,
Bristol

Dundee Printmakers Workshop,
Dundee

Glasgow Print Studio,
Glasgow

Inverness Printmakers Workshop,
Inverness

Lowick House Print Workshop,
Lowick,
Near Ulverston,
Cumbria

Moorland House Workshop,
Near Bridgwater,
Burrowbridge,
Somerset

White Gum Press,
Fleetwater Farm,
Near Lyndhurst,
Hampshire

Wilkey's Moor Print Workshop,
Wilkey's Moor,
Ivybridge,
Devon

PAPER-MAKING COURSES

Maureen Richardson's Wye Valley
Workshop,
Hereford

INSTITUTIONS THAT OFFER RELIEF PRINTMAKING COURSES

Brighton Polytechnic,
Brighton

Camden Adult Education Institute,
London

City and Guilds of London Art School,
London

Clock House,
Suffolk

Crafts Council,
London

Croydon College of Art and Design,
Croydon

Earnley Concourse,
Chichester,
Sussex

Flatford Mill Field Centre,
Colchester,
Essex

Gainsborough's House,
Suffolk

London College of Printing,
London

Missenden Abbey,
Buckinghamshire

North West Wales Arts Association,
Gwynedd

Ormond Road Summer School,
London

Paddington Print Workshop,
London

Seacourt Print Workshop,
County Down BT20 4LG

Small Press Group,
London

Southend College of Technology,
Essex

West Dean College,
Chichester,
Sussex

West Midlands CFE,
Mid-Warwickshire

Yorkshire Arts,
Bradford

Printmaking Courses are advertised in:

Artists Newsletter (monthly),
PO BOX 23,
Sunderland SR4 6DG

Field Studies Council,
Central Services,
Preston Montford,
Montford Bridge,
Shrewsbury SY4 1HW

Printmaking Today (Quarterly),
Editor: Rosemary Simmons,
14b Elsworthy Terrace,
London NW3 3DR

Useful publications in local libraries are:

DOFE (Directory of Further Education):
A Complete Guide to All Non-University Courses in the UK
NIACE (The National Institute of Adult Continuing Education) 1. *Guide to Residential Study Breaks*; 2. *Time to Learn* (winter/summer publications) UK

Most local libraries will have details of courses run by the Adult Education Department in your district. If they do not have a relief printmaking course, try and get them to organize one or to arrange short courses with visiting tutors.

Index